IMAGES
of America

CHICAGO RIDGE

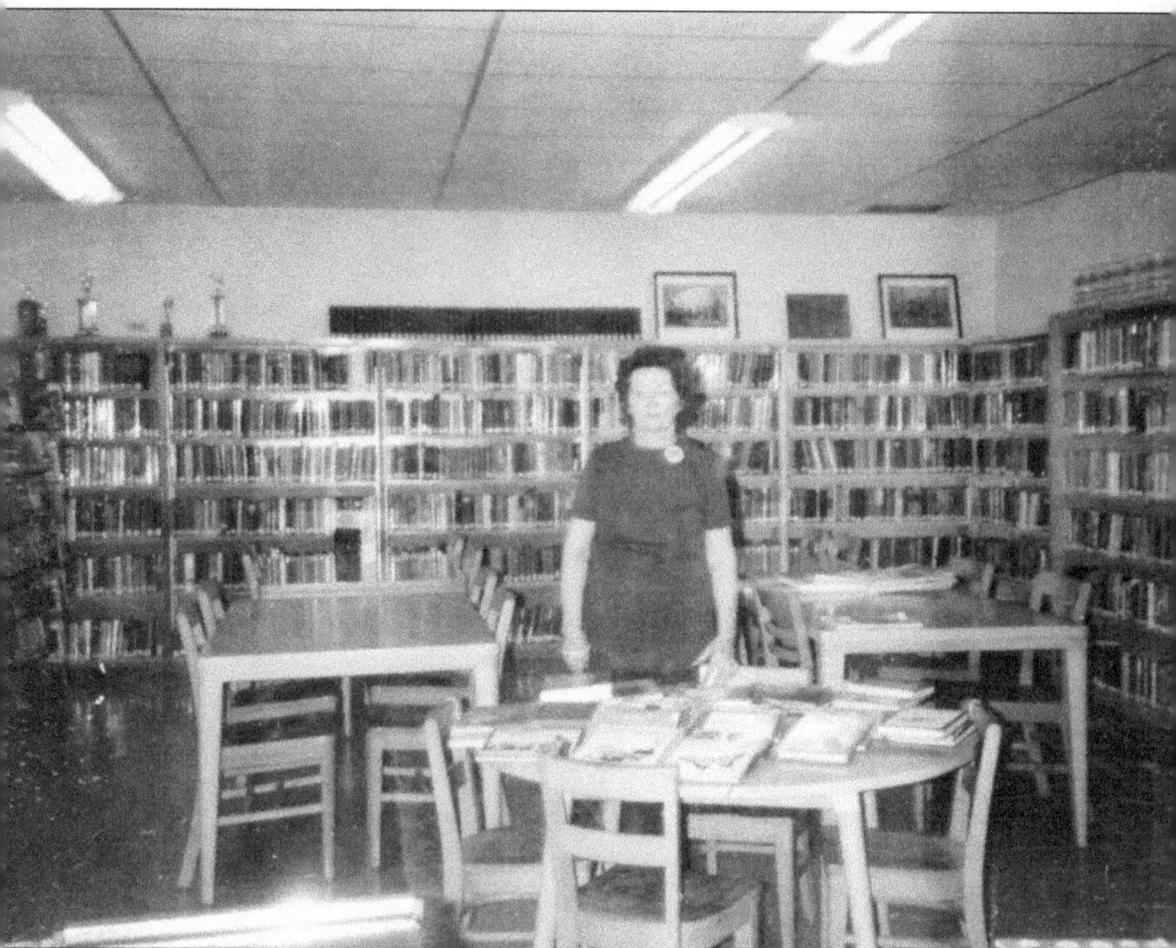

Anne Pote was the first administrative librarian of the Chicago Ridge Public Library. Seen in 1974, she is standing inside the library building at 10655 South Oak Street. Pote was hired in 1966 to manage the library and remained in this position until her retirement in 1981. Along with her passion for fostering reading, she dedicated herself to preserving Chicago Ridge's history. (Courtesy of the Chicago Ridge Public Library.)

ON THE COVER: The Chicago Ridge Hotel and Inn, which included a tavern, was operated by John Henry Meyer at 103rd Street and South Ridgeland Avenue. It served as a headquarters in the early 1900s for village policy-makers and small-game hunters. (Courtesy of the Chicago Ridge Public Library.)

IMAGES
of America

CHICAGO RIDGE

Ed Maurer Jr. and the
Chicago Ridge Public Library

ARCADIA
PUBLISHING

Published by Arcadia Publishing
Charleston, South Carolina

Library of Congress Control Number: 2013939952

For all general information, please contact Arcadia Publishing:
Telephone 843-853-2070
Fax 843-853-0044
E-mail sales@arcadiapublishing.com
For customer service and orders:
Toll-Free 1-888-313-2665

Visit us on the Internet at www.arcadiapublishing.com

*To Anne Pote, who not only preserved Chicago Ridge's
past but also contributed to molding its future—I hope this
book is a testament to the love she felt for this village.*

CONTENTS

FOREWORD

In 1914—a memorable year—Doublemint chewing gum was introduced and baseball legend Joe DiMaggio was born, but it was also the same year that Mother's Day was officially created by Pres. Woodrow Wilson and the Village of Chicago Ridge was incorporated.

This 100th anniversary book follows the trail of our village's colorful and unique history, and I know that readers will thoroughly enjoy looking back, reminiscing, and exploring that fascinating trail. Along the way, you will learn about the early days, the growing years, and how we matured into the village we are today.

It is hard to comprehend the difficult challenges faced by those who joined in the task of creating not just an official, incorporated village but also a community, a community of like-minded friends and neighbors who wanted a shared identity and a carved-out area on a map that they could be proud to call home.

I am personally very proud that, in 1953, my parents, George and Cecelia, established roots in Chicago Ridge and made Tokar's Supper Club into the successful family restaurant it became. I will always remember the great times I had inside those walls, especially when playing the organ for dinner guests.

Beginning with the first village president, Charles Polchow, many individuals have stepped forward to serve the community and its residents. It was only through their combined efforts that so much has been accomplished, and it is my privilege to extend our thanks to them. Without their hard work, Chicago Ridge would not be what it is today—a modern, yet neighborly, community and a place where people still count.

Finally, I would be remiss if I did not mention the 38 years of service by Mayor Eugene Siegel, whose leadership led to many infrastructure improvements and much growth. It was certainly my privilege and honor to serve alongside him as a trustee and as village clerk during his administration, and I thank him for his devotion to Chicago Ridge's residents.

—Charles E. Tokar, village president

ACKNOWLEDGMENTS

The Chicago Ridge Public Library has contributed thousands of hours in preserving the history of Chicago Ridge. The late Anne Pote's mission of collecting local history continues today. Unless otherwise noted, all images appearing in this book were provided by the Chicago Ridge Public Library.

A thank-you goes to my coauthor, Kathryn Sofianos, who was instrumental in starting the library's local history room and is the creator of the Chicago Ridge Online History Collection. She is the modern-day Anne Pote, sharing Anne's passion for all things Chicago Ridge. A great deal of thanks go to Stacey Reichard, who tirelessly scanned photographs, took pictures, and contributed to the final layout, and to Kathleen McSwain, the library's director, who provided her support during every phase of the project, as did the library board of trustees.

This project originated because of the involvement of Transitions Community Outreach (TCO), formerly the Chicago Ridge Youth Service Bureau. TCO's director Hank Zwirkoski and board members Tom Klein and Stephen Zumbo helped me construct a plan to publish the history of this town. Without their support, this book might not have been possible.

I also wish to thank village president Charles E. Tokar for writing the foreword and Mayor Emeritus Eugene L. Siegel for his enthusiasm for local history. They were an invaluable resource and have my immeasurable gratitude.

Special thanks must be given to those who contributed their time, photographs, and family stories to this publication. They are as follows: Gary Polchow; Herbert Polchow Jr.; Robert Babcock; Leonard Reichard; Robert and Marilyn Kurecki; Adehl Good; Alice Lasky; Mary Demchuk Waitches; the Dokter family; Henry, Doris, Melvin, Margaret, and Hilda Ozinga; Evelyn Dekker; Duane Exline; Mr. and Mrs. Charles Trapp and son, John; Fiore Chiappetti; Jack Walsh; Debbie Aguinaga; Larry Coglianese; Anne Stacy; Lorraine Werniak; Sandy Saunoris; Susan Frenzel Kasper; Mary Stockdale McEldowney; John and Karen Powers; Tammy Cooper Mancini; Ellen Tranowski; Ken Rutz; Cindy Rutz; Carol Bates Horacek; Jean Duignan; Ken Braasch; Bob Braasch; Bill Fagan; Rev. Wayne Svida; Kevin Zickterman; the O'Neil family, Gail, James Sr., and James Jr.; Richard Yaras; John Seleb; Greg Hoefling; Patricia Cooper-Grannum; Catherine Coletta; Geno Oostema; Jack McCullough; Bill Aldrich; Claudia Zekas; and the Sofianos family. Thanks go to all of you who contacted me through the Facebook pages, RidgeRats and RidgeRatts. Many thanks go to editors Amy Perryman, Kelsey Jones, and Maggie Bullwinkel, and to my family, parents Ed Sr. and Elaine; siblings Becky, Cheryl, and Tom; and their families. Lastly, thank you, Vicky Crouse; children Wade and Carrie; their spouses Meghan and Brent; and grandchildren Weston, Whitney, Wyatt, Ella, and Chloe, for your love and encouragement.

The authors' royalties from the sale of the book will be donated to the Friends of the Chicago Ridge Public Library and Transitions Community Outreach, a local counseling organization.

INTRODUCTION

When you think of Chicago Ridge, or "the Ridge" as it is affectionately known, a number of things come to mind: a mall, a train station, Ridgefest, and a big, blue water tower seen in every direction for miles. These days, what is often forgotten is how Chicago Ridge became a community. The forefathers of the village paid the price to lay the groundwork for this tough town that so many have called home. They started from scratch with places like Polchow's Grove, Rucies' Tavern and Grove, Liberty Hall, and John Henry "Dad" Meyer's Hotel and Inn—building this village by the sweat of their brows and the aches of their backs. Some people drifted into obscurity, but others we know from our lifetime. All of them are irreplaceable to the thriving community that Chicago Ridge is today.

Chicago Ridge is bordered by Oak Lawn on the north and east, Bridgeview on the west, and Worth on the south. It is approximately 15 miles southwest of Chicago. The village started simply enough on Stony Creek, a waterway that winds through town. It was actually a feeder canal for the Illinois and Michigan (I&M) Canal that reached from the little Calumet River westward through the Saganashkee Slough and brought some of the original settlers in the 1840s. German and Dutch farmers arrived after the 1850s, not long after Potawatomi Indians had vacated the area under order of the US government and President Van Buren. Prior to settlement, the region was actually known as "Alpine" or "Klondike." Once the Wabash, St. Louis & Pacific Railway came to town, things really started happening in the Ridge. The name Chicago Ridge comes from the ridges that were left behind after eight train cars of dirt were taken from this area to build up the grounds of the 1893 Columbian Exposition in Chicago. People first called the area Chicago's Ridge. Later, in the heart of town, the Wabash, St. Louis & Pacific Railway crossed the Chicago & Calumet Terminal Railway, bringing in rail yards and workers. Chicago Ridge resembled something right out of the Wild West, but luckily, we were fairly close to the bustling and burgeoning metropolis that was Chicago.

In 1898, the Paul E. Berger Company, manufacturer of slot machines and cash registers, was built adjacent to the railroad. The company built housing for its employees and a settlement around the factory, with a tavern, rooming house, grocery store, and even the town's first post office. To accommodate workers and travelers, the Wabash Railroad established a train depot in 1902.

Around the turn of the century, a horseracing track was built on the outskirts of Chicago Ridge, which brought a whole new group of people to town looking for a good time. Chicago Ridge supplied them with a number of boardinghouses, taverns, restaurants, and general stores. People would travel great distances to enjoy the hospitality of the Ridge. Chicago Ridge actually claims a Kentucky Derby–winning jockey as its own. Native Fred Herbert rode Donau to victory in 1910. In 1911, the racetrack was torn down and turned into an armory and training ground for World War I soldiers. Later, this ground became more familiar as Holy Sepulchre Cemetery.

Settlers knew their town had grown into something strong and vibrant. After towns surrounding Chicago Ridge incorporated, leaders in this village were determined to follow suit. In October 1914, Chicago Ridge was incorporated. Charles Polchow was elected as the village's first president. Michael Hankes was elected clerk along with a whole slate of trustees, a police chief, and other municipal positions. The mayor's salary was set at $10 per year, and the clerk's was $12. Some positions were paid on commission. Ordinances and fees were set as were the methods of collection. Committees were appointed, and the village was off and running.

Cinders and crushed stone were constantly hauled into Chicago Ridge for roadways and walkways. Wooden sidewalks were maintained, weeds cut, ditches dug, animals regulated, permits issued, and there were constant battles with the railroad for crossing markers. Flooding was a chronic problem. A review of the village meeting ledger from this era shows several heated exchanges and standoffs, one resulting in the village clerk threatening to resign on the spot.

Chicago Ridge was a favorite place for small-game hunters who would stay at "Dad" Meyers Hotel and Inn next to the railroad tracks on Birmingham Avenue. Hunters would bag rabbit, pheasant,

duck, and other game. Alvin Trapp set up a pelt business in town and did a brisk business buying and selling pelts. His brother Charles was known as one of the best shots in town. Charles's buddy "Fat" Daniels, as he was affectionately known, was grateful the day Charles came over to his house to go hunting and actually had a goose fly in right over the house. Being the crack shot he was, he took aim, and—bang—he brought down the goose. Poor Fat Daniels must have thought the Marines had landed as he was in another room not expecting the volley. Also during this time, people from Chicago would actually buy small plots of land in town and commute just to garden and grow fresh produce to bring back to the city with them.

The Roaring Twenties were certainly heard in Chicago Ridge as taverns and boardinghouses dotted the landscape. A thirsty patron could find relief up and down Ridgeland Avenue and 111th Street. Chicago Ridge taverns doubled as social centers, meeting places, special events halls, and even the village hall (until one was built). Children had their own rooms for play. Picnic groves, like Polchow's, were attached to them as well. Wedding receptions were hosted there, and kids would climb the trees and bang pots and pans for the bridal party who would show their gratitude by throwing change to the merrymakers. Glorious halls like Piccadilly Gardens, and in later years Tokar's Supper Club, were a real treat.

It has been said that Al Capone and other organized crime figures from that day would frequent Chicago Ridge establishments, and that at times, heavily armed locals would chase them out of town. There was a hit on gangster John "Dingbat" Oberta and Sammy Malaga on the outskirts of Chicago Ridge in 1930 during what was called the "Beer Wars." More concerning to village residents was the diphtheria epidemic, as told by former resident Hilda Dokter Ozinga, that forced the closing of school for an entire quarter, ravaged the town's schools, and caused one child's death. Dr. Theodore Casteyer of Oak Lawn could be seen going from house to house caring for just about everybody in town. Fear swept through the village like never before.

After the Great Depression, John "Jack" Walsh opened a gas station and created a Chicago Ridge institution. Later, James Saunoris Sr. added to the business landscape by opening a floral shop. Mather Stock Car Company, located in Chicago Ridge, saw its business boom. Mather not only created an ingenious refrigerated railcar to transport meat to market from Chicago's stockyards, but he also offered it on a leased basis, which made it much more affordable for the rail companies. The company revolutionized the rail transport of meat during a time when the country badly needed it. Mather employed a large number of residents during these difficult times; eventually, the company became a part of North American Car Corporation, a huge railcar manufacturer that resided in Chicago Ridge. The railroad was not only instrumental in founding this town but has also been its lifeblood as well.

Chicago Ridge's contribution to our nation's military cannot be overlooked. Our sons and daughters answered the call repeatedly, and some have paid the greatest price. World War II came to Chicago Ridge, and Glenn Maker was the first resident to lay down his life for his country, with others following. Current mayor Charles E. Tokar said in an interview for this book, "I believe it is only fitting that we also think about the sacrifices those in our armed forces have made over the years, and are still making today, on our behalf and for the cause of freedom and liberty around the world." Both the Veteran of Foreign Wars (VFW) and the American Legion Hall, named after Glenn Maker, boast beautiful stone monuments to our heroes.

During World War II, the Community Club raised money to have a wooden monument with a flagpole erected with the names of Chicago Ridge residents serving in the US Armed Forces. Ken Rutz made sure that the monument's flag was raised and lowered every day. The mayor at the time of World War II, Bruno Duckwitz, resigned his position and enlisted in the military. I remember Bruno in later years, from a Laundromat he owned in town. He was such a humble guy, not only did I not know he had made such a great sacrifice for our nation but I never even knew he was mayor at one time.

During the 1950s and 1960s, this town exploded, coming in at 888 people and growing to a whopping 5,748 residents by 1960. To keep up with this great immigration, Chicago Ridge needed services. Schools, fire service, a library, mail service, police department, garbage disposal, and

public works were created out of necessity. Boy Scouts, Girl Scouts, ladies auxiliaries, youth sports, and playgrounds were created for enjoyment. A new village hall was built at 107th Street and Oak Avenue, which later housed the library. According to Mary Demchuk Waitches, the village built a civil defense tower to keep people out of harm's way. Residents like Fred Poe and John Walsh actively participated and routinely showed up for drills to prepare for any emergency. Mary's ex-husband Bill Demchuk was among the first volunteer fireman in town and also was instrumental in providing mail service to residents.

Businesses sprung up all over town from grocery stores like Vern's and Jack and Pat's to Ed Sprinkles's bowling alley. Taverns like Frenzel's and Eddie's Jolly Inn added to the ambiance of 111th Street. Frenzel's spans generations of Ridge residents and is still operated by their family as Kasper's General Store in its original location. Few can match Susan Frenzel Kasper's ability to talk "Ridge." Mayor Herbert Polchow organized the first garbage service at 25¢ a can. School and church building accelerated with Henry Ford II School, Ridge Lawn School, and Elden D. Finley. Our Lady of the Ridge moved from the old Piccadilly Gardens location to 108th Street and Ridgeland Avenue, and the United Presbyterian Church, the village's first church, was rebuilt at 107th and Lyman Avenue. Mayor Tokar recalls fondly his grandmother playing the pull-tab games at the 107th Street and Ridgeland Avenue carnival and believes that this was the impetus for Ridgefest, which has generated more than $1 million for local nonprofit organizations.

Eugene L. Siegel was elected to fill an unexpired term in 1975 and never looked back. Mayor Siegel is largely responsible for bringing Chicago Ridge into the modern era. At this time, he is the longest-serving mayor the village has ever had, and his accomplishments are evident throughout Chicago Ridge. When it was not uncommon to wait more than an hour for a train to cross town streets, Mayor Siegel mediated a remedy. Charles E. Tokar recalls drenching thunderstorms, which provided him an opportunity to row his neighbor's boat down Mayfield Avenue. Flooding and street repair were chronic problems in Chicago Ridge. Modern sewers and curbs spearheaded by Siegel's administration answered a great deal of these concerns. The Siegel administration also had a sidewalk installed on the Southwest Highway Bridge for pedestrian safety. Police, fire, and public works were improved dramatically to become a modern, effective force admired in the area.

Mayor Siegel had the foresight to make Chicago Ridge Mall a reality for the village, which not only became an attraction in town but also generated much needed revenue dispersed in many ways to its residents. In conjunction with a town sales tax, this revenue even allowed resident's property tax rebates for a number of years unlike that of many surrounding communities. His annual Christmas party, paid for largely out of his own pocket, has always been popular. He established a Youth Commission, later called Chicago Ridge Youth Service Bureau, and then Transitions Community Outreach (TCO), to promote positive guidance of Chicago Ridge youth. During his term, the modern village hall and police headquarters were constructed, creating the Eugene L. Siegel Municipal Complex. The building bears his name, not at his request but at the insistence of a grateful village. The local history room is housed there as well.

Lastly, but of the utmost importance, no introduction of Chicago Ridge history would be complete without mentioning Anne Pote. Anne had the incredible foresight to collect voluminous amounts of material on local history for safekeeping and perpetuity. This material, including face-to-face interviews that Anne conducted is just astonishing. No one deserves more credit for preserving the history of Chicago Ridge than her. I was fortunate enough to know Anne when she was the library director, and I have vivid memories of her, Harriet Clark, and the other librarians calling us kids up to the library on a moment's notice to get our picture in the paper for some promotion. This was in the days long before social media, so it meant a lot to some kid from a small railroad town.

This book was written in conjunction with the Chicago Ridge Library, the library that Anne built. The entire library staff has been remarkable throughout this experience. My coauthor, librarian Kathryn Sofianos, chose to remain anonymous in this book. If you see her, please thank her for her tremendous contribution to this project. I know despite the great deal of material included in this book, there is still much that has not been discovered, many who have not been interviewed, and some lost in the mists of time.

One

IN THE BEGINNING

Present-day Chicago Ridge is far different from when initial settlers arrived. Land grants were given to Civil War veterans to build homes, and the area was identified as "Alpine" and "Klondike" on the map. Work began on the Cal Sag Canal, and workers found the area via Stony Creek or even by sled as was the case for the Bizzotto family. Once train tracks were laid, people started paying attention to the area. The government decided the Potawatomie Indians should be moved when President McKinley gave the order. Except for the little area of Indian Village, which was located behind the present-day Stony Creek Golf course, Native Americans moved out of Chicago Ridge, and residents tell of Native Indians living there well into the modern era. The Columbian Exposition of 1893 in Chicago was announced, and large amounts of soil were given to the cause, scarring the landscape to the point that it was named Chicago's Ridge.

The fact that Chicago Ridge was born with a scar only adds to the town's reputation for resiliency. The founders of this town had a clear vision and endured great sacrifice, but through hard work and determination, they saw the Ridge dig its roots in deeply. Make no mistake, this town knows how to have a good time—a nearby racetrack around 1900 flooded the area with revelers, and they found Chicago Ridge very accommodating. Paul E. Berger is largely overlooked, but because he chose the town as the location for his slot-machine and cash-register factory around 1900, a whole community was born. Paul E. Berger not only wanted to have a business here, but he built a big beautiful house for himself at 107th Street and Oxford Avenue that is still occupied today. Berger had whole neighborhoods constructed for his workers as well. He named one of his first slot machines Chicago Ridge. Look around town today, and it is easy to forget that in the beginning, somewhere in the town's past, a lot of tough, dedicated people would not give up on the place bearing the scar of Chicago and called Chicago's Ridge.

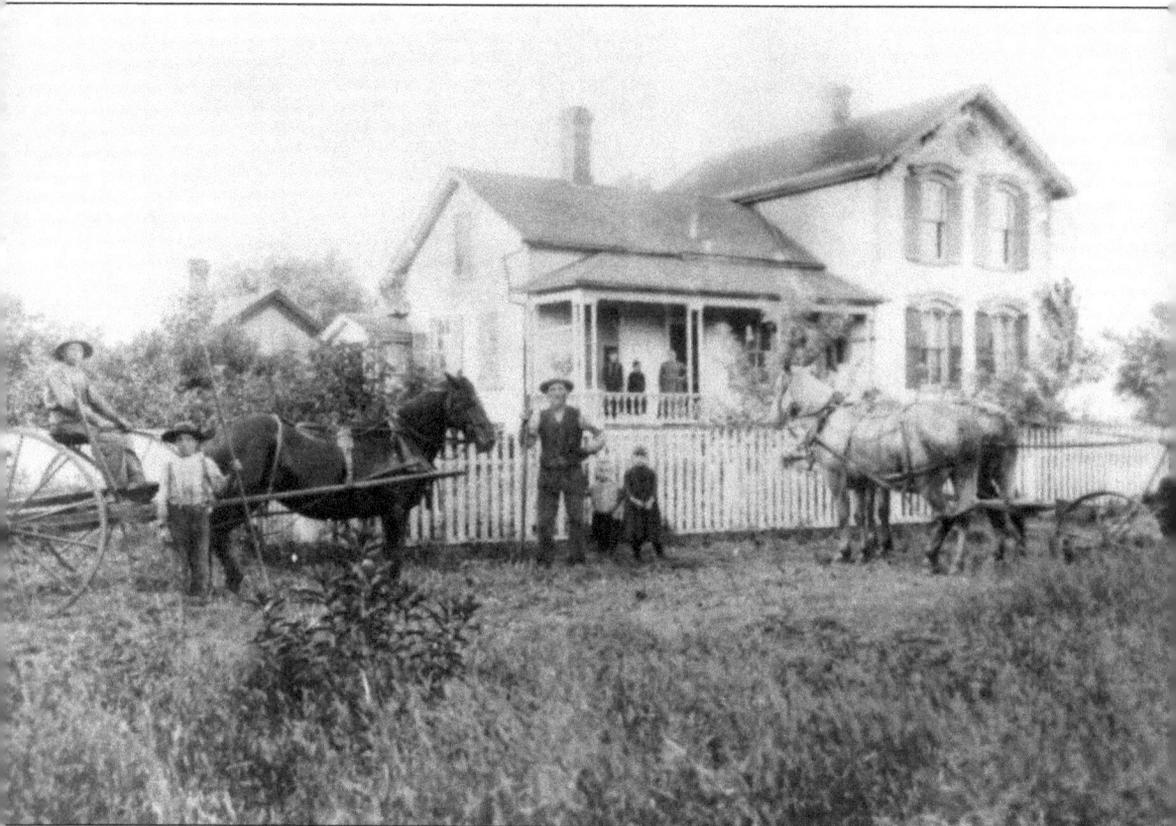

The photographer captures members of the Heinrich "Henry" Friedrich Wilhelm Aulwurm family in 1883 at their homestead on 110th Street and Moody Avenue. Henry Aulwurm's wife, Bertha, stands on the porch with children Arthur and Emma. In the foreground is Henry Sr., surrounded by his children, from left to right, Henry Jr., Louis, Ernst, Bertha, and William. Emigrants from Germany, the Aulwurms purchased the home and its surrounding 80 acres in 1865, raising 10 children on the property. Valued at $5,000 in the 1870s, it was a sizable estate, bounded by 111th Street on the north, 107th Street on the south, Austin Avenue on the east, and Lombard Avenue on the west. Only the third born son, Louis, followed in Henry Sr.'s footsteps and became a farmer. By 1930, Louis had died, and his widow had moved to a residential area in Oak Lawn. Mike and Martha Tuszl bought the farmhouse and 5.5 acres of surrounding property in 1944. This area was later known as Tuszl Subdivision.

The Aulwurm home located at 110th Street and Moody Avenue is the oldest surviving farmhouse in Chicago Ridge. Robert and Marilyn Kurecki purchased the home in 1984 and spent 27 years carefully restoring it to its original 1865 state. (Courtesy of Robert and Marilyn Kurecki.)

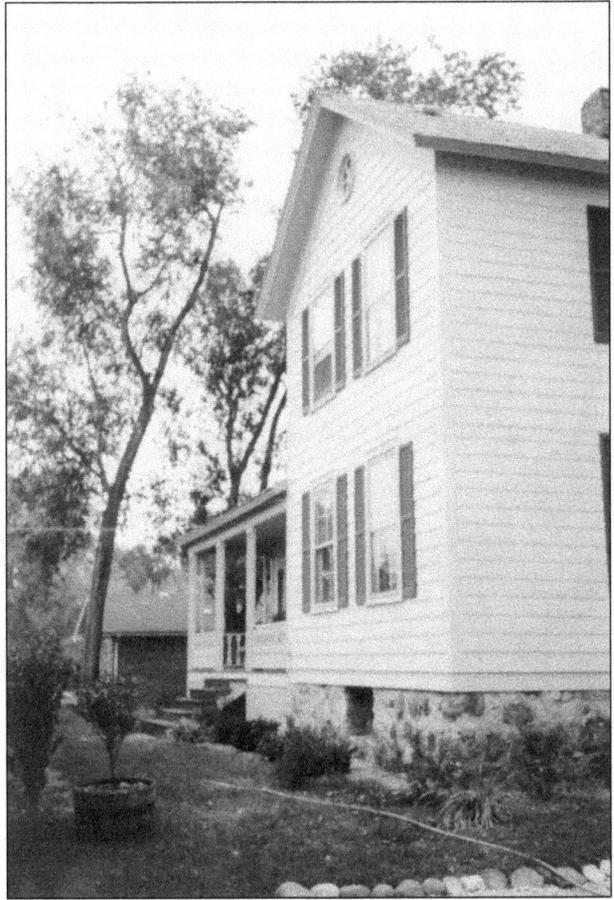

When the first European settlers arrived to this area, they encountered vast areas covered with tall grasses and wildflowers. The Chicago Ridge Prairie, located at 105th Street and Menard Avenue, provides a window to this past. The prairie is an Illinois Nature Preserve and one of three gravel-based mesic prairies remaining in Illinois.

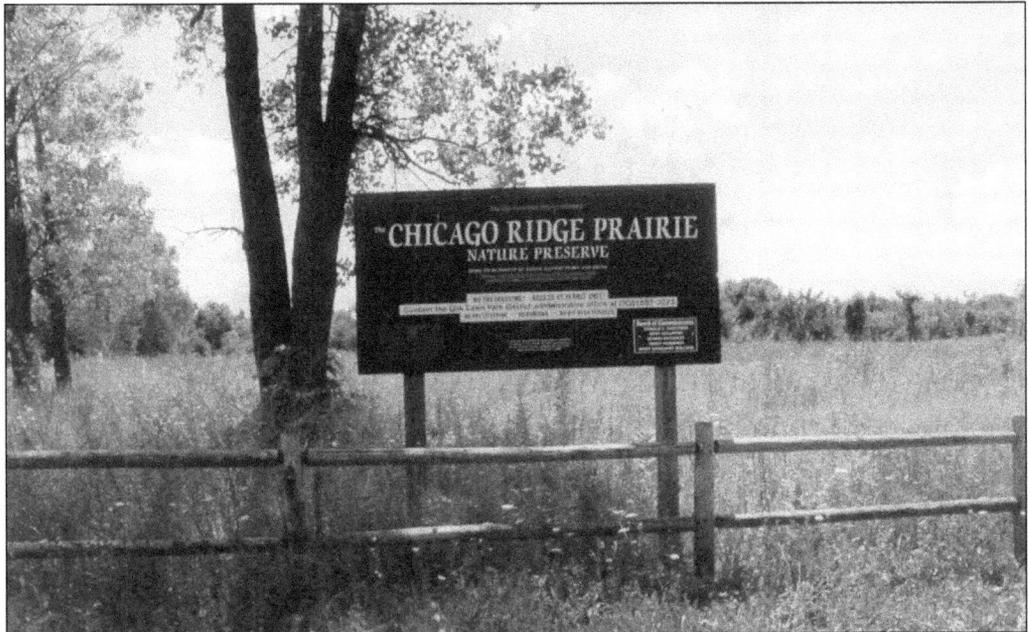

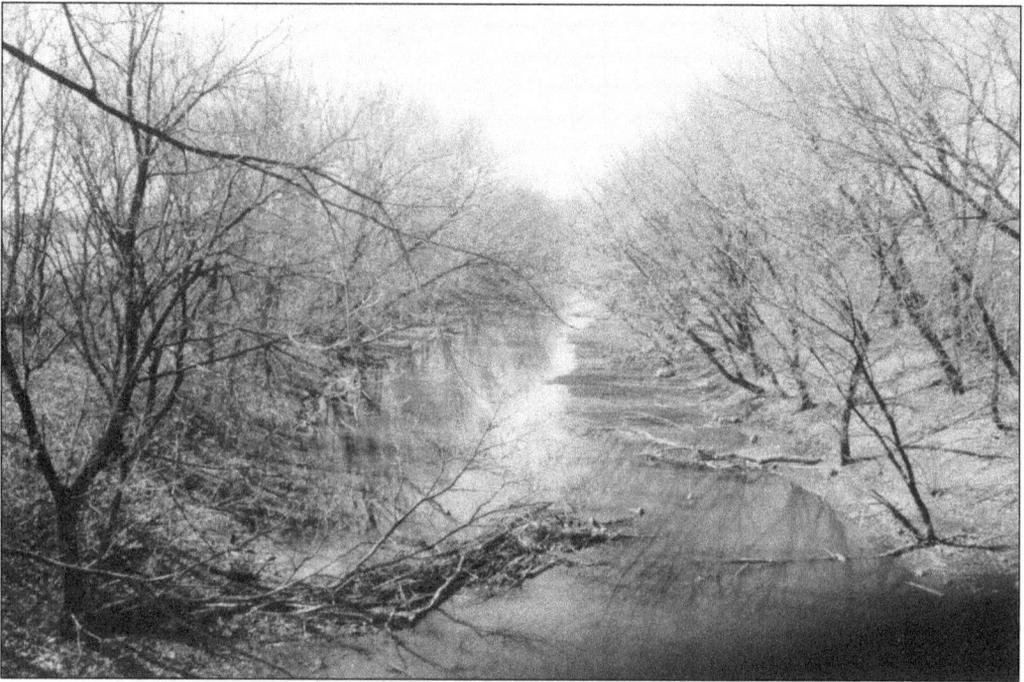

The path of Stony Creek arcs through Chicago Ridge. It is an old waterway, 14,000 years by some estimates. The creek was an aquatic highway for Native Americans, explorers, and others. Its many marshy areas were well stocked with fish and game. Stony Creek became a feeder canal for the Illinois and Michigan Canal in the 1840s. Workers excavated sections of the creek to reverse its natural flow to the Calumet River.

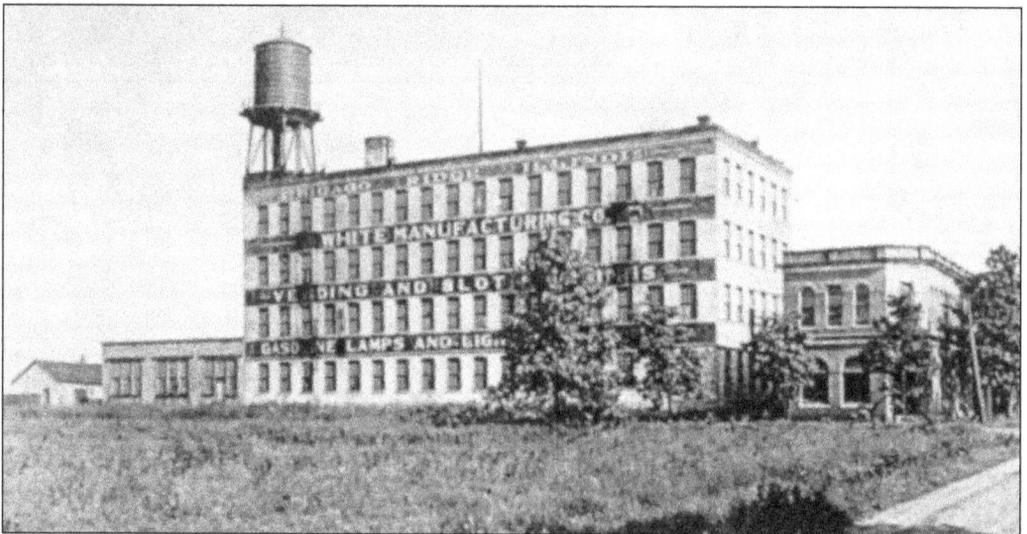

Chicago Ridge was home to factories in the 1890s to the early 1900s that made slot machines and cash registers. This picture is of the White Manufacturing Company, located at Birmingham and Oxford Avenue. Before Ripley J. White owned the factory, it belonged to Paul E. Berger Manufacturing Company. The building was also the site of the first Chicago Ridge Post Office. Established in 1895 by Berger, who lived at 106th Street and Oxford Avenue, it covered five acres. After losing a lawsuit in 1901, the company unfortunately went out of business.

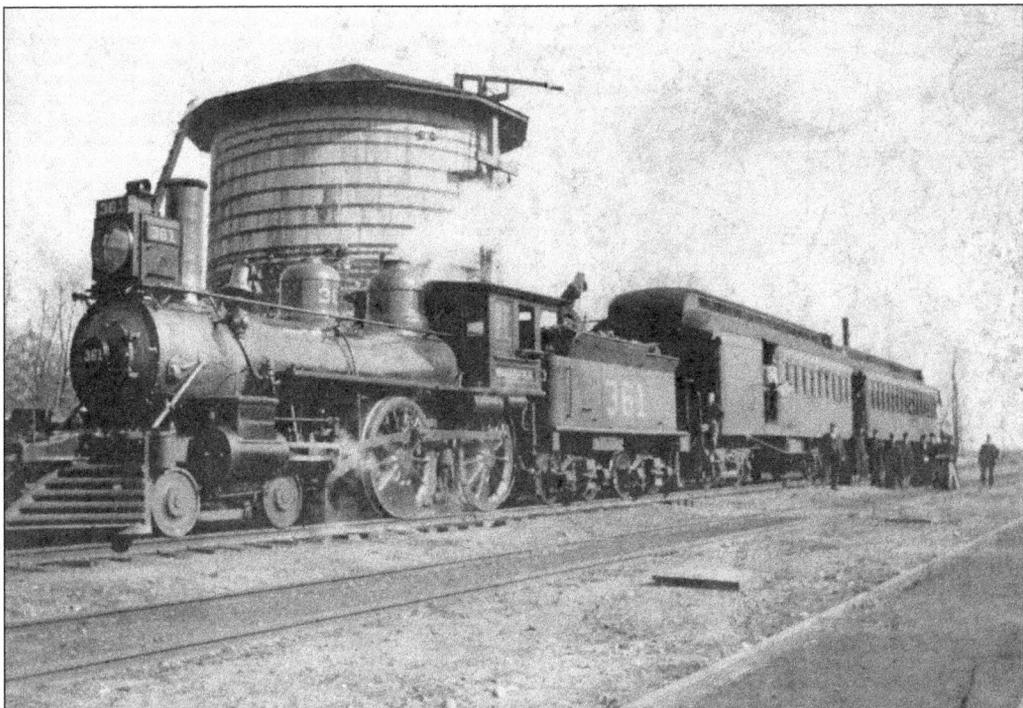

The year 1882 marked the arrival of the Wabash, St. Louis & Pacific Railway, making it easier for men to come and go out of town for work. Commerce increased, and in 1902, a train depot was built at 103rd Street and Ridgeland Avenue. Mail came to town by means of a postal car. When the Wabash rolled through town, a postal clerk would snatch a pouch of outgoing mail that hung from a trackside crane. Mail was delivered just as quickly. The clerk would kick the mail pouch off the train, hoping that it would not get run over.

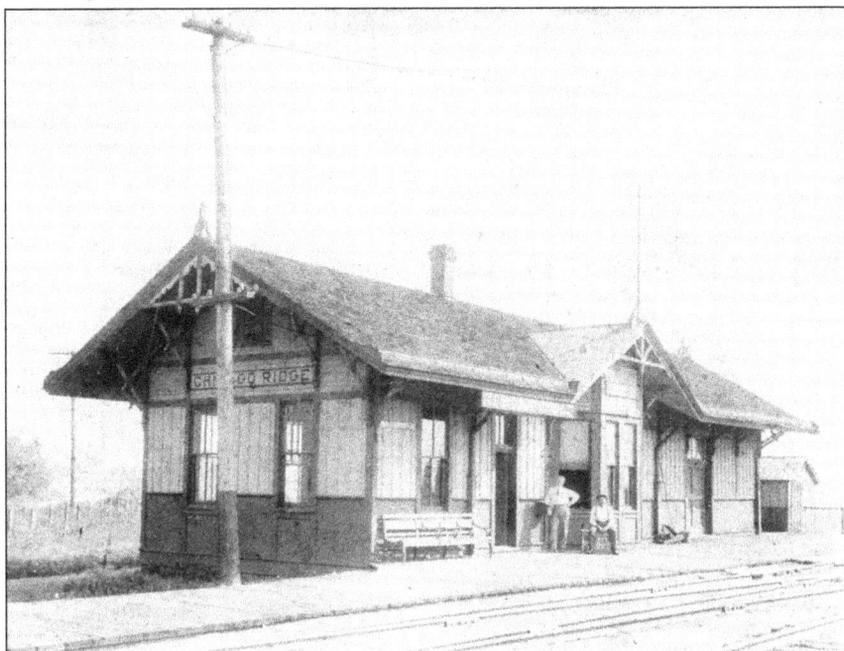

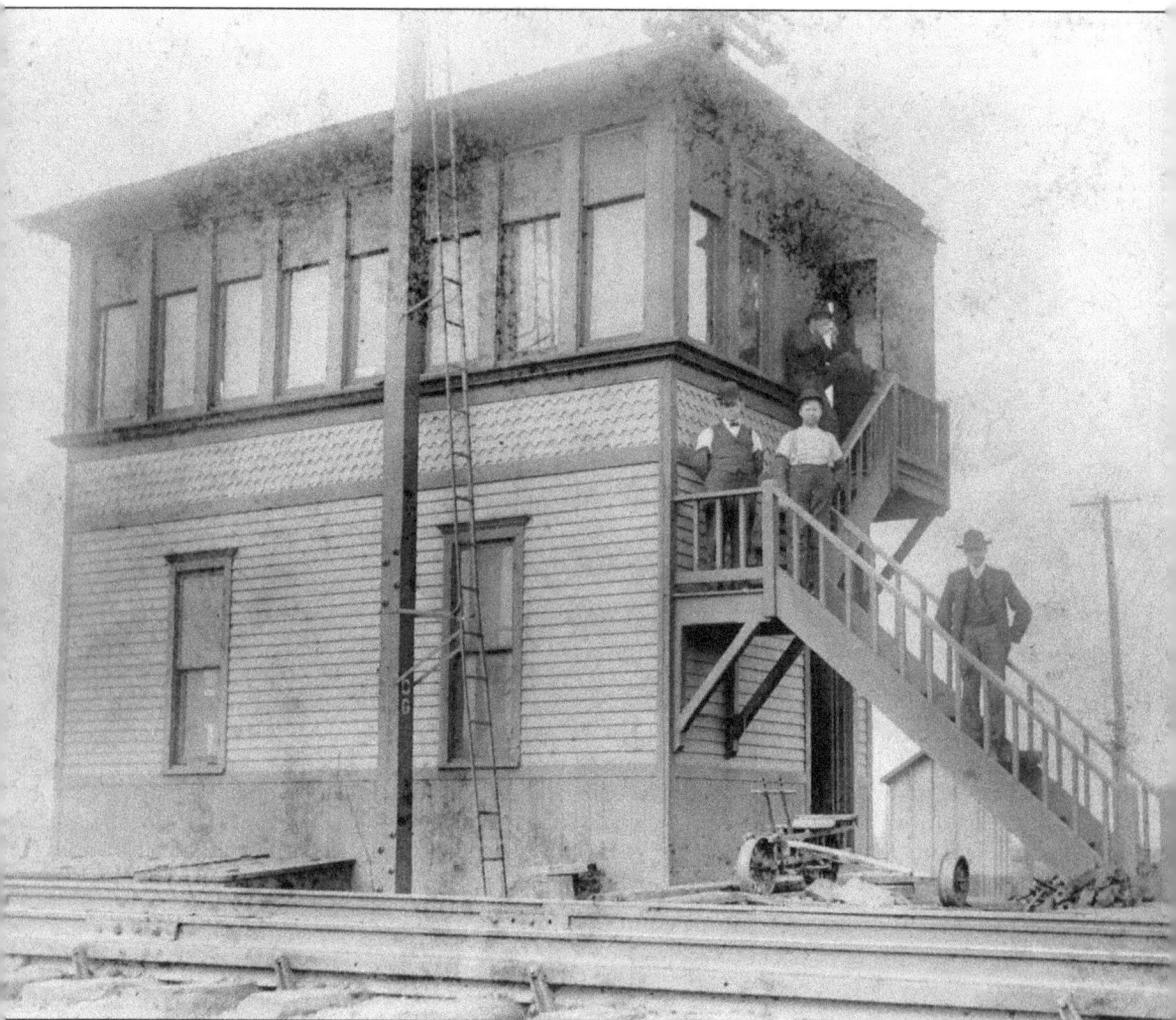

This early-1900s photograph is of the two-story traffic control tower that was constructed at the intersection of the Wabash, St. Louis & Pacific Railway and the Chicago & Calumet Terminal Railway. Located in the middle of Chicago Ridge, the intersection was managed by a watchman, who, by means of colored flags and lanterns, signaled trains to stop or proceed. Later, after the Chicago Ridge Terminal Railway came under the control of the Baltimore & Ohio Chicago Terminal Railroad, the tower was equipped with interlocking levels that controlled switches, derails, and signals, eliminating the need for trains to stop at the intersection. When the Indiana Harbor Belt Railroad negotiated for track rights on the Baltimore & Ohio Chicago Terminal's tracks around 1915, Chicago Ridge became an important interchange. It is here that the Wabash interchanged entire trainloads of perishable commodities from the western United States to the Indiana Harbor Belt for movement to the East Coast.

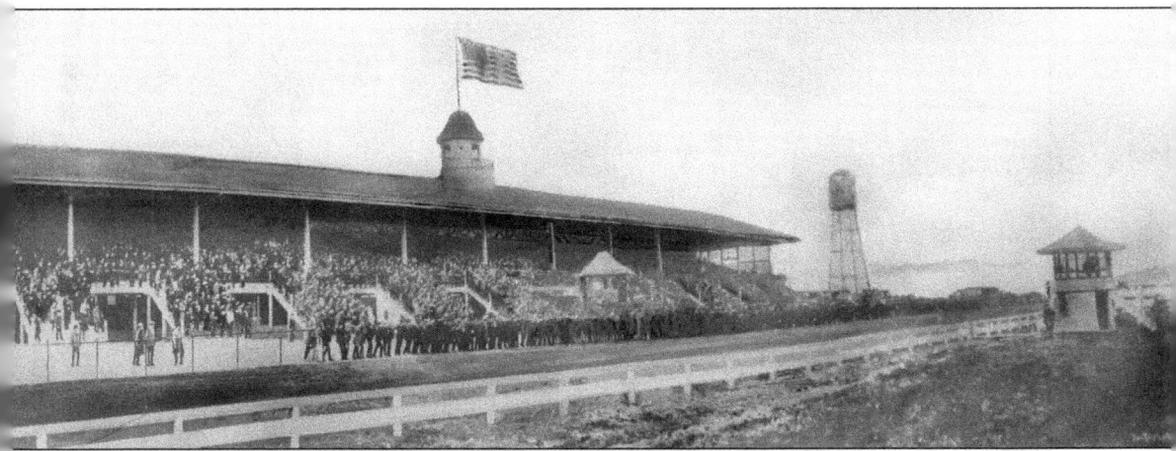

The Wabash Railroad not only brought workers to Chicago Ridge but also those seeking a day at the racetrack. The Worth Racetrack opened in 1900 on the land between Ridgeland and Central Avenues and 115th and 111th Streets. Many of the early homes in Chicago Ridge had been built to house track employees. The Illinois State Gaming Board closed the Worth Racetrack in 1905, and six years later, it was demolished. The property was used as a training ground for state militia during World War I and later stockades. In 1923, the land became Holy Sepulchre Cemetery. During the early part of the 20th century, there was a local story that a horse named Dan Patch, the Worth Racetrack's top horse, had been buried in the center of the track.

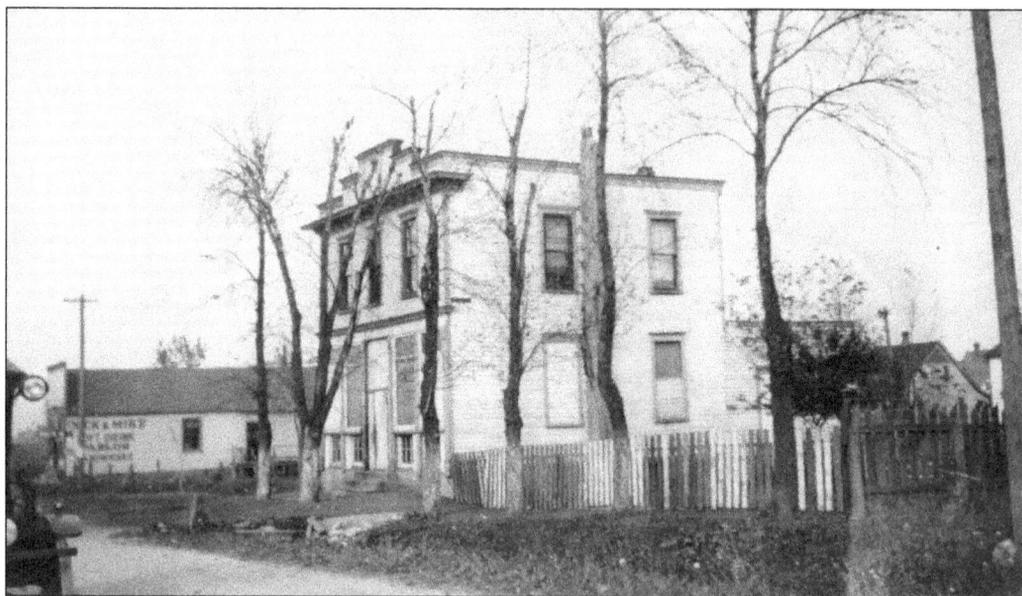

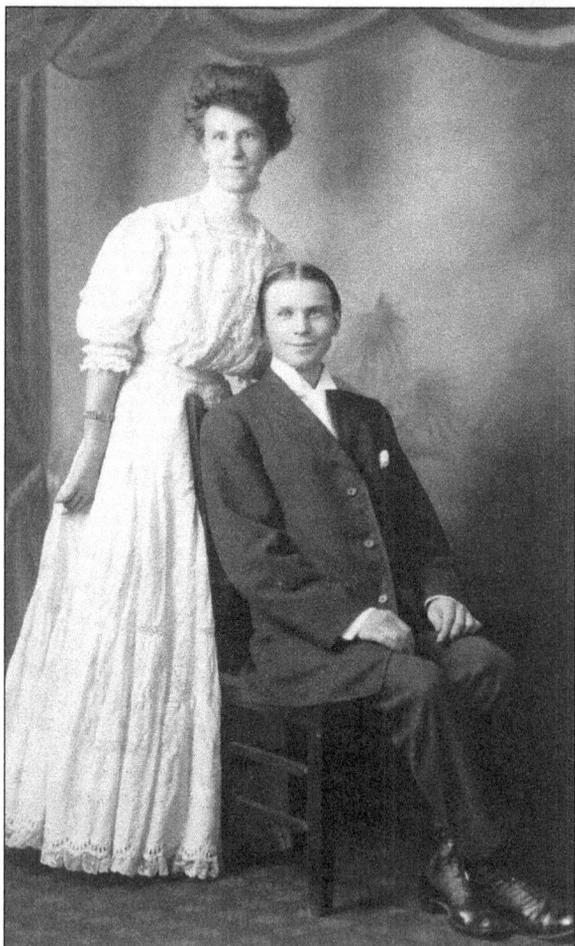

The commercial center of the community was on Ridgeland Avenue between 103rd and 108th Streets. On this stretch of dirt road could be found a hotel, taverns, and the Klee General Store. Ernest and Elizabeth Klee ran the store at 106th Street and Ridgeland Avenue; it also served as the post office when Elizabeth became postmistress in 1917. Ernest was an early village trustee and police magistrate. The Klees had married in 1907 and opened the store that same year. The photograph at left was taken on their wedding day. After the Klee General Store closed, the building became the home of Bristow's barbershop, and an ice cream parlor run by the Jacobs family. In 1967, the building was condemned and burned down. Bruno Duckwitz, village president from 1937 to 1942, opened Bruno's Laundromat on the vacant lot. (Left, courtesy of Alice Lasky.)

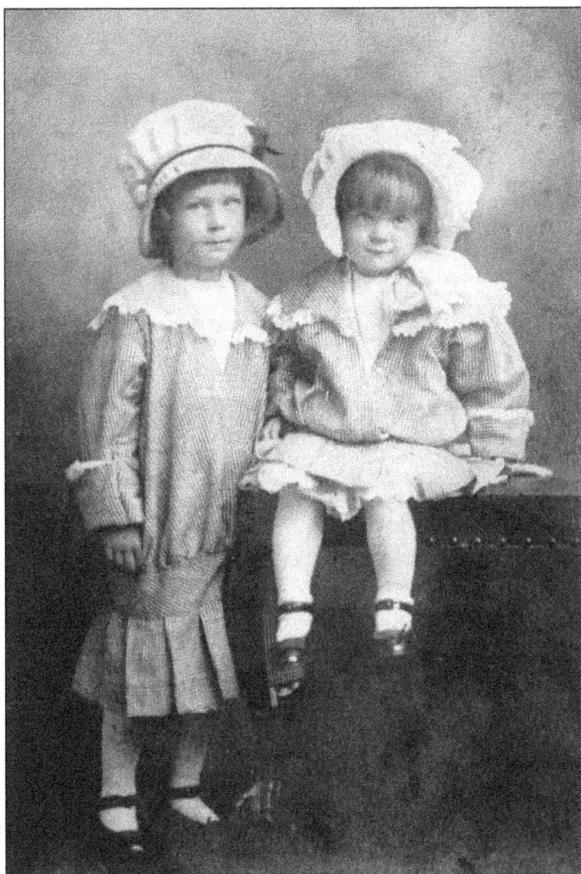

Ernest and Elizabeth Klee's daughters, Louise and Alice, sit for a portrait in the early 1900s. Louise, born in 1909, is on the left, and younger sister Alice, born two years later, is on the right. Louise followed in her mother's footsteps and became postmistress in 1954. Below is a picture of the girls in 1920 as they stood in a yard near 106th Street and Ridgeland Avenue. (Both, courtesy of Alice Lasky.)

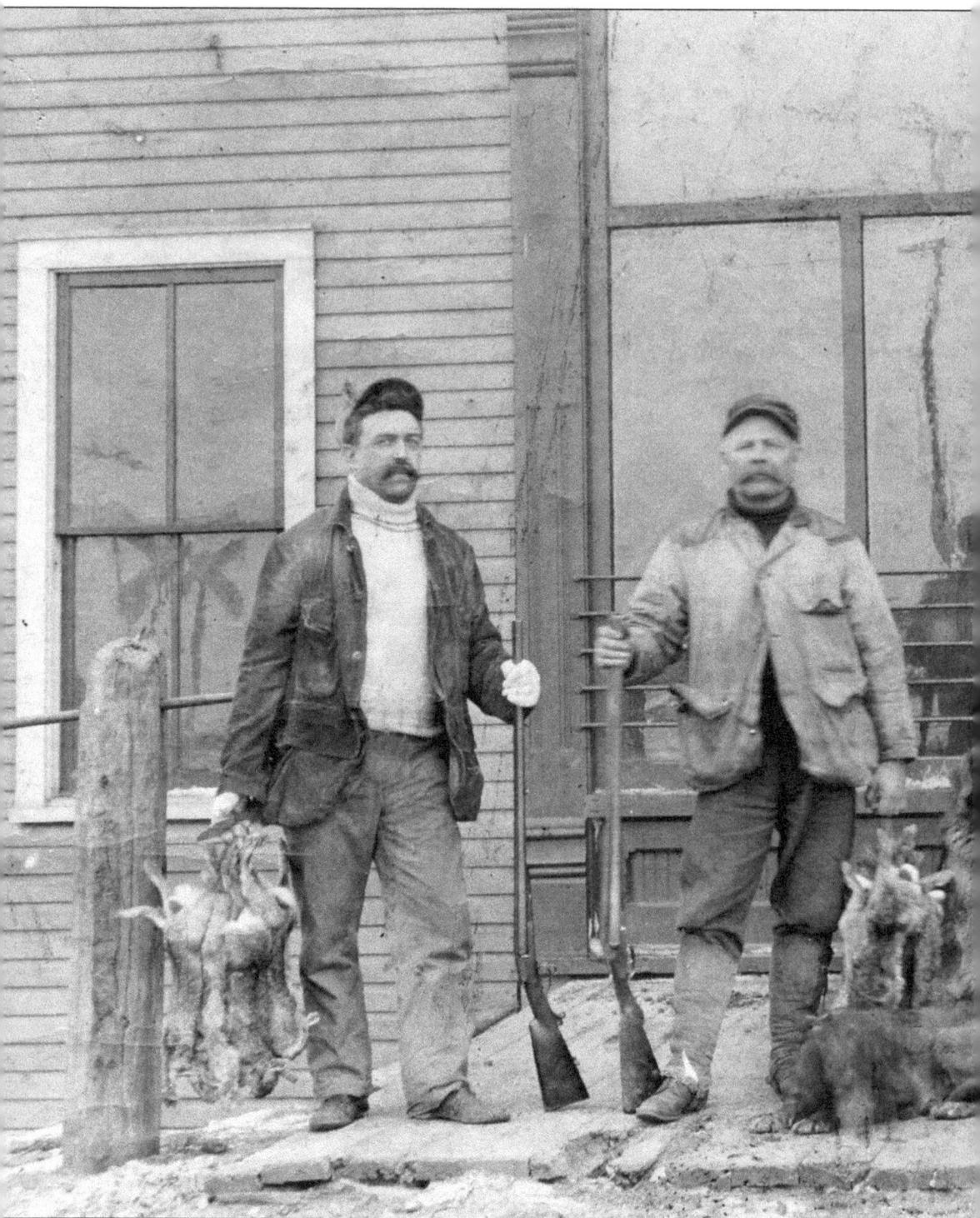

Small-game hunters stand in front of John Henry Meyer's Chicago Ridge Hotel and Inn at 103rd Street and Ridgeland Avenue. Meyer is on the far left, and the young men at the far right may be two of his sons. He had four children: sons George, Harry, and Arthur with his first wife, who

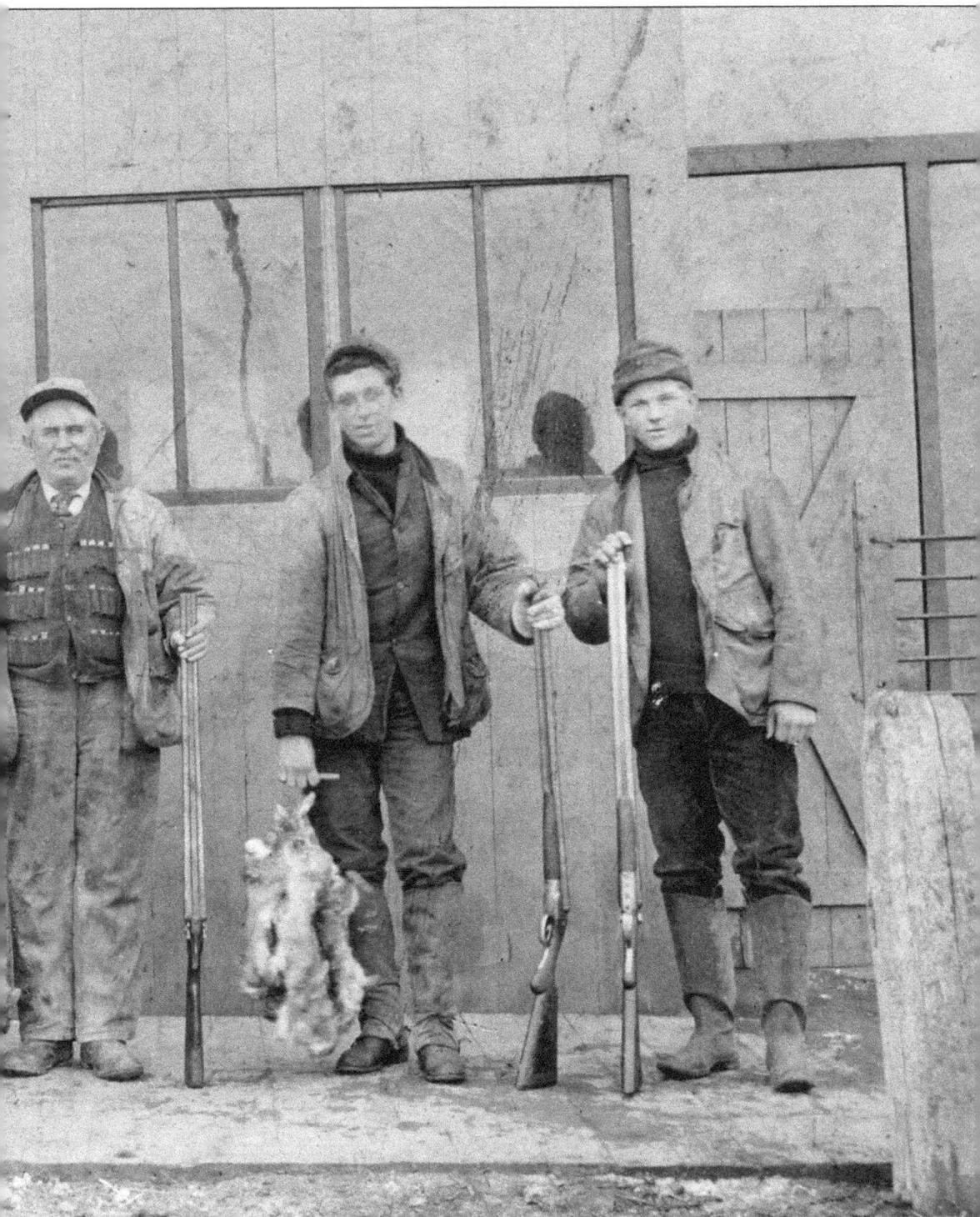

died, and a daughter, Dorothea, with his second wife, a Worth, Illinois, schoolteacher. Meyer was selected village clerk in 1915. Harry served as village clerk, magistrate, and trustee between the years 1916 and 1921, and Arthur served as a trustee from 1916 to 1926.

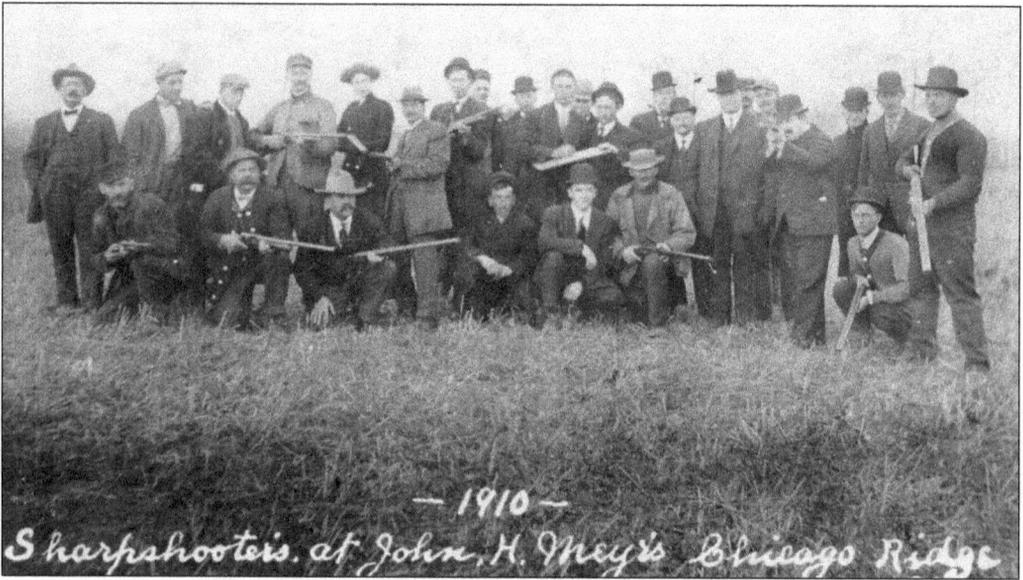

—1910—
Sharpshooters at John H. Meyer's Chicago Ridge

In 1910, these sharpshooters got together at Chicago Ridge Hotel and Inn for an afternoon of sport. The hotel was a headquarters for Chicago-area hunters. John Henry Meyer is crouching in the front row, third from left. His son Harry is squatting at far right. "Dad" Meyer, as many knew him, moved to Chicago Ridge from Blue Island. Meyer is shown below with his daughter, Dorothea, on the family farm that extended from the Wabash Railroad tracks to 106th Street. He sold feed at the Chicago stockyards. Meyer was a great storyteller and was known to play a concertina and sing in German. He was described as a heavy-set man who wore a mustache and 10-gallon hat. Late in life, Meyer left Chicago Ridge for Chicago where he served as a guard in the original county jail. He died in 1950 at the age of 92.

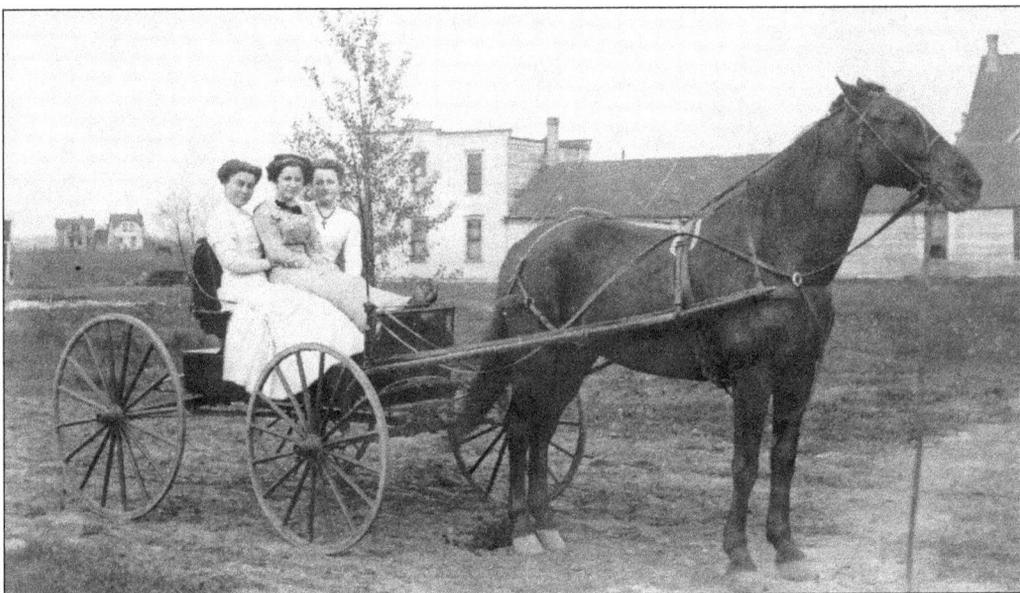

Village residents (from left to right) Inez Lenox, Abbie Short, and Lettie Kennedy travel by horse and buggy in 1910. The Klee General Store at 106th Street and Ridgeland Avenue can be seen in the background. William Harnew of Oak Lawn, Illinois, owned the horse, named Black Hawk.

Friends gather at the Kennedy family home near 106th Street and Oxford Avenue. Seated in back is William Harnew, and in front are (from left to right) Dayton Kennedy, Inez Lennox, Lettie Kennedy, and Abbie Short. In 1911, Lettie Kennedy married Harnew, and they moved to a farmhouse at Mason Avenue in Oak Lawn. Harnew became a tax collector for Worth Township, collecting taxes by horse and buggy.

As the population grew in Chicago Ridge, so did the places for entertainment. Taverns and restaurants lined Ridgeland Avenue. These places absorbed leisure hours and provided rooms for travelers. Decks of cards were always available, and many locales had billiards. Taverns were an important place for political discourse and policy making. Polchow's Grove at 107th Street and Ridgeland Avenue was one of three popular village establishments; the other two stopping points were John Henry Meyer's and Liberty Hall, which stood at 108th Street and Ridgeland Avenue. Charles Polchow, seen in the photograph at left in front of his establishment, became the first village president in 1914. (Both, courtesy of Ken Rutz.)

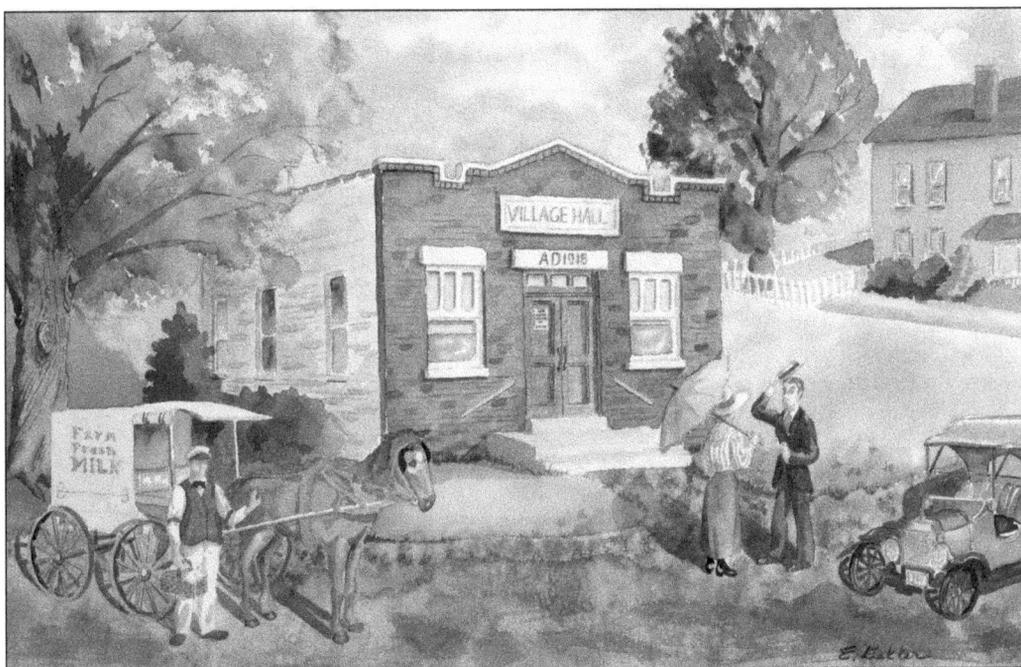

The Chicago Ridge Village Hall was built in 1918, four years after the village's incorporation. When the hall was built, a plaque was placed on the side entrance listing the names of village officials. The names read, Pres. Charles Polchow, board members Emory Dravo, Arthur Meyer, Emil Newman, Daniel Kennedy, William Ehmckie, and Henry Schmalen, and clerk Harry Meyer. Artist Evelyn Dekker created the painting above, and it was based off an early photograph of the village hall. Dekker placed the horse-drawn milk wagon, 1915 Model T Ford automobile, and the timely dressed couple in the foreground to reflect the great leap forward transportation made during the era of World War I. A native Chicagoan, Dekker moved to Chicago Ridge in 1958. She was commissioned by the Chicago Ridge Public Library to paint local historic buildings for the library's 30th anniversary. At the time of its anniversary in 1996, the library was at Birmingham Street and Oxford Avenue, as shown below.

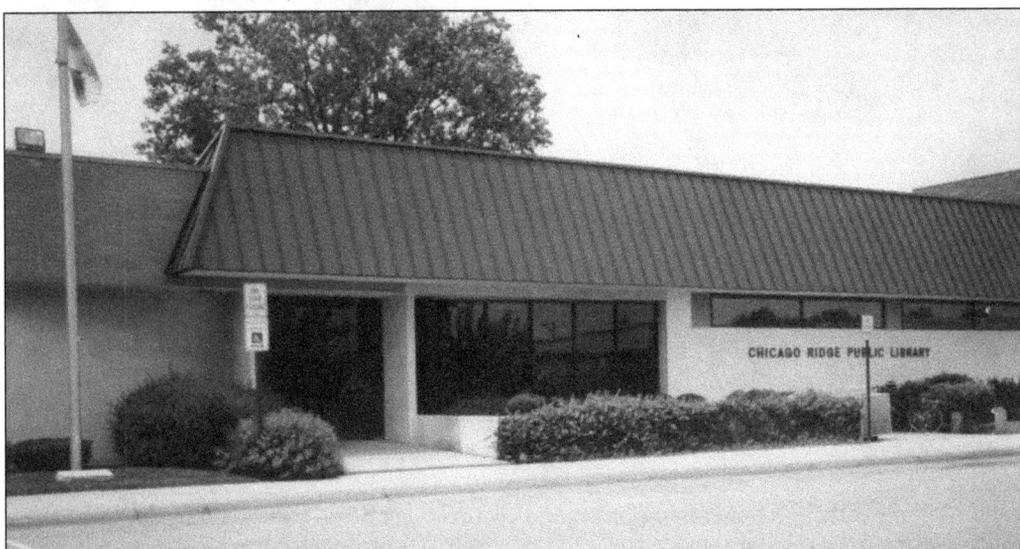

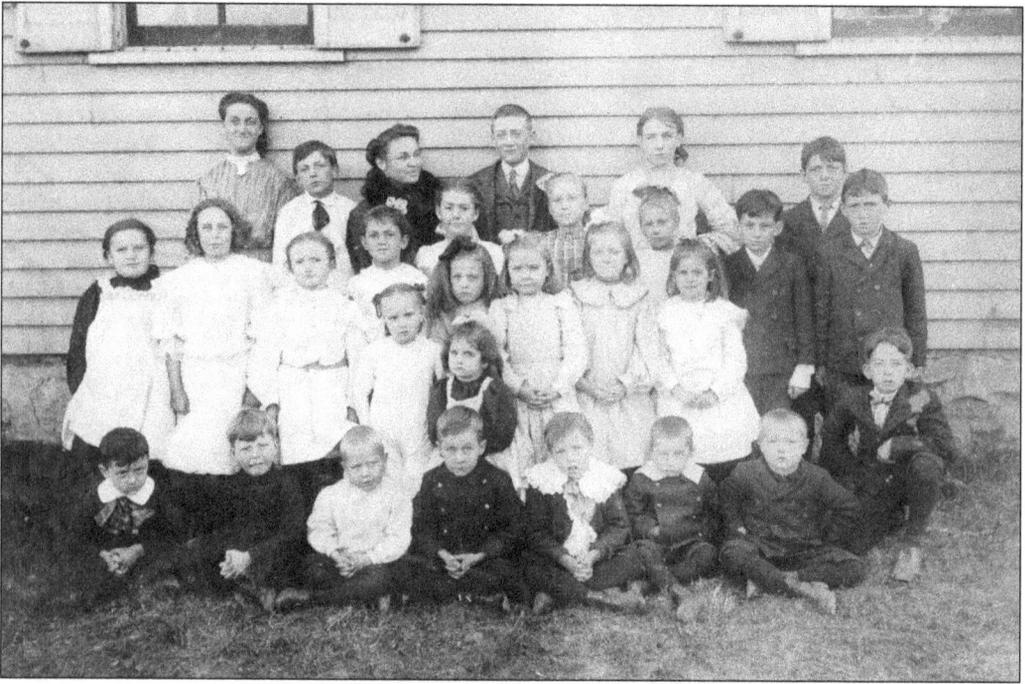

Students pose in 1910 at the one-room schoolhouse at 106th Street and Ridgeland Avenue. In the photograph can be seen a son of John Henry Meyer sitting third from left in the front row and Charles Polchow's daughter Elizabeth standing third from the left in the second row.

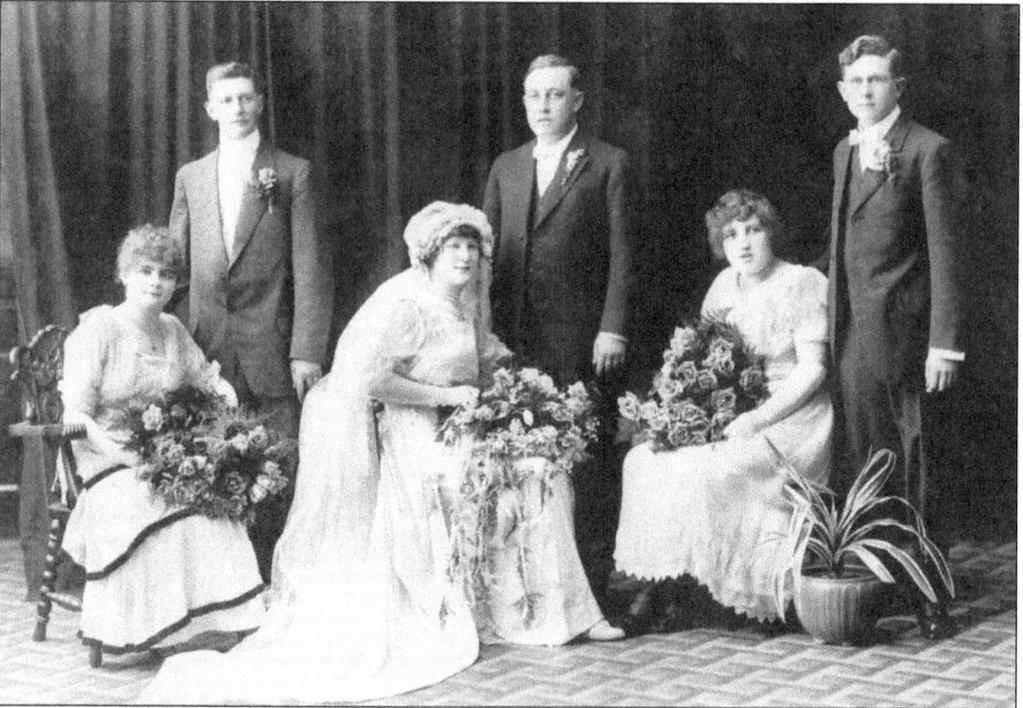

Pictured in the early 1900s are Mary Hankes and Glenn Maker Sr. on their wedding day in Chicago Ridge. Mary's sister Elizabeth made the wedding gown. (Courtesy of Alice Lasky.)

Two

THIS PLACE CALLED "THE RIDGE"

If one were to say that he or she is from the Ridge, many in the area know what he or she means. Sure, there are other towns with "ridge" in their names, but their residents do not seem to wear the moniker like those from Chicago Ridge; they probably embrace "the Ridge" because the name comes from helping to build something in Chicago that was spectacular and worthwhile, the 1893 Columbian Exposition. It adds greatly to the character of a town that has had its share of character.

Charles Polchow, the town's first president, is irreplaceable as a founding father. It was largely through his leadership and generosity, not to mention his future generations, that Chicago Ridge survived. Polchow's determination and foresight led Chicago Ridge from its infancy to standing on its own two feet. This is a man that could not be satisfied by simply saying, "Do it"; he needed to be a part of it. Polchow's restaurant and grove served as Chicago Ridge central for many years and even as the first village hall. His involvement in incorporation cannot be overstated. He donated time, land and a great deal of effort, pushing this town forward to future generations knowing something worthwhile was here. His talent for acquisition is unrivaled. Polchow pulled people together and molded them into a community. There are many great people from this era who deserve gratitude, but Chicago Ridge history buffs know that Charles Polchow is this village's George Washington. Perhaps, the greatest testament to him is his humility. Travel throughout the village today, and there is little evidence this man even existed. It is not hard to imagine that this town could have easily been called the town of Polchow had Charles Polchow desired notoriety. He did not, and that is so much like the town he left for community members.

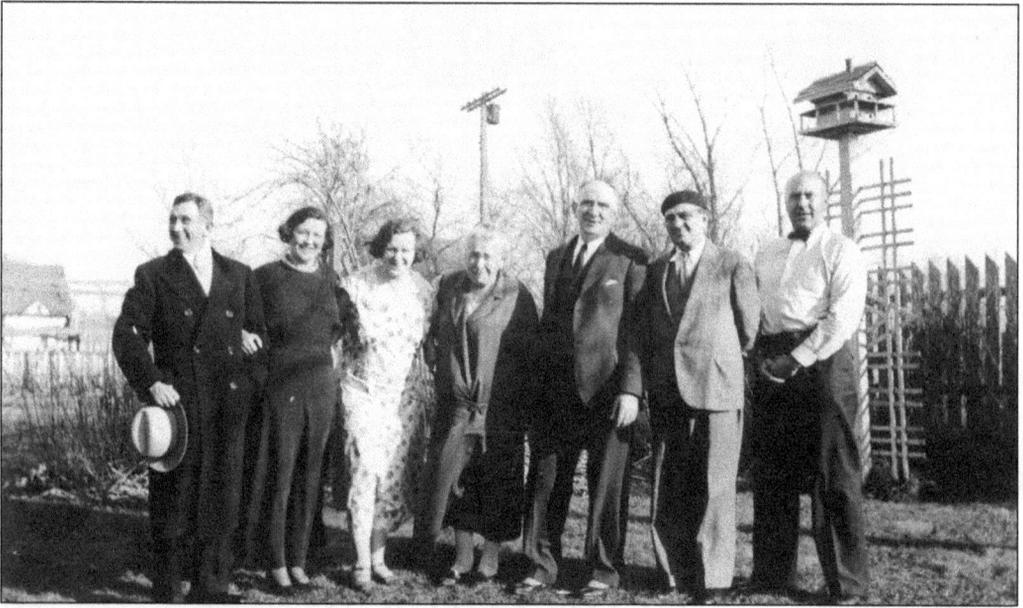

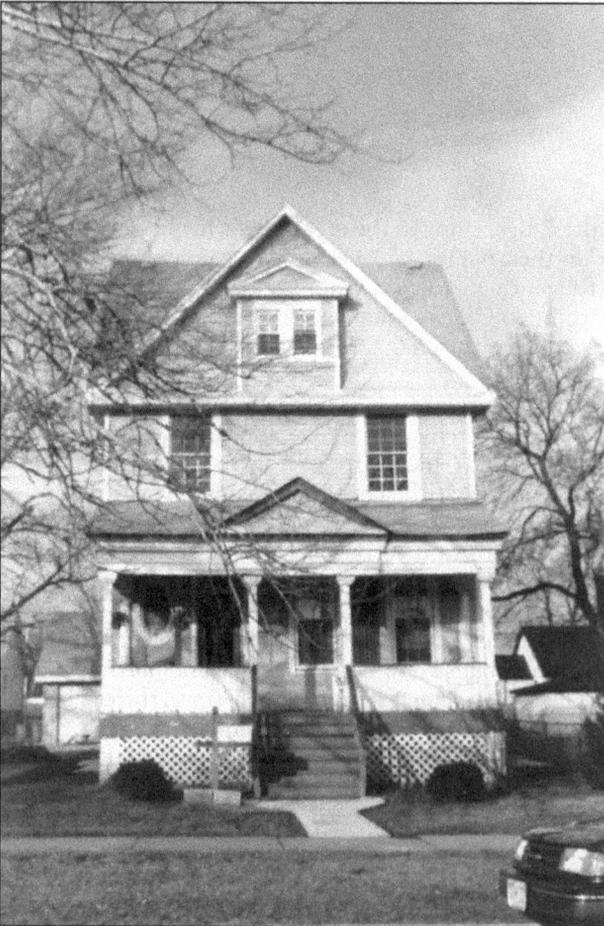

Members of the Hankes family pose for a photograph in the backyard of their home at 106th Street and Princess Avenue. Pictured are, from left to right, John Hankes, Mary Maker, Elizabeth Klee, Mary Hankes, Michael Hankes, Nicholas Hankes, and Henry Hankes. Politics were part of the family. Mary Maker's uncle Henry Schmalen was village president from 1921 to 1924, and her brother Michael was a village clerk. The Hankes family home, pictured at left, is one of the oldest residential structures in Chicago Ridge.

Mary Maker (née Hankes) became the village's first woman trustee in 1921. She was raised and married in the Hankes family home on Princess Avenue.

Sgt. Glenn Maker, the son of Mary Maker, was the only serviceman from Chicago Ridge killed in action during World War II. He enlisted in the Army in 1939 and served five years with the glider infantry in Panama, Iceland, England, and the Western Front. Maker was 27 years old when he was wounded and died in a Belgian hospital on January 4, 1945.

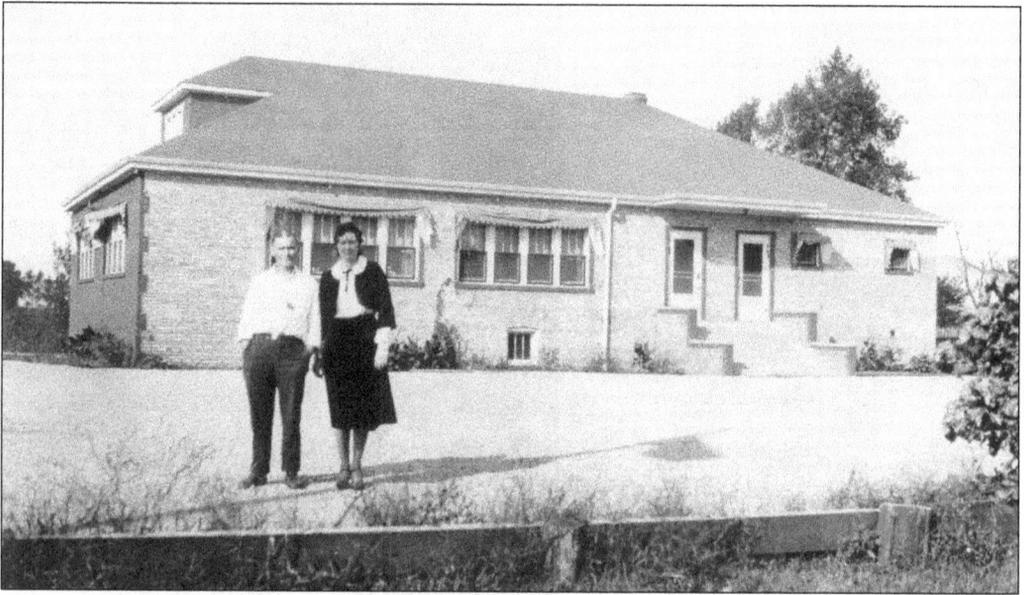

Ernest Klee and daughter Louise stand outside of Piccadilly Gardens, located at 105th Street and Ridgeland Avenue. It was a popular dance hall in the 1930s that attracted people from miles around. The building, formerly a general store, was converted to an entertainment establishment owned by Klee and William Brandt, shown at left standing next to wife, Alice, Louise's sister. After the dance hall, the building became Our Lady of the Ridge Church in 1948 and then a grocery store. In 1969, the Chicago Ridge VFW Post No. 177 opened in this location. (Both, courtesy of Alice Lasky.)

Seen posing outside of Rucies' Tavern and Grove at 106th Street and Ridgeland Avenue are World War II servicemen Wally Cridge (left) and Albert Bizzotto (right) with friend John Towzelowski. Pictured at right, outside of Eisler's Place, is Arthur Polchow. Rucies' and Eisler's, formerly John Henry Meyer's, were favorite gathering points for soldiers on leave. Rucies' was also known for the murals that lined its walls. One female resident recalled drinking strawberry pop with a childhood friend surrounded by a mural of the Hindenburg Disaster on one wall and a painting of men running from an enormous grizzly bear on the other. The friend became so scared that he quickly finished his soda and ran out the door. (Right, courtesy of Ken Rutz.)

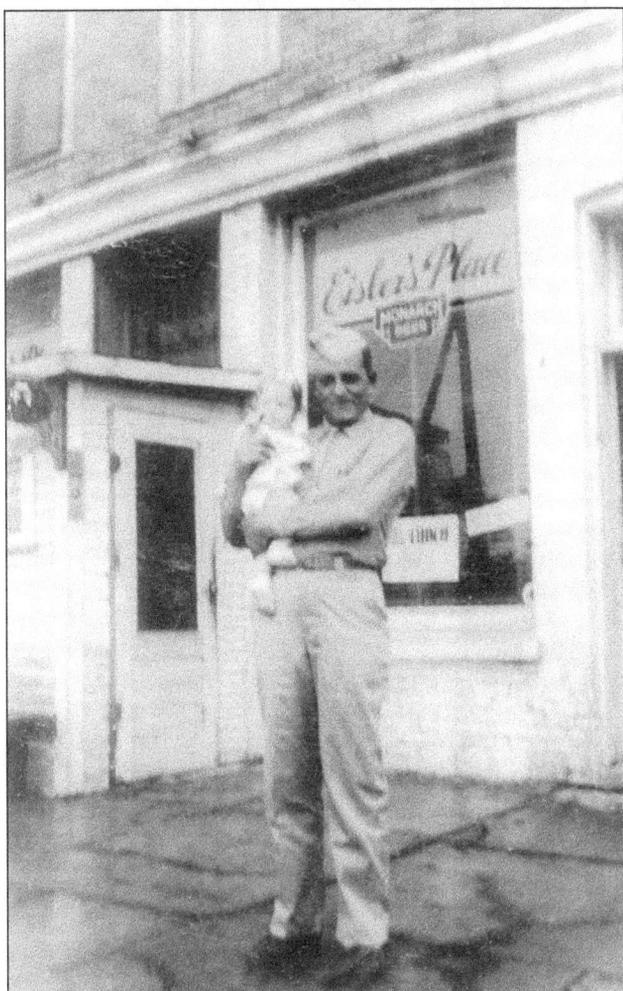

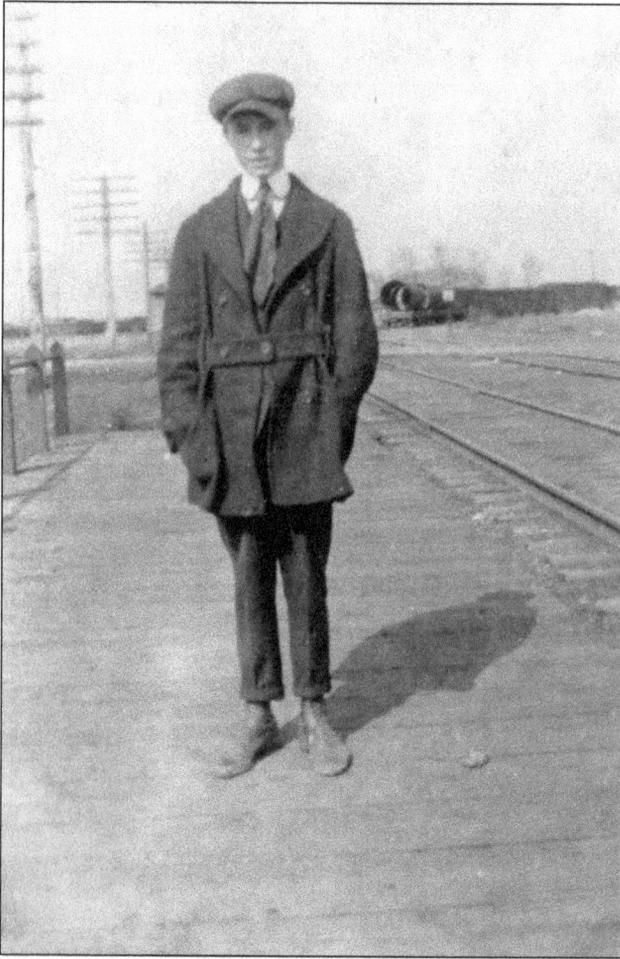

John Walsh stands at the train depot alongside the Wabash Railroad tracks at 103rd Street and Ridgeland Avenue. In the background, behind his right arm, can be seen a portion of the switch tower. His parents, William and Mary, moved to Chicago Ridge with their five children in 1914. William Jr., the eldest, established the village's first zoning code and its first village-wide athletic program for children. Seen below is Walsh's Service Station at 111th Street and Central Avenue. John opened the station in 1931 and could often be found filling up the village's fire department vehicles at no charge. (Left, courtesy of Ken Rutz.)

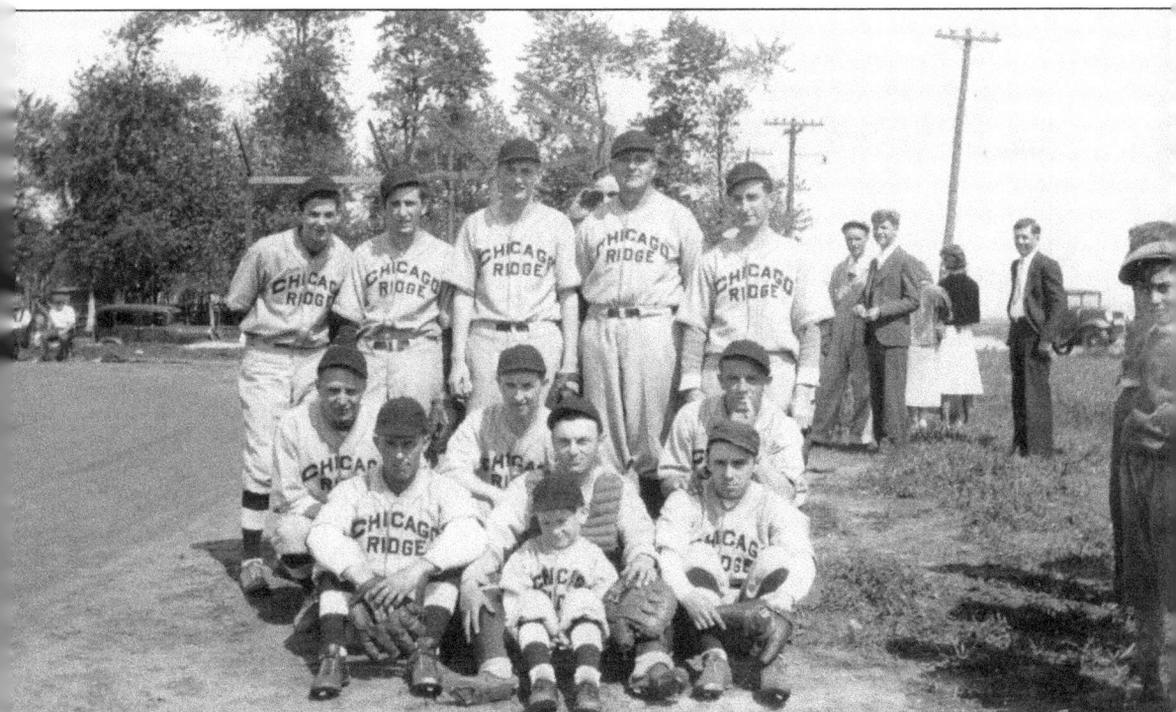

The summer activity was baseball. Residents of all ages came to watch the games at the diamond across from Polchow's Grove. The Chicago Ridge baseball team, seen in the 1940s, provided a recreational activity for the village's young men. Herbert Polchow, village president from 1953 to 1956, and his wife, Phyllis, started the town's first Little League around 1953 on this same field. Pictured are, from left to right, (first row) Elmer Braasch, Eddie Cridge, and Wally Cridge; (second row) L. Cridge, Edwin Braasch and John Bizzotto; (third row) Herbert Polchow, Art Cooper, Wally Polchow, Art Rucies, and Ed Walsh. A batboy identified as a member of the Polchow family sits in front. Standing at right in the background, from left to right, are John Walsh, Bill Duckwitz, and Bruno Duckwitz.

Frenzel's Tavern, at 111th Street and Moody Avenue, bought by Tom and Virg Frenzel from Violet Downs has been one of the mainstays of Chicago Ridge. Issued the town's first liquor license on November 4, 1939, Frenzel's has served the village since the 1930s. In the past, chickens were kept outside, and once a week, fresh chicken dinners were available to patrons. Pictured below is the son of Tom and Virg, Marion, with his wife, Donna, who carried on the Frenzel's tradition and passed it along to their daughter Susan. (Both, courtesy of Susan Frenzel Kasper.)

Jim Woods, owner of Ridge-Worth Hardware, is shown as he walks across a field located near Frenzel's Tavern in 1942. The building in the background is a monument and memorial company. Companies of this nature are still found today on 111th Street across from Holy Sepulchre Cemetery. (Courtesy of Susan Frenzel Kasper.)

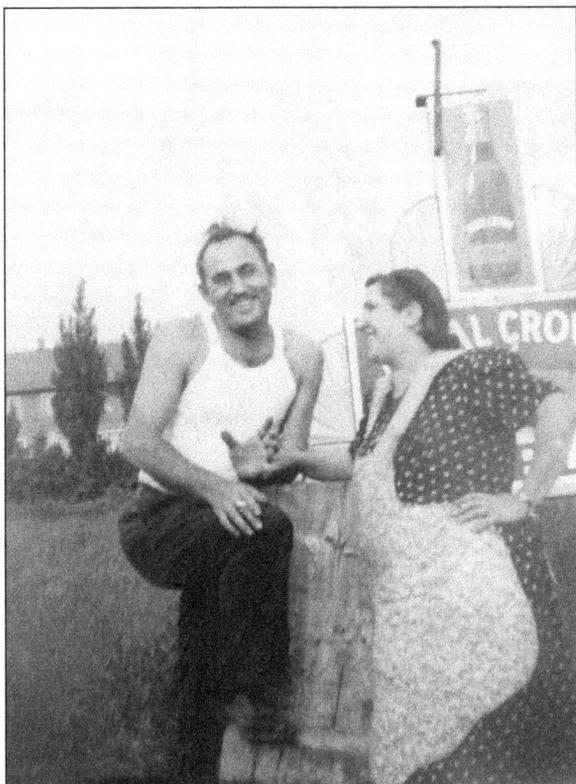

Here, Tom and Virg Frenzel share a laugh outside of their tavern on 111th Street. (Courtesy of Susan Frenzel Kasper.)

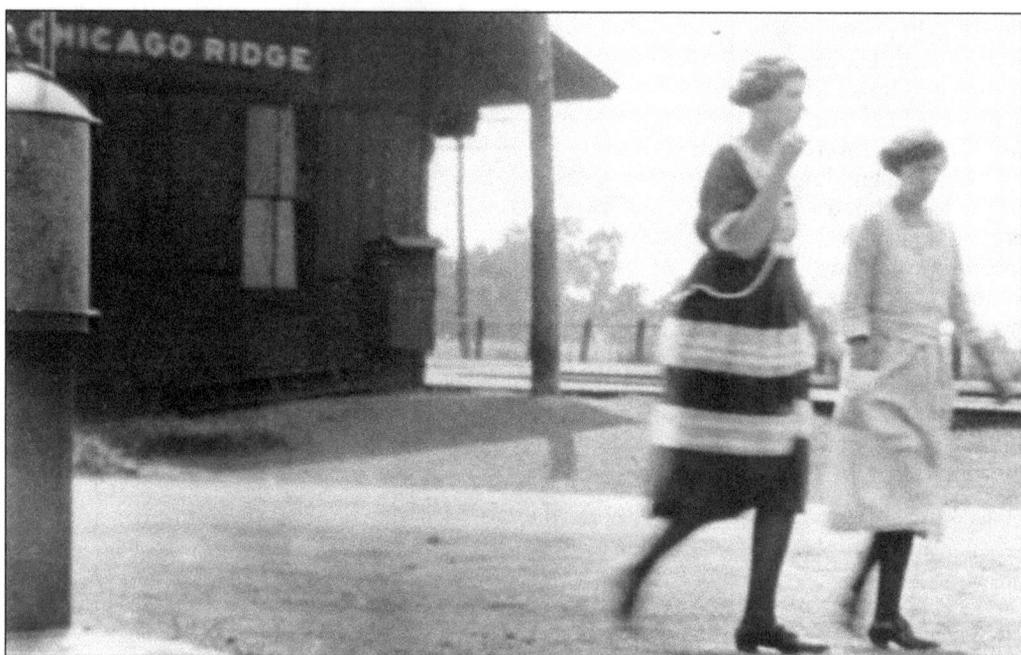

Home from the city, two young women, dressed in their day-out clothes, walk from the train depot at 103rd Street and Ridgeland Avenue. On Saturdays, local teenagers took the Wabash Railroad into Chicago for an evening of fun and excitement. Their destinations included the Stratford and Tivoli cinemas and the dance hall Karzas' Trianon Ballroom at Cottage Grove and East Sixty-second Street. At times, they went all the way downtown to see a picture show at the Oriental or McVickers Theater. (Courtesy of Ken Rutz.)

Marie Paulus, pictured at right wearing a corsage, was village postmistress for 26 years, beginning in the late 1920s. Her house, at 105th Street and Oxford, became the home of the post office in 1927. It has been said that when residents received their mail from Paulus, it often smelled like freshly baked pies. Mail was carried three times a day from the Paulus house to the Wabash Railroad at 103rd Street and Ridgeland Avenue. (Courtesy of Adehl Good.)

In the 1930s and 1940s, children were often found riding to their friends' houses, to the Stony Creek, and to the general store on the village's dirt roads and sidewalks. Bicycling also became a favorite way to get to school for many students. In the above photograph, (from left to right) Melvin and Henry Dokter, get ready to ride near their home at 102nd Place and Southwest Highway. Pictured at right, are childhood friends, from left to right, Rosemary Grossi, Frank Chiapetti, and Ken Rutz near Oxford and Princess Avenues. Chicago Ridge School at 105th Street and Oxford Avenue can be seen in the background. (Above, courtesy of the Dokter family; right, courtesy of Ken Rutz.)

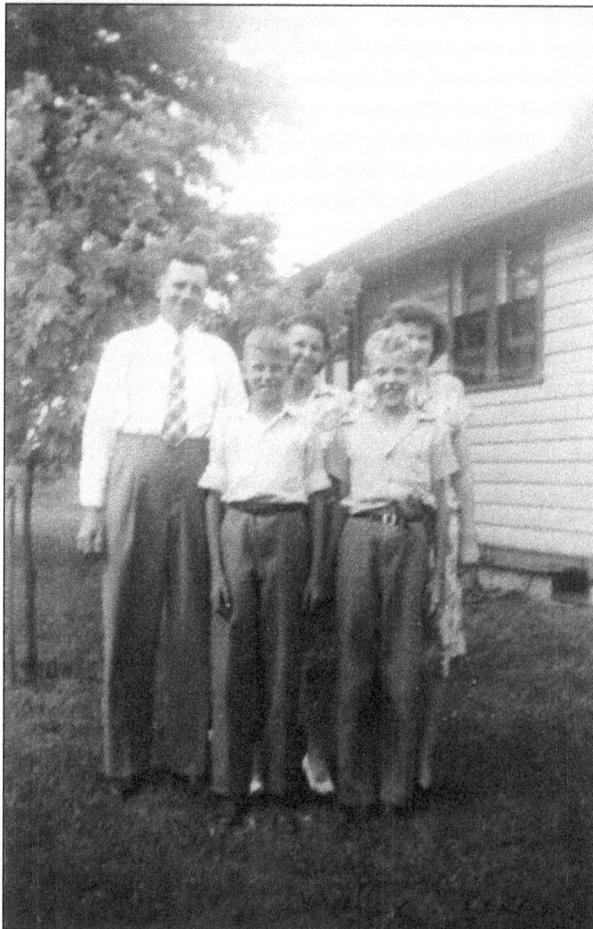

After the Depression, residences slowly began to spring up along Southwest Highway. One of the first, the stucco home of the Dokter family, was among the fields on 102nd Place with only two other homes nearby. Sitting in front of the Dokter house, from left to right, are siblings Henry, Melvin, and Hilda Dokter. Henry was known for his curly locks that his mother, Nellie, hesitated to cut. Their father, John Dokter, was village president pro tem from 1943 to 1944. He held the position of trustee for 20 years and served many years on the school board. Pictured at left are John Dokter and his wife, Nellie, standing in the yard with their children. (Both, courtesy of the Dokter family.)

Three

SCHOOLS AND CHURCHES

A town is not a town until there is a school system. Many would not consider it a town until there is a house of worship as well. Chicago Ridge knew this and got right to work on it, initially establishing a one-room schoolhouse on 106th Street and Ridgeland Avenue. Students had to walk to Worth to take final exams however, leading to the construction of Chicago Ridge School, which was located on the site where the modern village hall and police station now stands. Teachers for this school roomed together in a house across the street on Oxford Avenue. In the late 1930s, a diphtheria epidemic swept through the school, causing the death of one child and shutting the school down for a whole quarter.

Other schools needed to be built as population grew. Henry Ford II, which later became Ridge Central and Ridge Lawn, offered the village's children a public grade school education. Elden D. Finley, built in the late 1960s, brought a junior high school to the area. Our Lady of the Ridge offered a grade school and junior high for those who wanted religious education for their schoolchildren.

The United Presbyterian Church located at 106th Street and Oxford Avenue was the village's first church. In the late 1920s, through the efforts of Bessie Cridge and Charles Polchow, townspeople had a center of faith to call their own. Bessie solicited Mr. Mather of Mather Stock Car Company who gladly put his financial backing behind the project. The church later moved to 107th Street and Lyman Avenue and stands there today.

Starting as a mission, Our Lady of the Ridge soon overwhelmed its accommodations and moved into the old Piccadilly Gardens building at 105th Street and Ridgeland Avenue in 1948. When this location proved inadequate for the growing faithful, the Catholic Archdiocese saw fit to have Our Lady of the Ridge Church and school constructed at its current site at 109th Street and Ridgeland Avenue. Later, Father Gentleman, who started the parish, passed the baton to Monsignor Roche.

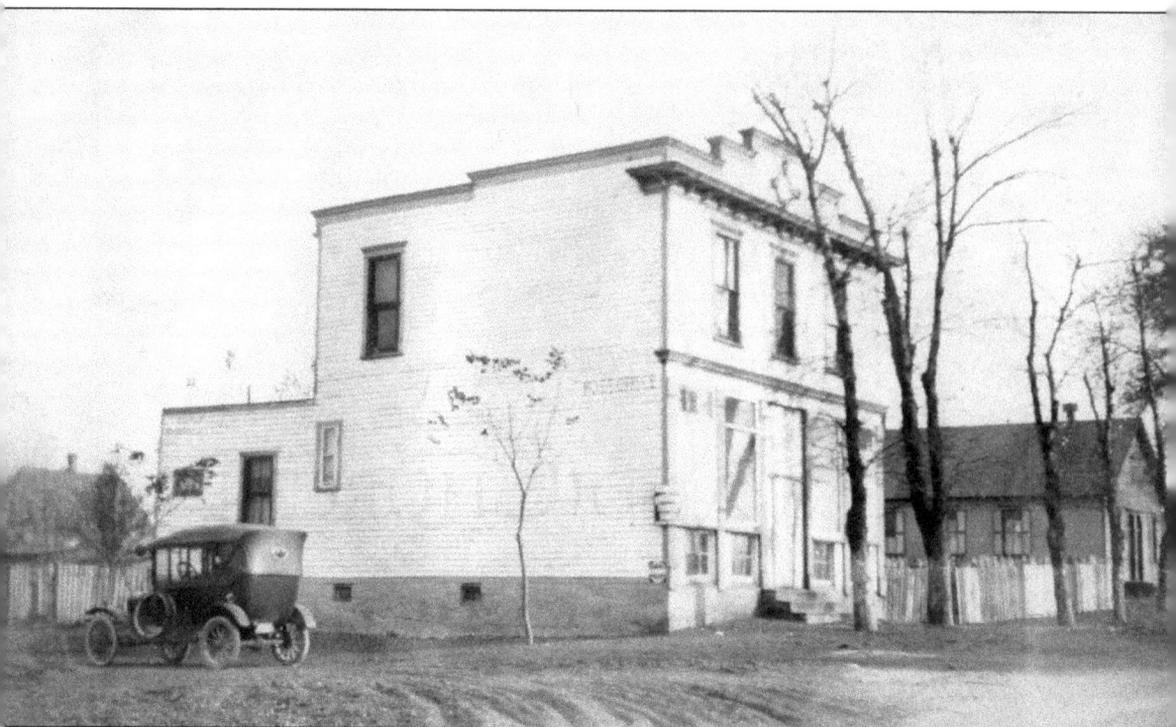

In the early 1900s, children attended a one-room schoolhouse located next to the Klee General Store at 106th Street and Ridgeland Avenue. Because the school was part of Worth District 127, students had to walk to the district's main building at 111th Street and Oak Park Avenue to take their final exams. The schoolhouse was later converted into a home, which was occupied by the Thomas Balkas family. With the photographer looking south, this picture, taken in 1925, shows the one-room schoolhouse on the right of the general store. At the time, Klee's housed the village's post office.

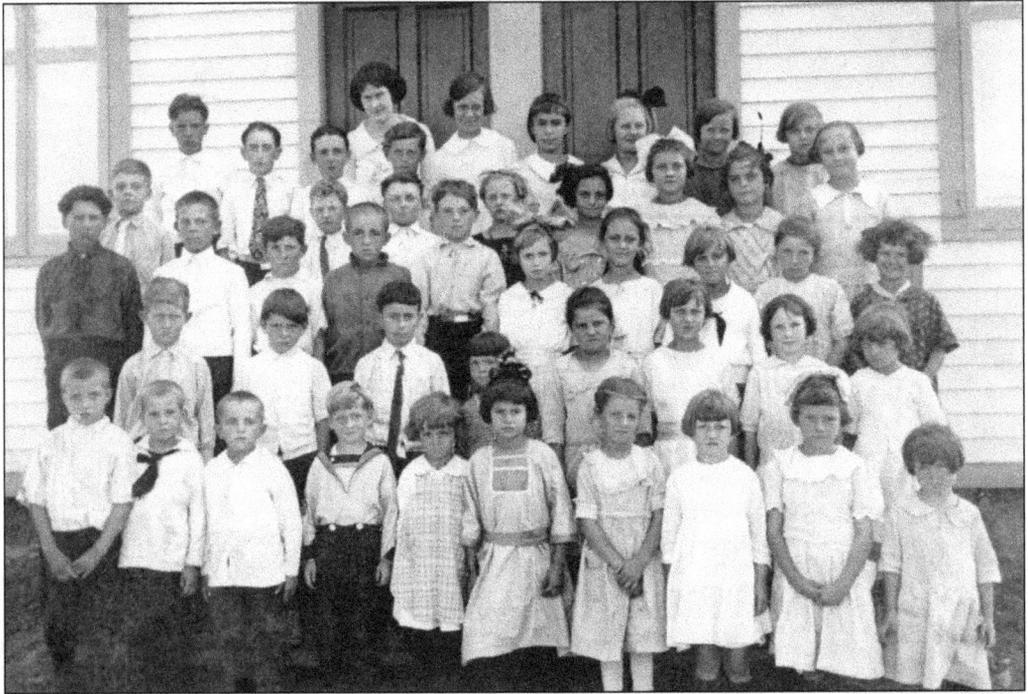

Students pose on the steps of the schoolhouse at 106th Street and Ridgeland Avenue in 1923. From left to right are (first row) Arthur Polchow, Herbert Polchow, John Bizzotto, Bernard Bartusch, Ida Bizzotto, three unidentified, Fay Dougherty, and Eileen Walsh; (second row) William Duckwitz, Chester Foyle, Buddy Aquino, Marion Foyle, unidentified, Elizabeth Rucies, Dorothy Walsh, and Elsie Cridge; (third row) ? Aquino, Elmer Braasch, Arthur Cooper, Albert Bizzotto, Walter Polchow, Ethel Polchow, Louise Meyer, Edna Braasch, Anita Bizzotto, and Winifred Cridge; (fourth row) Elwood Beckwith, Art Schmidt, Edward Cridge, Ruth Schmidt, Olive Foyle, June Dougherty, Ella Mae Hageman, and Hazel O'Connor; (fifth row) Edwin Braasch, Edward Walsh, Walter Cridge, Bruno Duckwitz, Louise Klee, Gail Hageman, Anita Calais, Alice Klee, and Clara Polchow. At right is the graduation picture of Louise Klee, age 13, who graduated from the one-room schoolhouse in 1922. (Right, courtesy of Alice Lasky.)

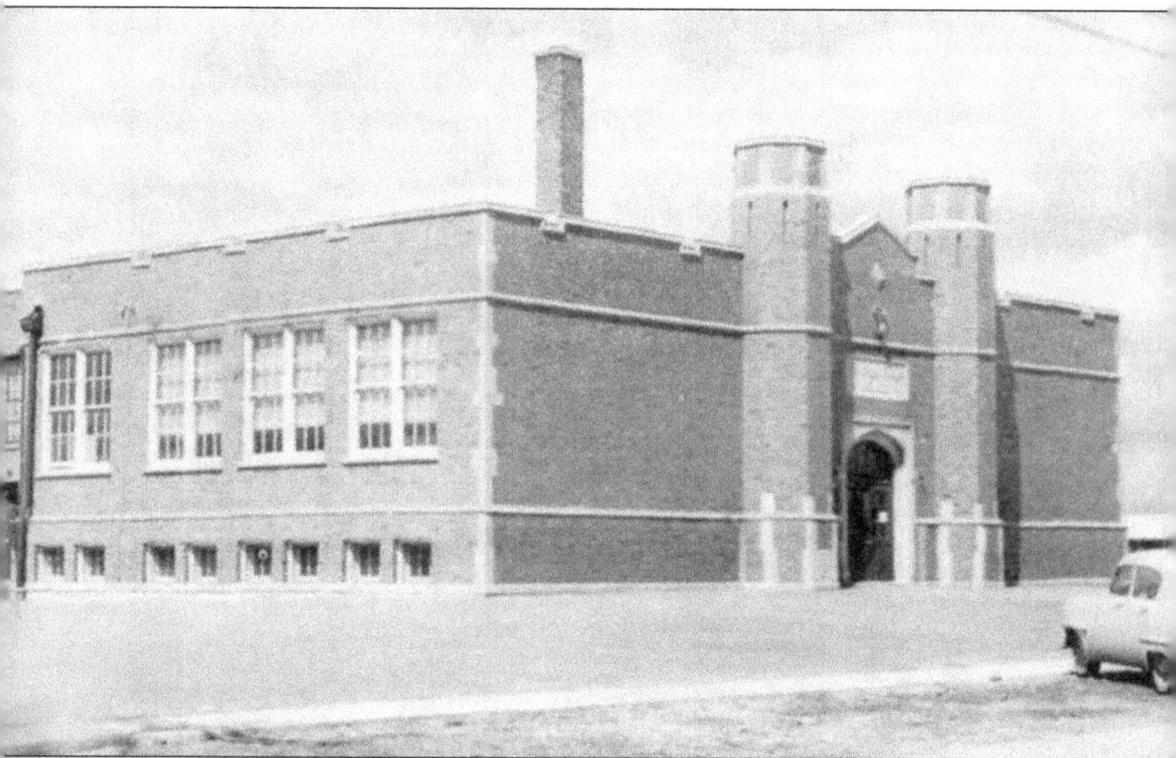

After the establishment of Chicago Ridge School District 127 1/2 in the mid-1920s, the school moved to a larger location at 105th Street and Oxford Avenue in 1927. The name "Chicago Ridge School" was chiseled in stone above the front entrance, and two towers graced its facade. A four-room addition was constructed in 1941, and two more rooms were added in 1952.

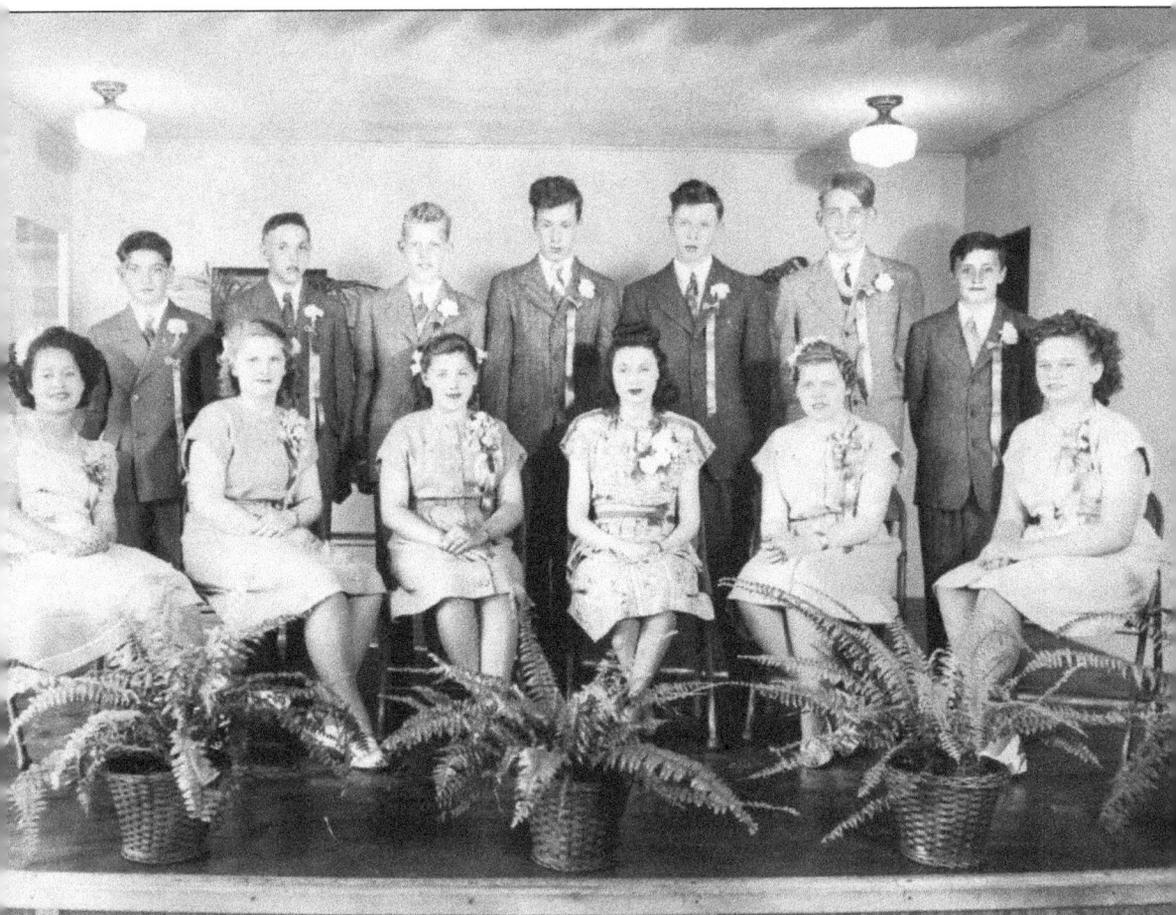

Pictured is the 1946 graduating class, posing on a stage in the basement of Chicago Ridge School. From left to right are (first row) Anita Fernandez, Barbara Raddatz, Mary Ann Hedge, ? Dorfman, Evelyn Freundt, and Jean McKay; (second row) Sam Grossi, Pete Evancoh, Henry Dokter, Jack Walsh, Ray Barthel, Ronny Olsen, and Ray Arndt. (Courtesy of the Saunoris family.)

Children gathered for a picture at the Chicago Ridge School in the 1940s. Pictured below is the Chicago Ridge School building in 1992. Growth in Chicago Ridge's population during the 1950s and 1960s brought the construction of additional schools in the village. With more modern facilities available, the Chicago Ridge School closed. The building later served as the 5th district courthouse, Chicago Ridge senior center, and youth services bureau. The Chicago Ridge School building was demolished in 1998. (Above, courtesy of the Saunoris family.)

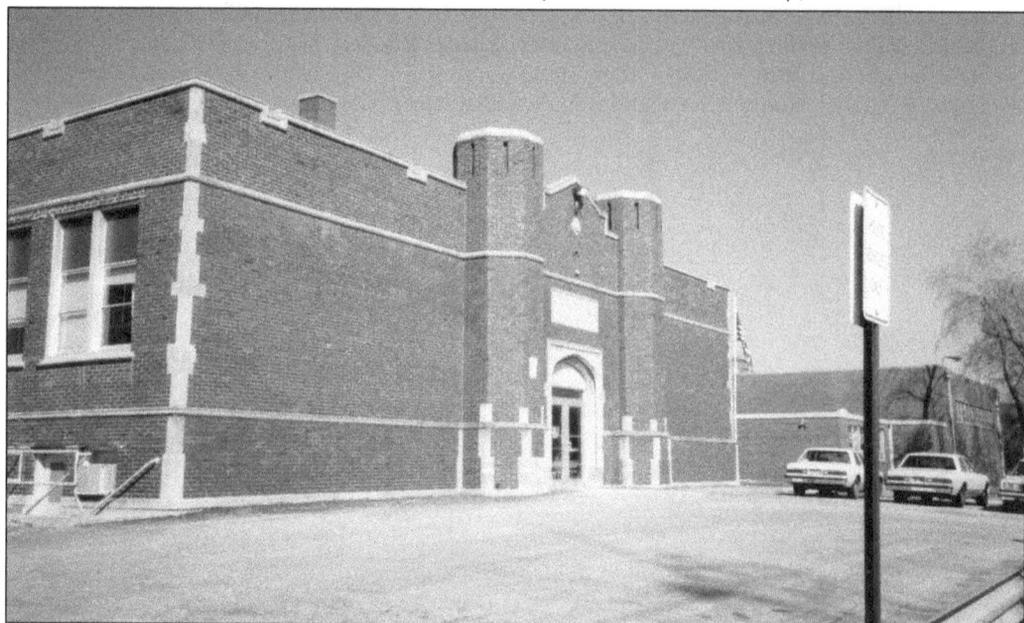

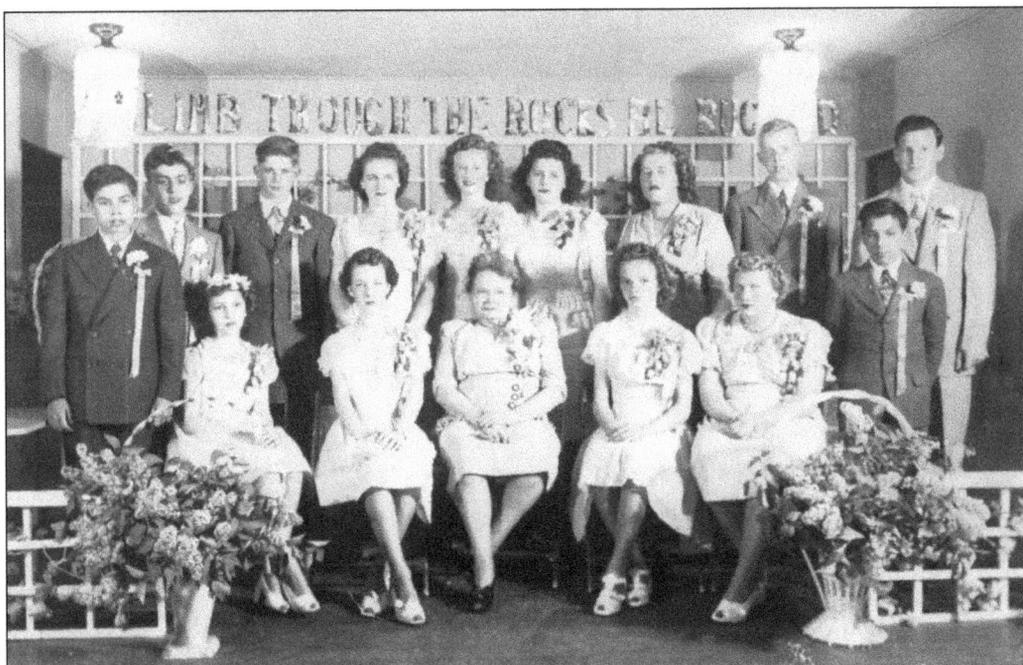

Pictured is the 1947 graduating class of Chicago Ridge School with teacher Edna Albright. From left to right are (first row) Norma Coones, Alice Florian, Edna Albright, Jane Ipema, and Marie Gelander; (second row) Robert Sisson, Fiore Chiapetti, John Ipema, Ruth Aldrich, Jean Schoonveld, Chrystal Dolejs, Marcella Mullman, Melvin Dokter, Charles Trapp, and Louis Gutierrez.

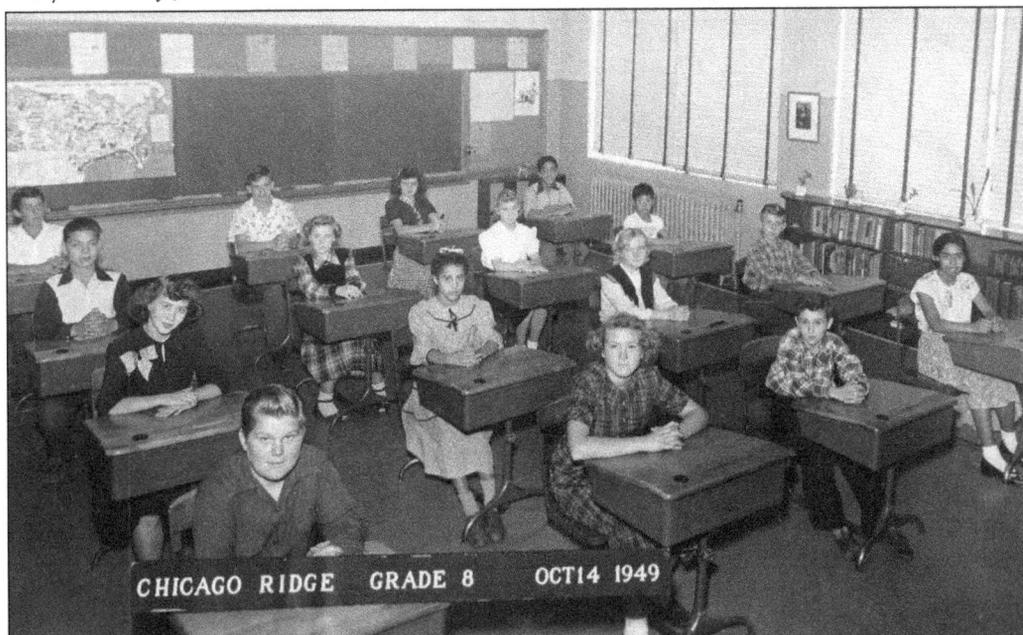

This photograph is of an eighth-grade class in 1949. From left to right are (first row) Leonard Abney, June Musch, Ken Schaal, and Robert Ashley; (second row) Mary Ann Begeman, Delores Fernandez, Lorraine Schmidt, and Jim McKay; (third row) George Drish, LaMara Abney, Marie Kunz, and Louise Arndt; (fourth row) Eleanor Relles, Frank Grison, Peter Gurretez, and Frank Gurretez.

Students sit for a day's lesson at Chicago Ridge School at 105th Street and Oxford Avenue in the late 1940s. Below, students line up outside the Chicago Ridge School during a practice fire drill in the 1960s. (Above, courtesy of the Saunoris family.)

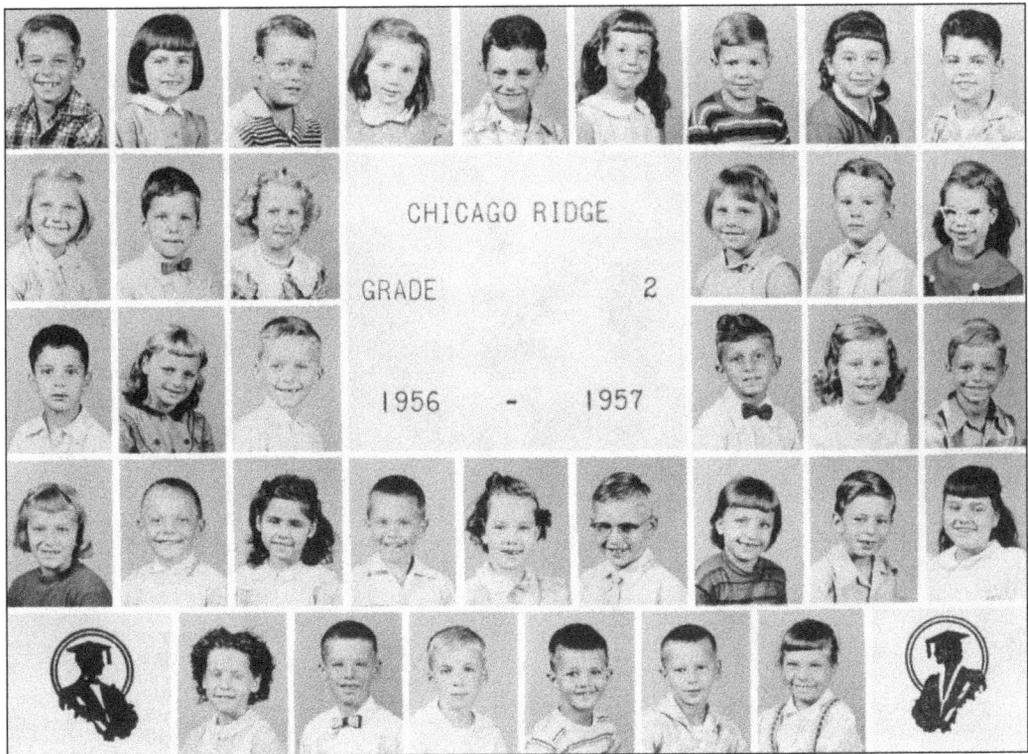

Pictured above are second-grade students at the Chicago Ridge School in 1956. In 1956, Henry Ford II School was constructed at 108th Street and Lyman Avenue. (Courtesy of Adehl Good.)

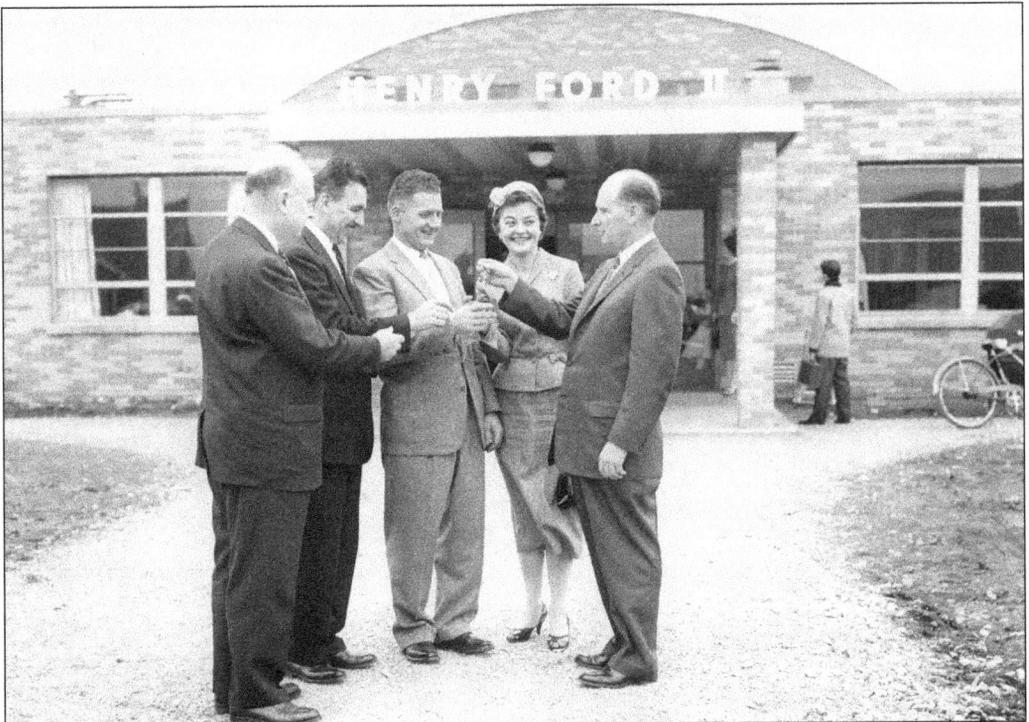

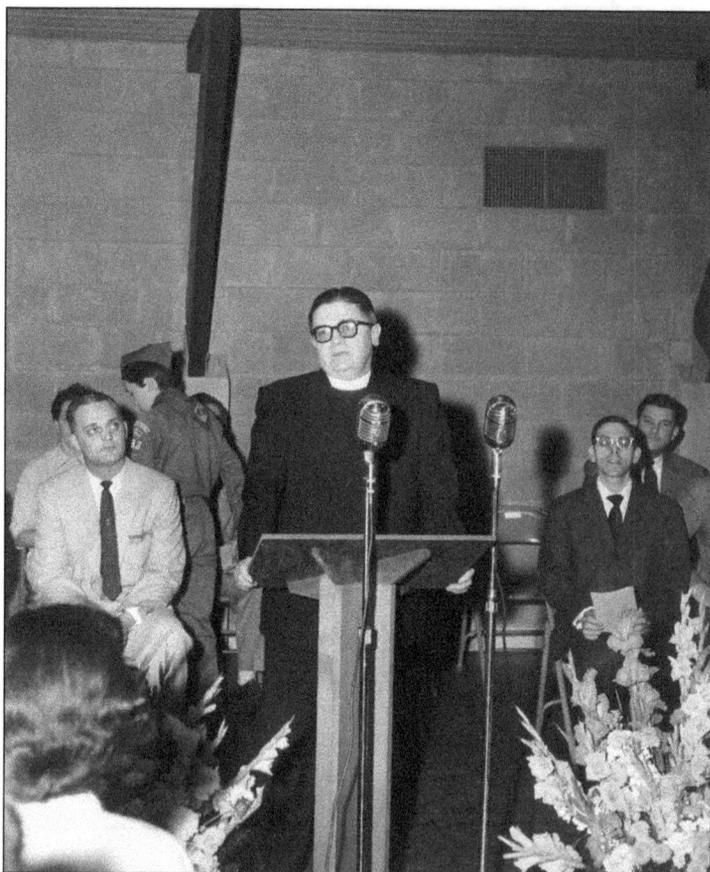

Pictured is Father Gentleman of Our Lady of the Ridge Parish at the dedication on Henry Ford II School. The 1960s brought with it plans for another school building, a 12-room facility at 105th Street and Menard Avenue. The school, named Ridge Lawn (below), opened in 1966. This boom in school building was overseen by a seven-member school board, which had increased from a three-member board in 1953. In 1959, Chicago Ridge School District 127 1/2 employed its first full-time school nurse and instituted its first full-time physical education program. (Left, courtesy of Adehl Good.)

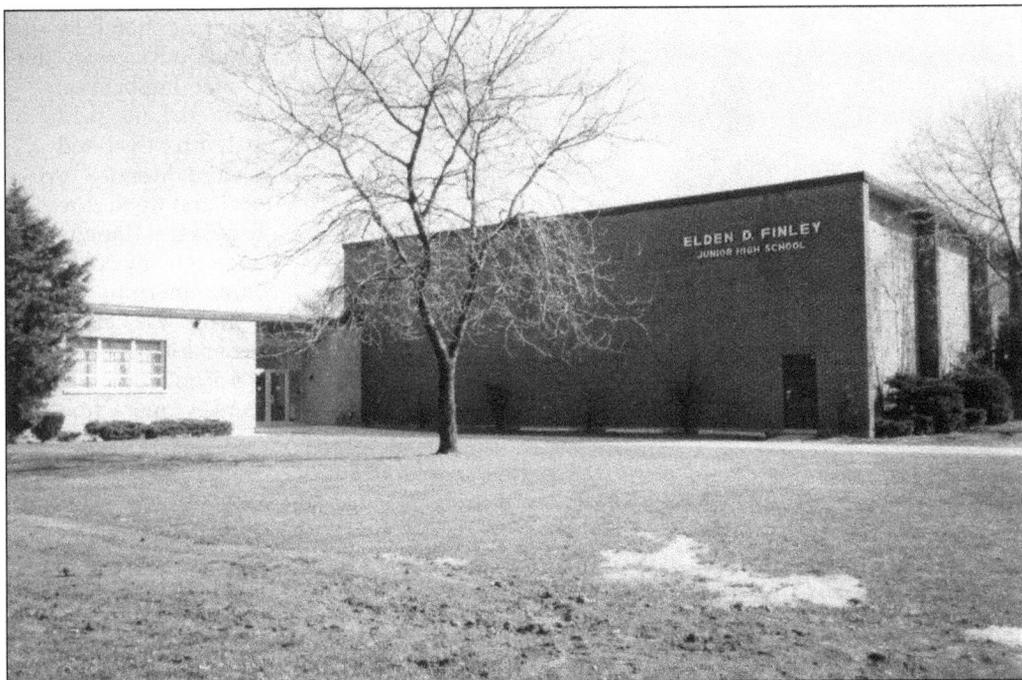

The village's first facility dedicated solely to middle school students, Elden J. Finley Junior High School opened in 1971. The school was named in honor of Finley who was superintendent of Chicago Ridge's schools at the time. He served in this position from 1959 until his retirement in 1973. Below is an architectural drawing of Henry Ford II School, which was renamed Ridge Central in the 1960s. (Below, courtesy of Adehl Good.)

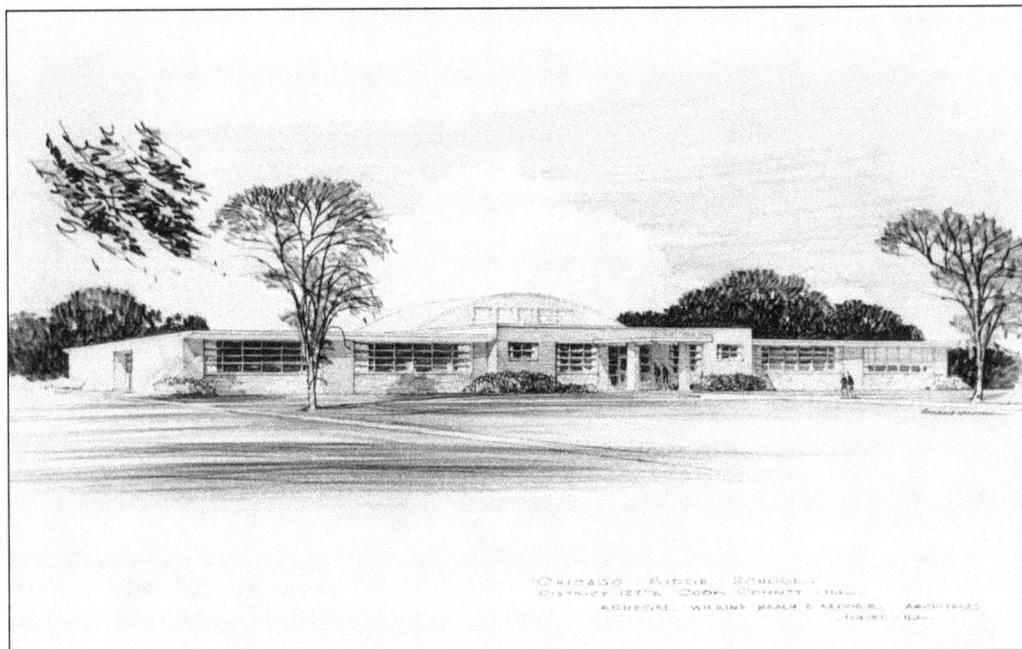

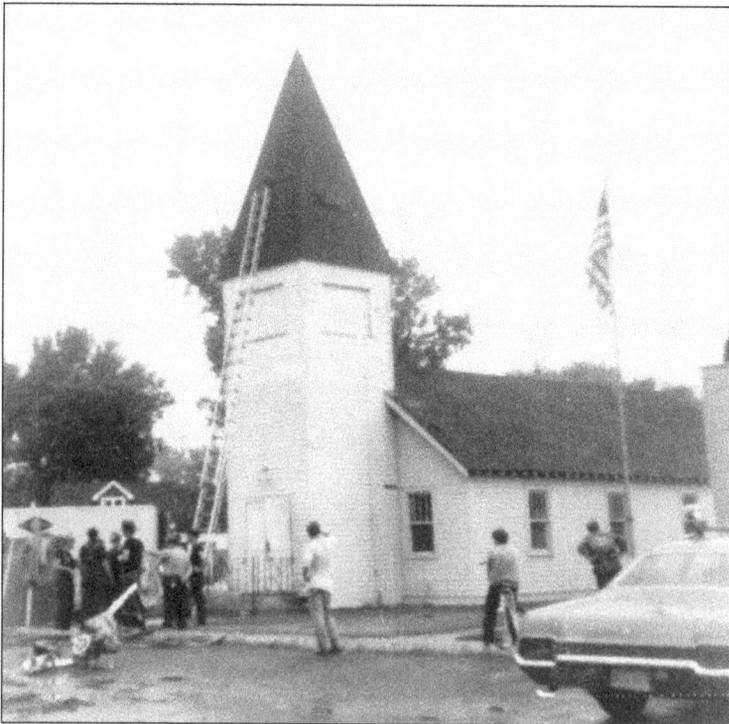

The first church in Chicago Ridge was the United Presbyterian Church, built in 1927, at 105th Street and Oxford Avenue. Two coal and wood stoves heated the church, and on many cold winter mornings, worship was held near a kitchen stove. It was said that cold feet kept many home on these mornings. When a new church was built in the 1960s on Lyman Avenue, this building was sold and later destroyed in a controlled-burn exercise for the volunteer fire department, as seen in this photograph.

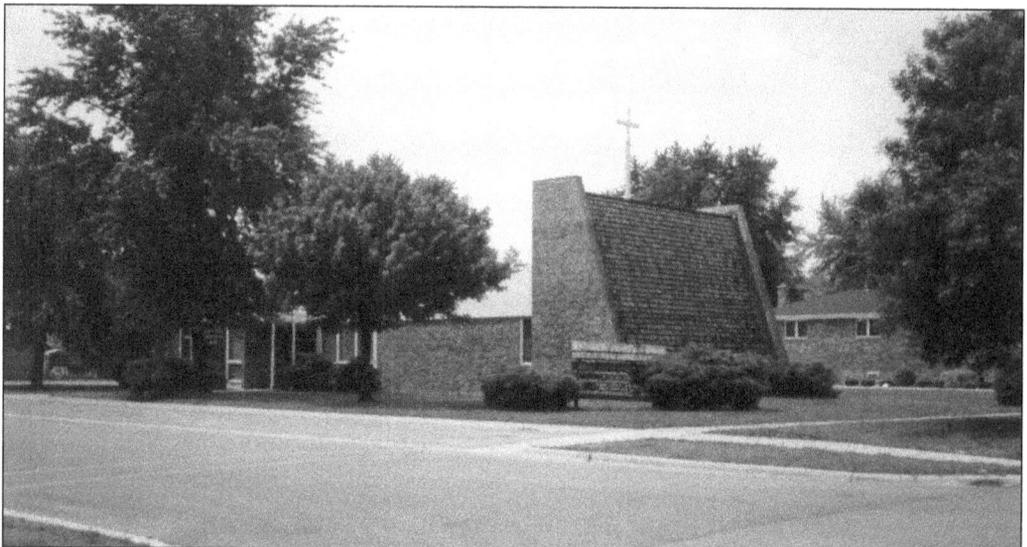

The United Presbyterian Church, 107th Street and Lyman Avenue, was dedicated in 1965. Prior to the dedication, two final Sunday morning services were held at the old church on Oxford Avenue.

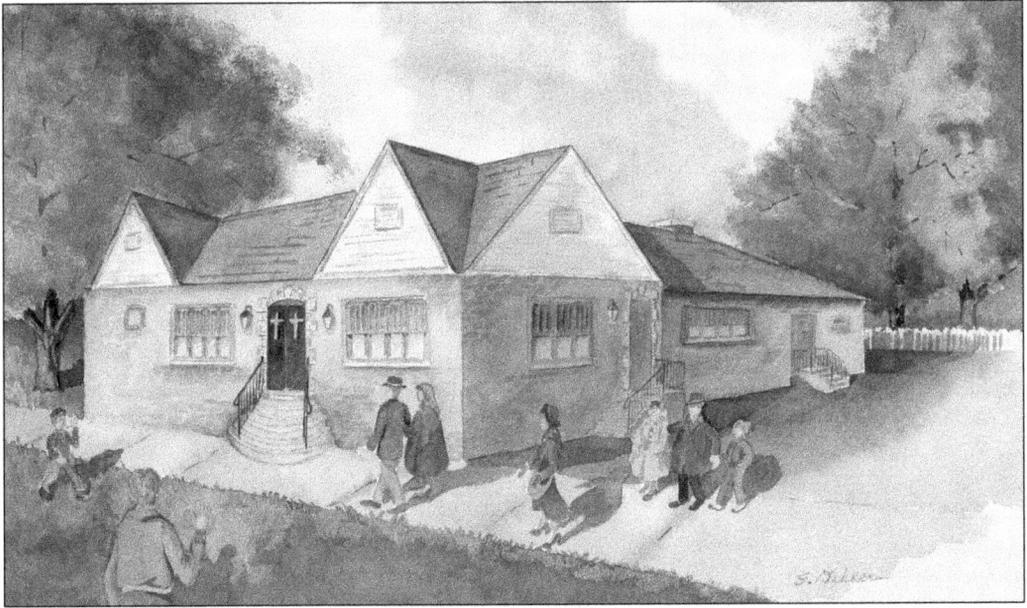

Our Lady of the Ridge held its first mass in the 1930s at the Chicago Ridge Public School at 105th Street and Oxford Avenue. The church began as a mission of St. Christina's Church in Mount Greenwood after a group of families petitioned the Chicago Archdiocese for a church of their own. As the village's population grew, petitions were taken up in Chicago Ridge and Worth, and in 1948, Rev. William Gentleman was appointed to establish a parish. He acquired the Piccadilly Gardens Building at 105th Street and Ridgeland Avenue for the new parish's location. According to parishioner Alice Gallagher, an entry way was built into the existing front window area, and eventually, an addition was built, creating a T-shaped structure. The church remained at the 105th Street location, as depicted in the watercolor above by artist Evelyn Dekker, until 1964, when it moved next to its school on 109th Street and Ridgeland Avenue. Below is an interior photograph of Piccadilly Gardens before the building was converted to the Our Lady of the Ridge Church. (Below, courtesy of the Tranowski family.)

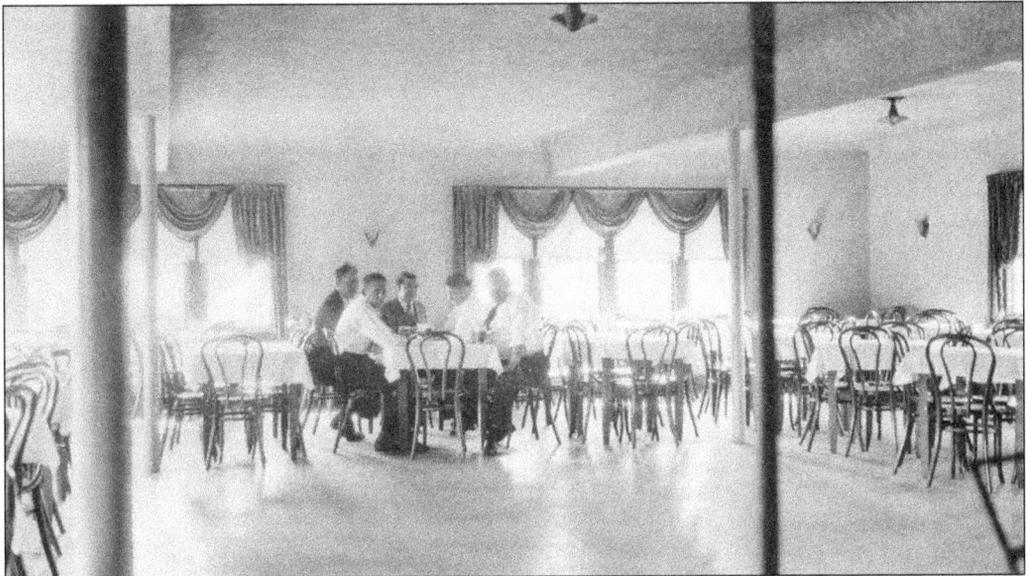

The photograph above of Father Gentleman was taken in the 1950s. Below, Father Finn conducts the Our Lady of the Ridge children's choir in 1962. (Both, courtesy of the Tranowski family.)

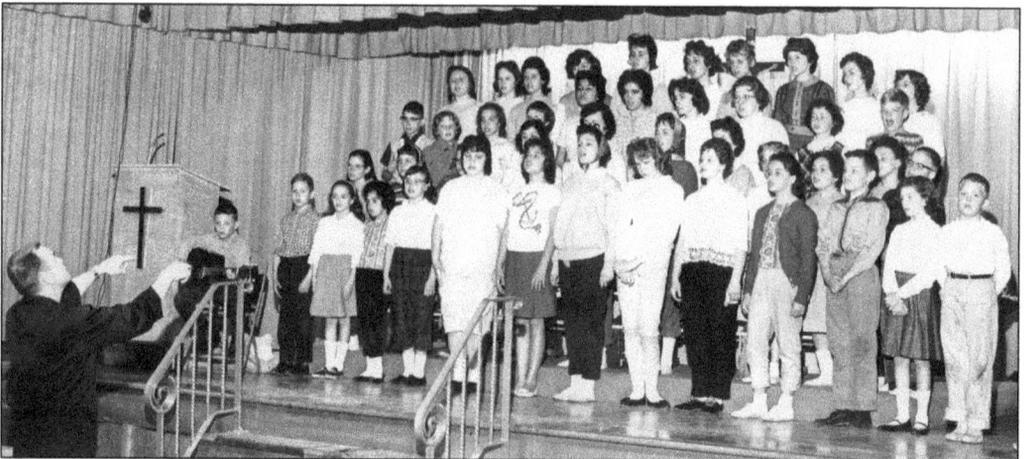

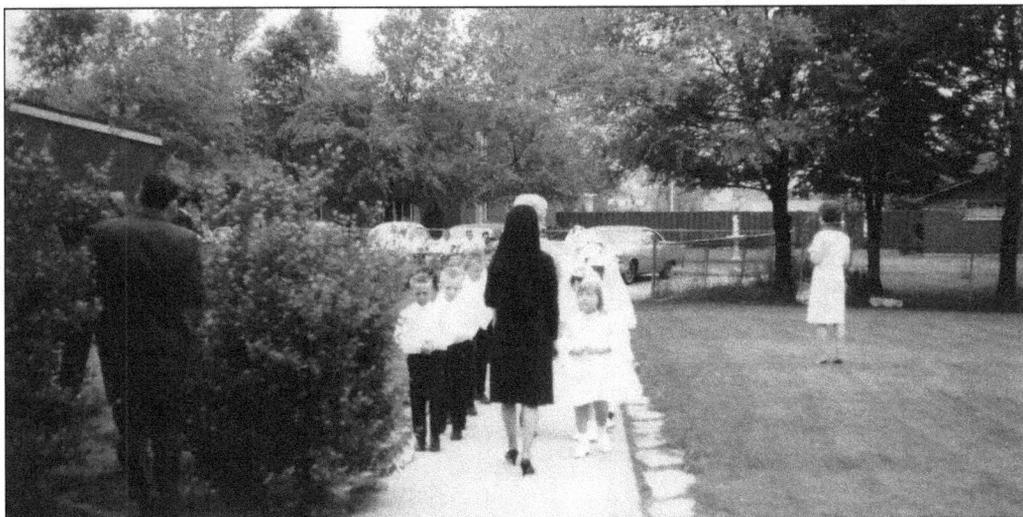

Second-grade communicants line up to receive their First Holy Communion at Our Lady of the Ridge Church at 109th Street and Oxford Avenue in the late 1960s. Author Ed Mauer Jr. can be seen in this photograph as a young boy. He is on the left, walking at the head of the line.

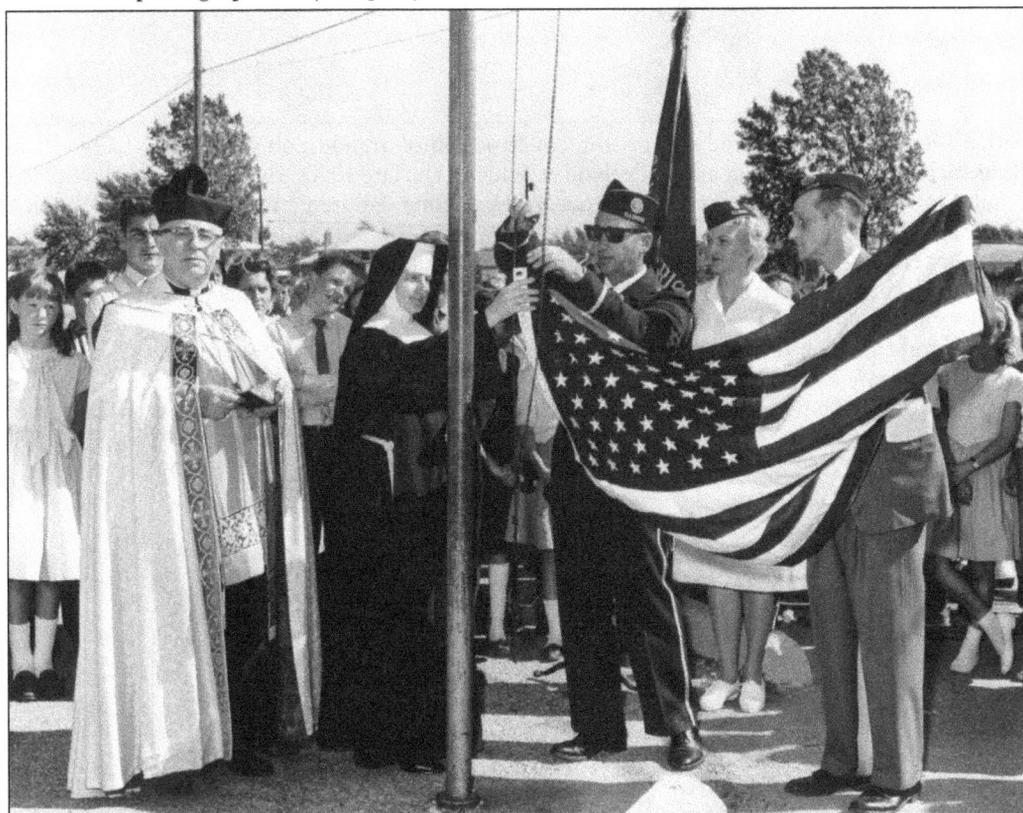

The Our Lady of the Ridge School was opened in 1954 by the Sisters of St. Francis of Perpetual Help from Ferguson, Missouri. Its first lay teacher, Anita Stecker, was hired in 1955. The American Legion Glenn Maker Post No. 1160 presented a flag to the school in 1961. Accepting is school principal Sister Demetria with Father Gentleman. (Courtesy of the Tranowski family.)

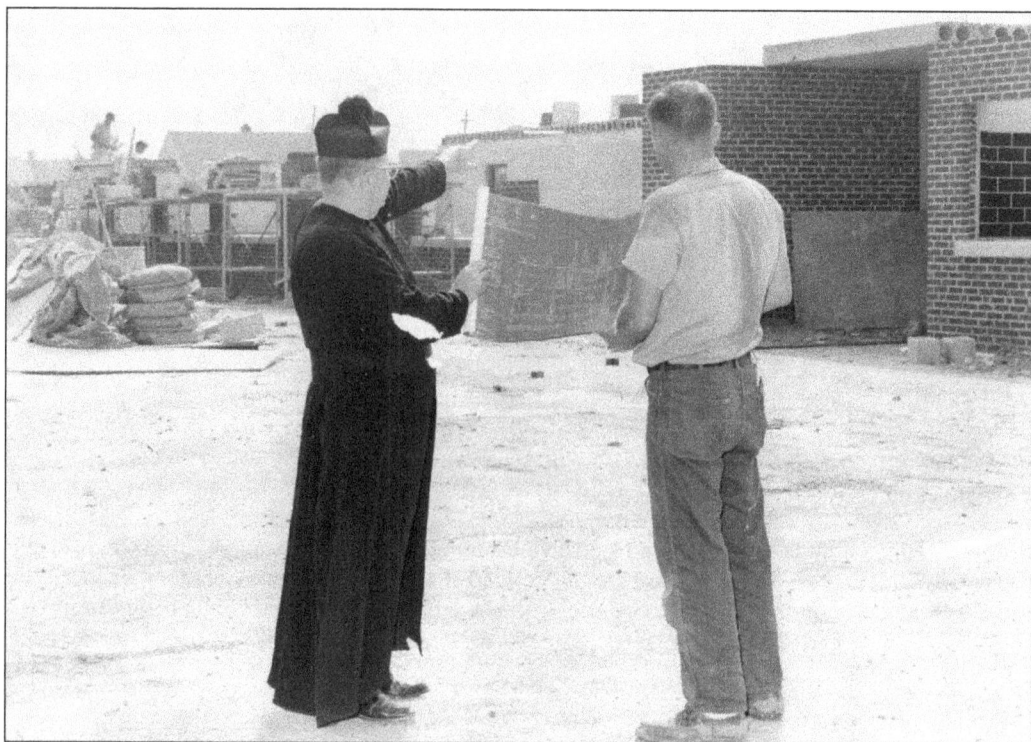

Father Gentleman is pictured supervising construction of an addition to the Our Lady of the Ridge School at 109th Street and Ridgeland Avenue in the late 1950s. By 1961, the staff included 6 nuns and 11 lay teachers. To meet the needs of Catholic children enrolled in public school, a Confraternity of Christian Doctrine (CCD) program was organized. In 1964, Msgr. M. Edward Roche extended the school's auditorium with a church building and sanctuary. Mass was said "in the round" when crowds required the use of the auditorium for additional space. In the late 1990s, a new church building was constructed. In the summer of 2000, the church's cornerstone was blessed, and a dedication occurred in the fall of that year. Below is a photograph, taken outside the front entrance of the Our Lady of the Ridge School in the 1960s. Students and staff are shown participating in a fire drill led by Chicago Ridge Fire Department chief Joseph Tarquino. (Above, courtesy of the Tranowski family.)

Four

NEIGHBORHOOD LIFE

The longevity of Chicago Ridge is remarkable. The pieces are laid out throughout this book. What may not be as apparent is the glue that holds it all together—the people. They are the bond that keeps it sturdy.

During the 1960s and 1970s, the population of Chicago Ridge mushroomed. Whole neighborhoods popped up seemingly overnight. The head count was staggering. People gravitated toward each other. They looked for ways to socialize and to be a community. Parades were a big deal and drew the entire town. Carnivals at 107th Street and Ridgeland Avenue transformed an empty field and a dusty baseball diamond into a wonderland every year.

Kids went home when the streetlights came on. They were known for knocking and yelling, "Yo [insert name here]," followed by walking into someone's house because the front door was always unlocked. No matter what block a kid misbehaved on, it somehow also got back to his parents, and the neighbor who discovered the wrongdoer would also scold him or her.

Children were always safe with these people, and they would defend the innocent from danger with their last breath if need be. Borrowing someone's child to run to the store, as well as telling him or her to keep a quarter as payment for their effort, was normal. Payment to mow one's lawn or shovel snow if needed was not uncommon either. Endless trick-or-treaters at Halloween with clever homemade costumes and groups of Christmas carolers made the rounds from door to door singing. Businesses were not as worried about being flashy as they were about helping the patrons. This at-home feeling is hard to find elsewhere.

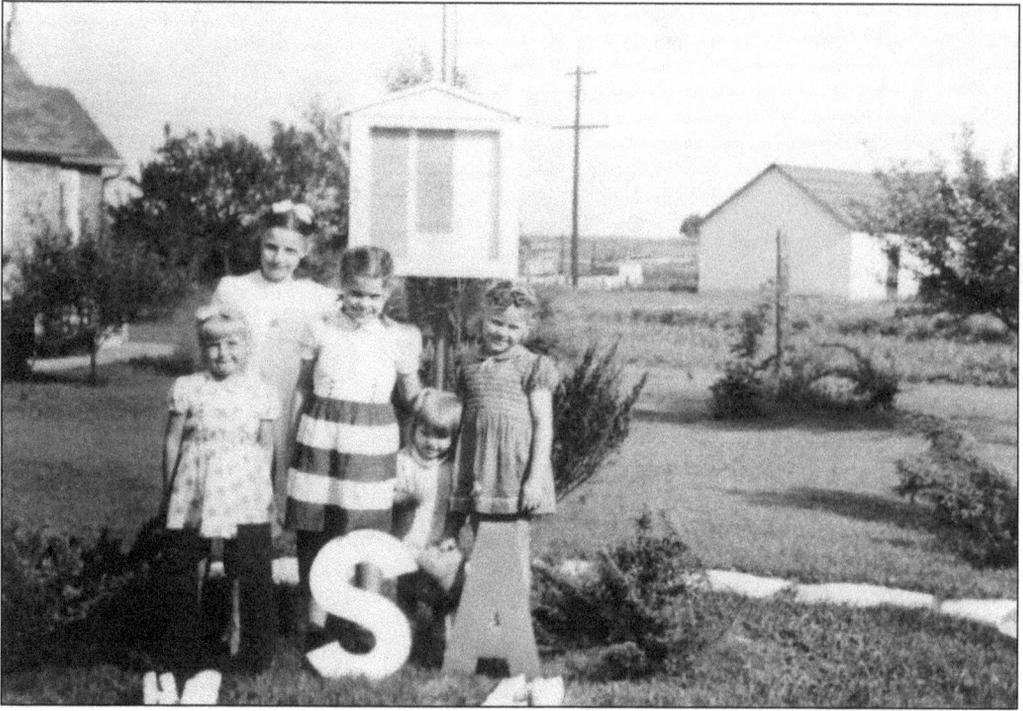

Taken in 1943, this photograph shows children gathered around a monument erected outside of Rucies' Tavern and Grove to honor Chicago Ridge residents away serving in World War II. Behind the box with the servicemen and women's names is a flagpole that was tended to daily by Ken Rutz. Residents tell that Rutz took it upon himself to raise and lower the flag on a daily basis. In the foreground are the letters USA, colored in patriotic red, white, and blue. (Courtesy of the Saunoris family.)

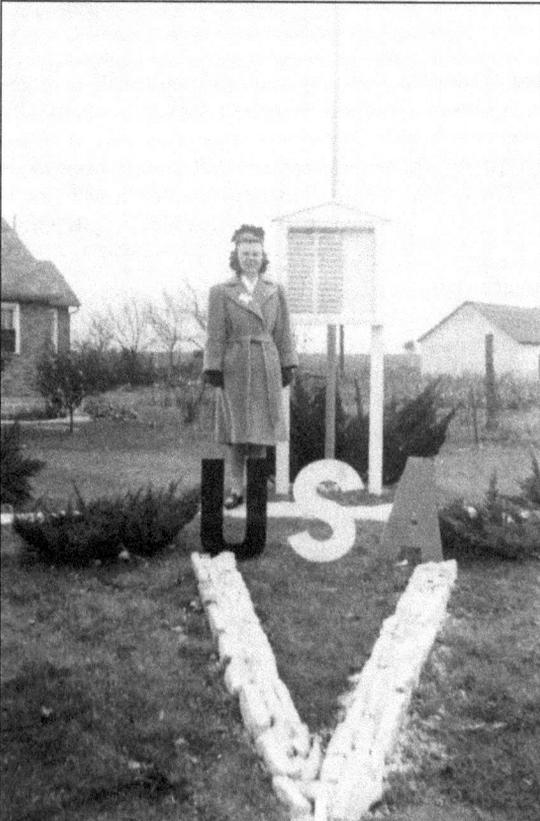

Resident Florence Cridge poses in the Victory Garden to honor the military during World War II. The view is from 106th Street and Oxford Avenue looking eastward. The fields used for growing hay and grazing livestock by "Dad" Meyer were prevalent in that day. (Courtesy of Ken Rutz.)

This is Victory Garden with the flag at full staff. People would frequent this spot to share their pride and support for residents actively serving in World War II. Listed in the center box in front of the flagpole were the names of residents serving in the armed forces. USA was spelled out in red, white and blue on the ground as well as a large, white V for victory. The lawn was well manicured and circled with small stone. (Courtesy of Ken Rutz.)

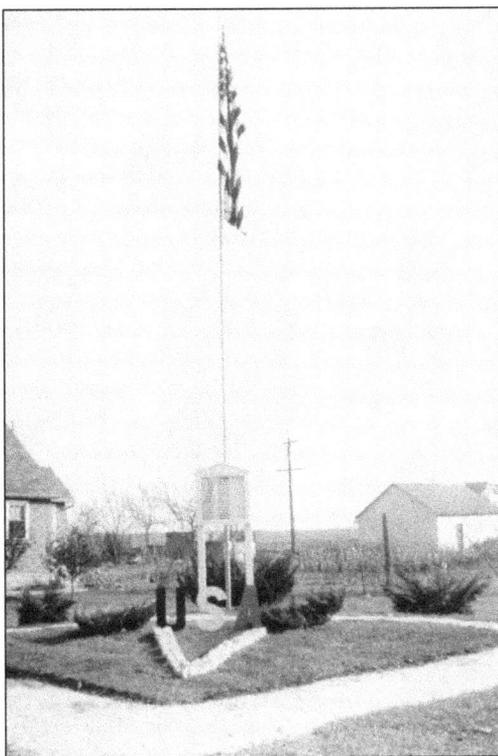

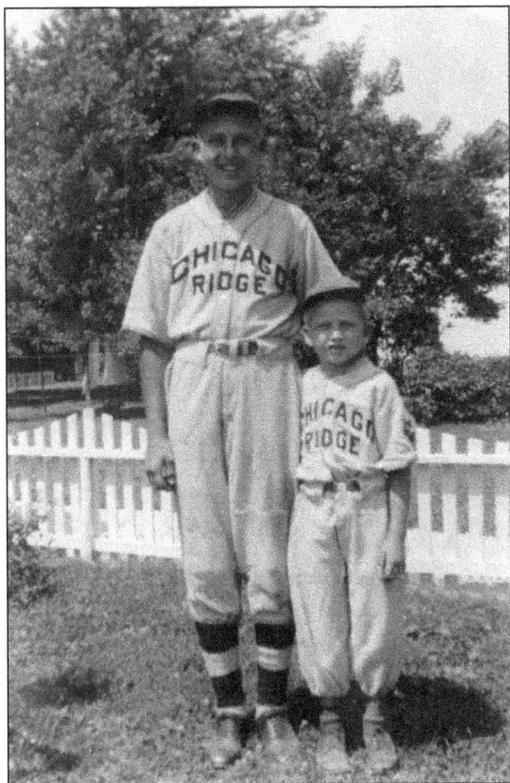

Photographed in the 1940s, Ken Rutz (left) and his younger sibling Allen wear Chicago Ridge baseball uniforms. Ken, out of civic pride and without compensation, dutifully tended to the town's Victory Garden that honored the military while they were away. (Courtesy of the Saunoris family.)

At left, Ken Rutz stands in front of his home on grade school graduation day. Pictured below is a resident leaning against a tree in his front yard during the early 1940s. (Both, courtesy of Ken Rutz.)

Pictured are Dora (left) and Ruth Schmidt. Dora, who came to the area during the building of the I&M feeder canal in the mid-1800s, washed the clothes of canal workers. Below, Dora Schmidt, seated in the foreground third from the left, celebrates her 81st birthday near the fish pond behind Rucies' Tavern and Grove, a favorite spot for villagers to celebrate special occasions. Located at 106th Street and Ridgeland Avenue, it hosted holiday picnics, political events, and weddings. In the foreground are (standing) Mrs. Schroeder, Mrs. Bazonta, Grandma Schmidt, and Mrs. William Walsh Sr.; (sitting) Mrs. William Walsh Jr., Mrs. Brutzke, and unidentified. In the background are, from left to right, Mrs. Schmalen, Mrs. Manion, Mrs. Kennedy, Mrs. Rucies, and Mrs. Bizzotto. (Both, courtesy of the Saunoris family.)

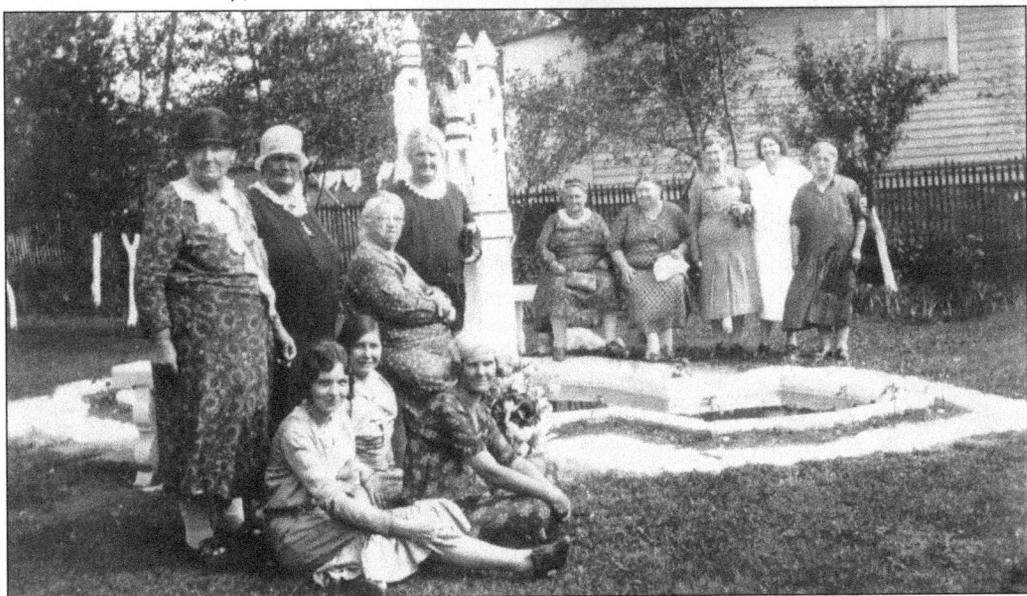

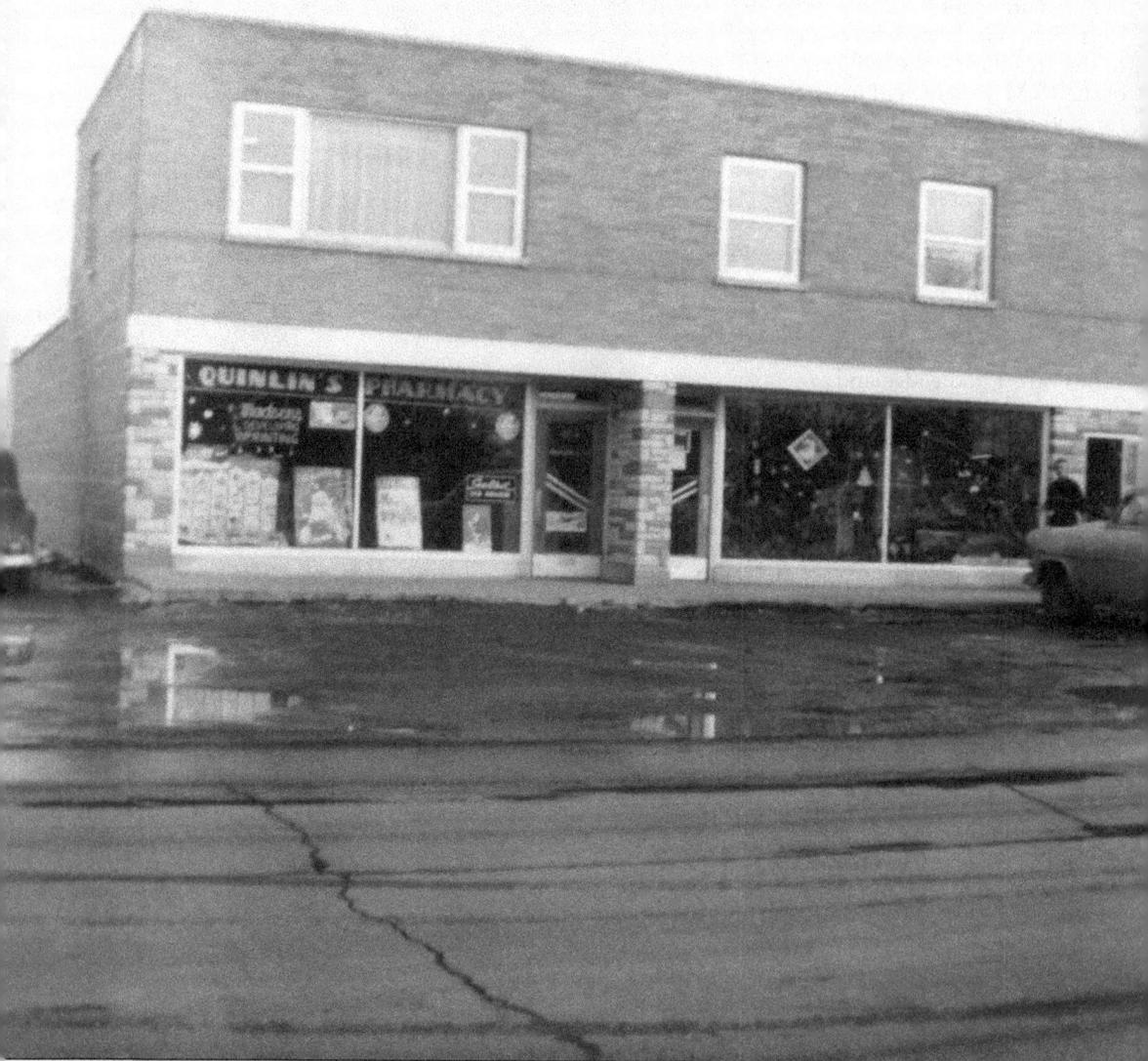

Quinlin's Pharmacy, an old-fashioned drugstore, operated at 108th Street and Ridgeland Avenue. Pictured is the building before the addition of the Glenn Maker American Legion Post on the right, and the strip mall that housed Schall's Hardware and Jack and Pat's Old Fashioned Butcher Shop to the left. This store housed the Chicago Ridge Post Office for a time and provided living quarters on the second floor. Later, this became Carmen's Drugstore.

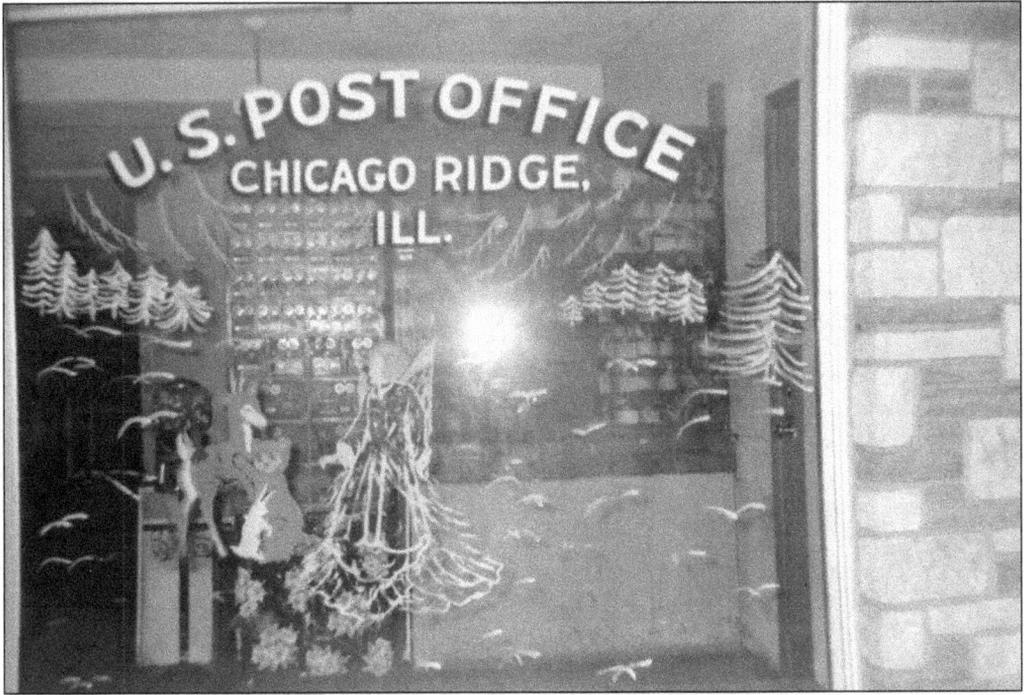

Pictured is the front window of the Chicago Ridge Post Office as it was in 1954 at 107th Street and Ridgeland Avenue. Through the window are the brass post office boxes as well as a gumball machine. The post office has bounced all over town but began in Berger's slot-machine factory, visited Marie Paulus's kitchen, and ended up at its current location of 105th Street and Ridgeland Avenue. It has come a long way since mail was thrown off a moving train car. Parked in front of the Chicago Ridge Post Office are three-wheeled "mailsters" used after World War II. Glen Maker Post No. 1160 is in the background. These vehicles proved dangerous and were phased out nationally after a large dog tipped over one.

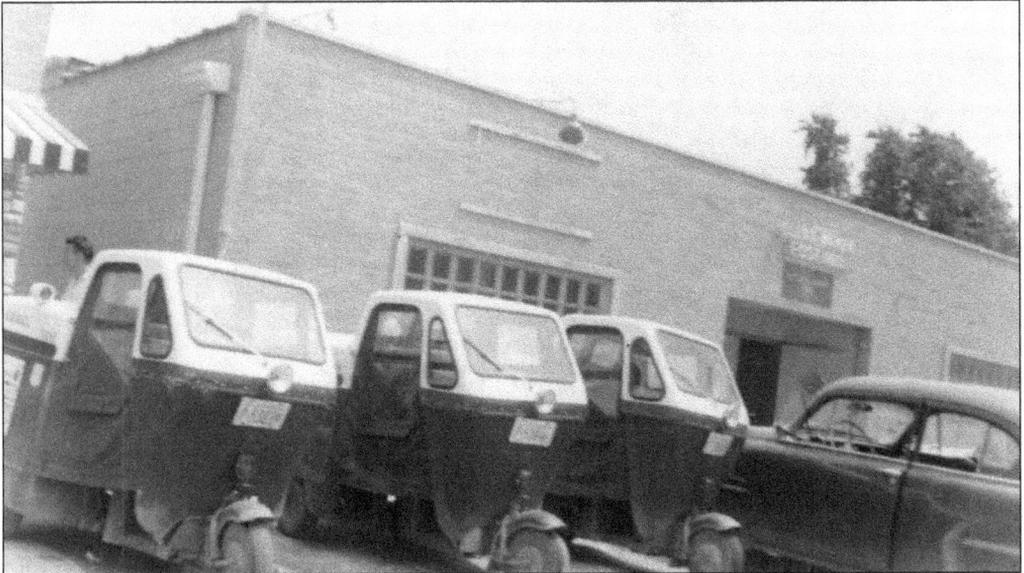

Welcome to George Sherman's General Store. Seen here, on the right, with Pete Chiapetti, Sherman ran the store after Our Lady of the Ridge Church vacated this site for a more accommodating structure at 108th Street and Ridgeland Avenue. Sherman's store stood on the site of the former Piccadilly Gardens and General Store, a popular entertainment establishment and sundries location. Some locals believed that the building was haunted by a Piccadilly Gardens patron who

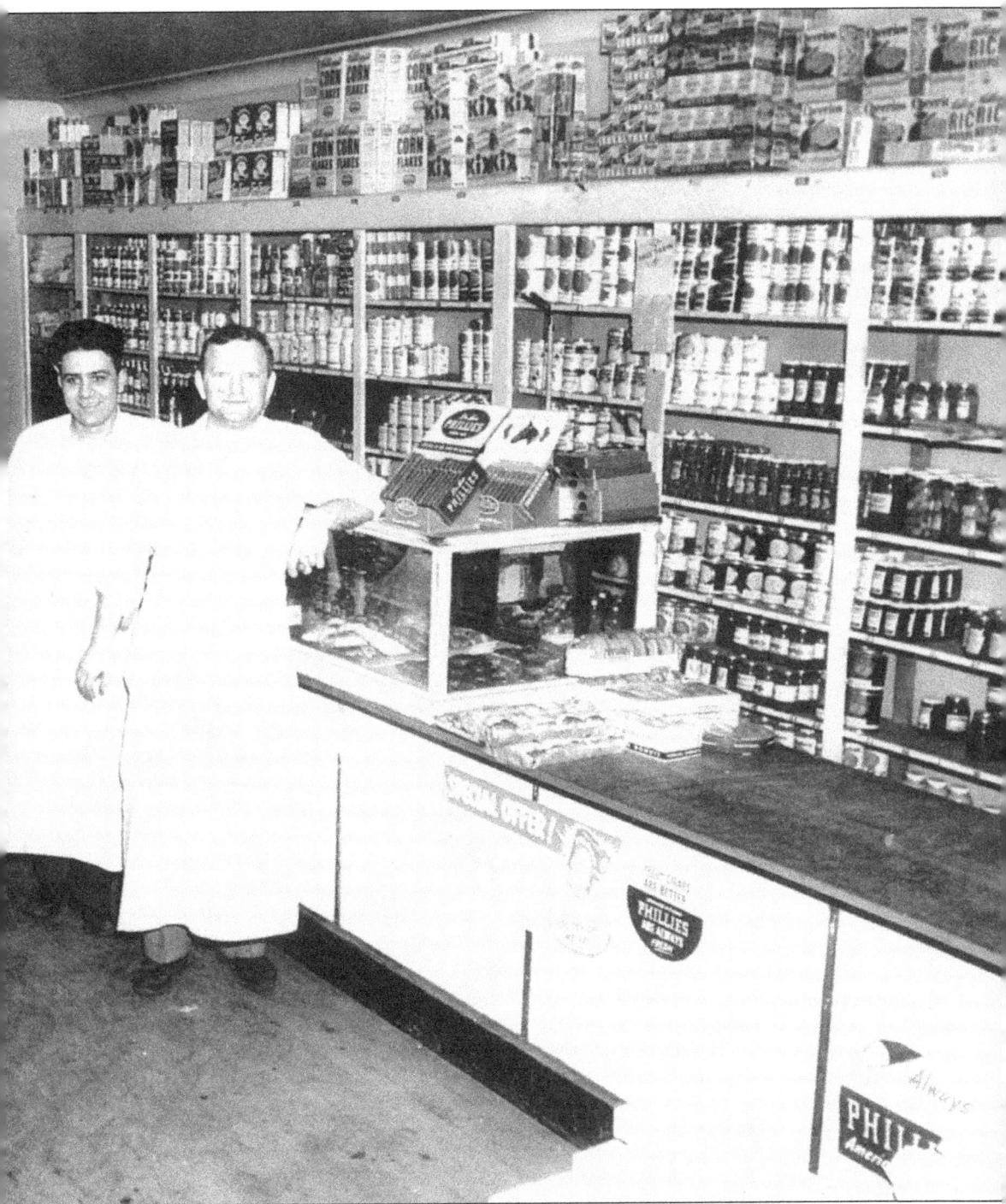

passed away there suddenly. Reports stated that she was seen in the attic. Our Lady of the Ridge Church moved from this building after a fire involving its altar. The current tenant, Veterans of Foreign Wars Post No. 166, has one of the two stone monuments in town honoring the military, previously mentioned in this book, on the Ridgeland Avenue side of the building and is located at 106th Street and Ridgeland Avenue. (Courtesy of the Saunoris family.)

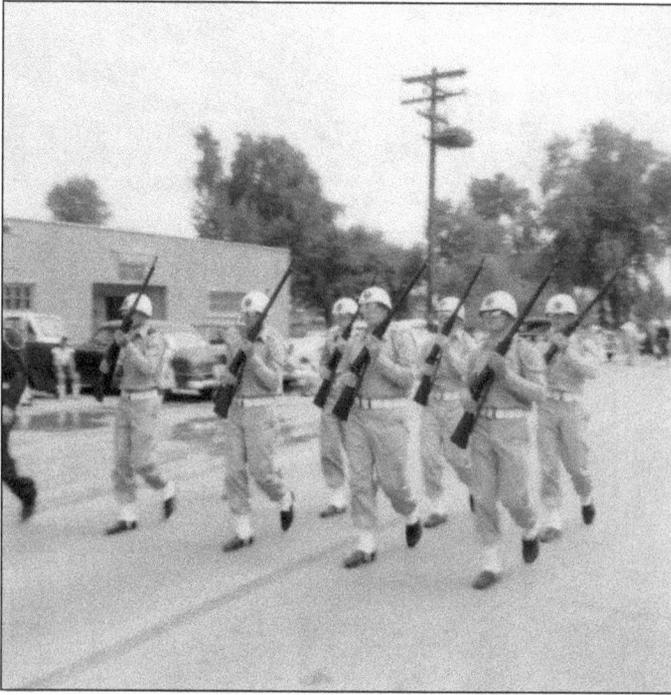

Marching in the Ridge Days Parade in the 1960s, a military honor guard passes in front of Glenn Maker American Legion Post No. 1160, located on 109th Street and Ridgeland Avenue. These parades attracted many residents and often culminated at a carnival ground where everyone joined in celebrating their civic pride. This American Legion post was named in honor of Glenn Maker, born in Chicago Ridge, on Princess Avenue, he was the first village resident to give his life in war during World War II.

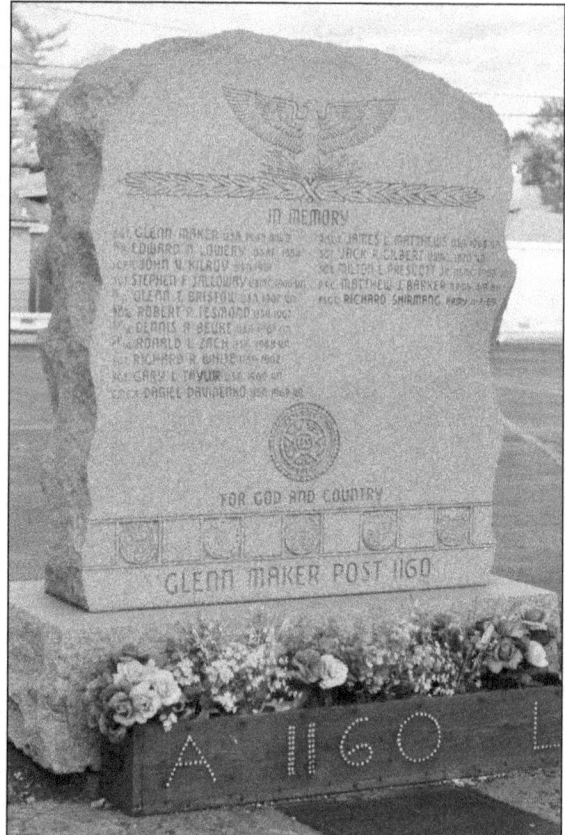

This stone monument located outside the Glenn Maker Post contains the names of all Chicago Ridge military men and women who made the ultimate sacrifice. This post was dedicated in Sergeant Maker's name in 1957. (Courtesy of Stacey Reichard.)

Gracing the Ridge Days Parade in the 1960s with elegance and charm were these lovely young ladies and their parade float. They were the participants for Ridge Days queen. In the background of the bottom photograph is a string of stores, including Ridge Barbershop and Schall's Hardware. Note the cars parked behind the float are nosed in as Ridgeland Avenue was still only two lanes.

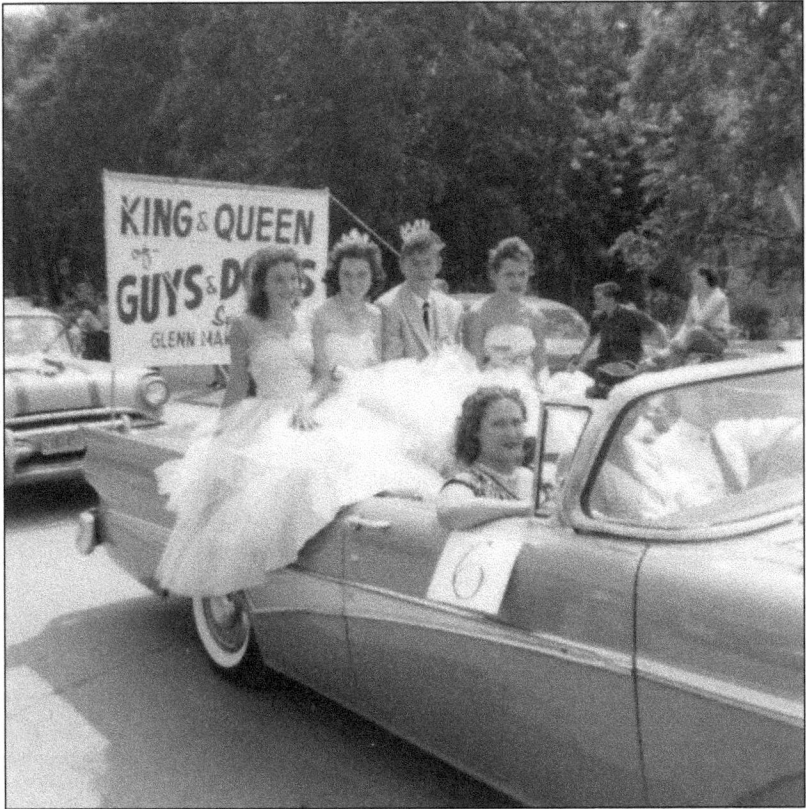

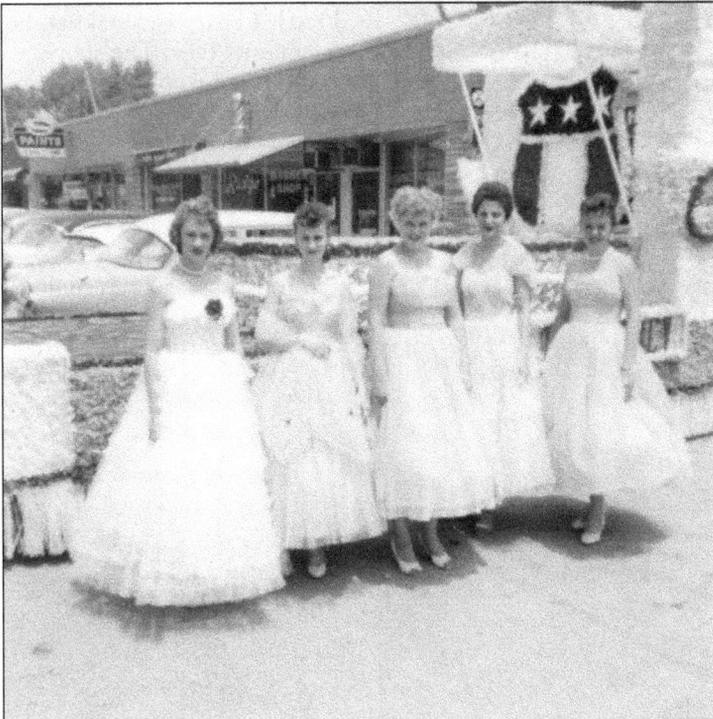

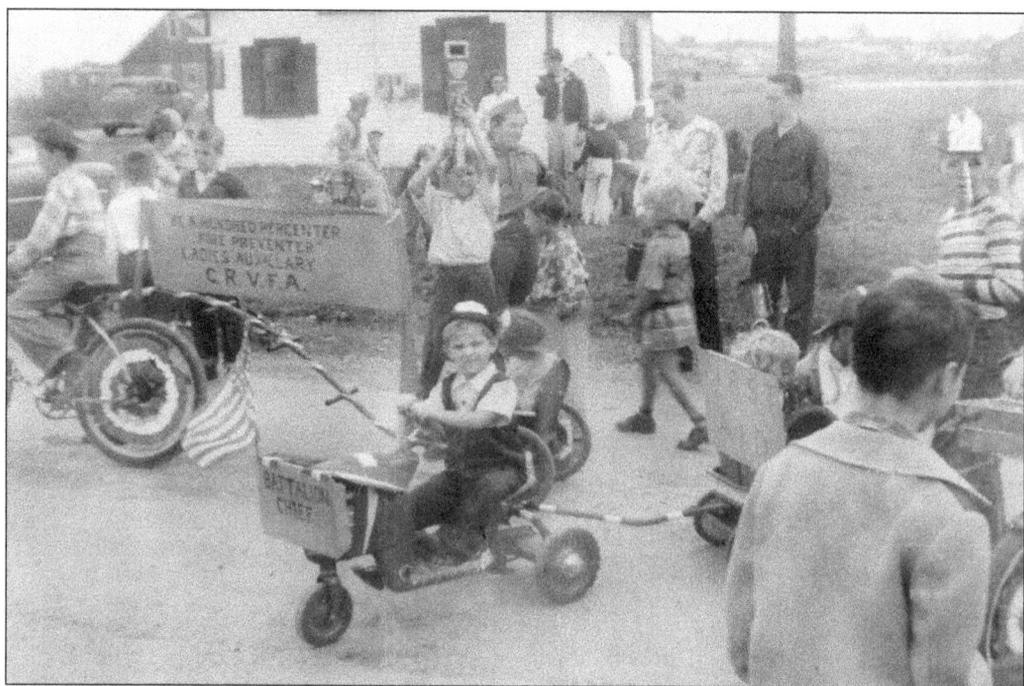

Civil defense was a serious matter in 1954, and Chicago Ridge was at the ready. During its Fire Prevention Week Parade in 1954 residents participated directly in exercises making the community safer. The above picture was taken from the front of the firehouse on 107th Street and Lombard Avenue and shows the civil defense building across the street. The building was unique to the area and helped Chicago Ridge stand out as a leader in civil defense. Chief Doty is pictured at left with participants of the Fire Prevention Week Parade.

CIVIL DEFENSE PREPAREDNESS

PREPARE:

Your family shelter and equip with two-week supply of food and water, first aid kit, battery radio.

Evacuation kit for your automobile with food, water, first aid kit, battery or car radio, blankets.

LEARN:

1. Warning signals and what they mean.
2. Your community plan for emergency action.
3. Protection from radioactive fallout.
4. First aid and home emergency preparedness.
5. Use of **CONELRAD—640 or 1240** for official directions.

GPO 825110

The village distributed the card above to all residents to be prepared in case of emergency. Pictured below, the Chicago Ridge Wabash train station was located on 103rd Street and Ridgeland Avenue in 1958. Arriving to the station is a period locomotive. The station had always been considered a landmark of this railroad town and stood from its construction in 1902 until torn down and replaced with a modern station in 1985. In the background, behind the station, appears to be the remnants of "Dad" Meyer's Chicago Ridge Hotel and Inn.

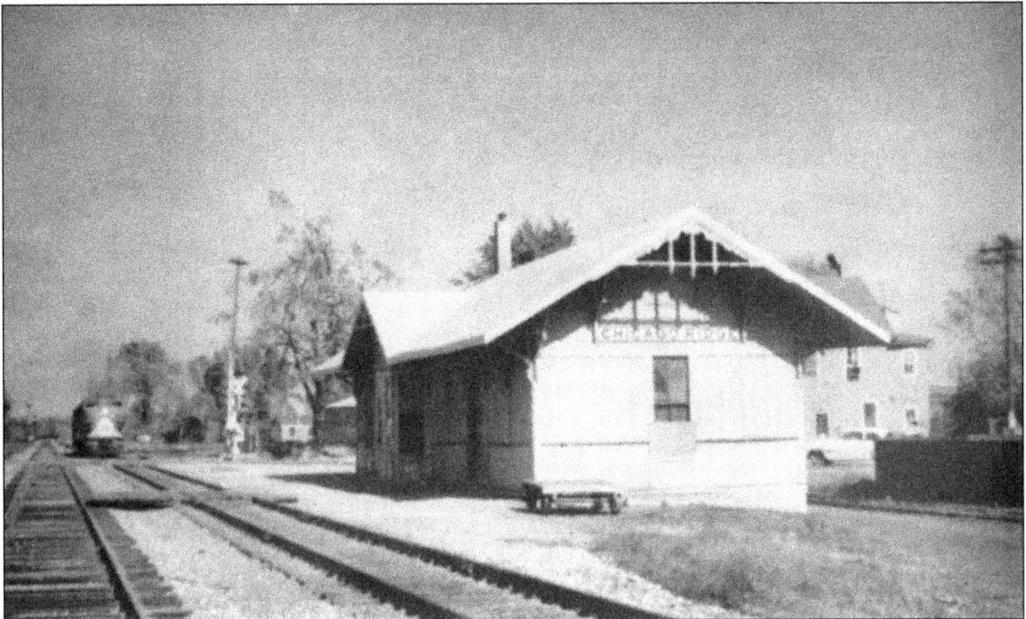

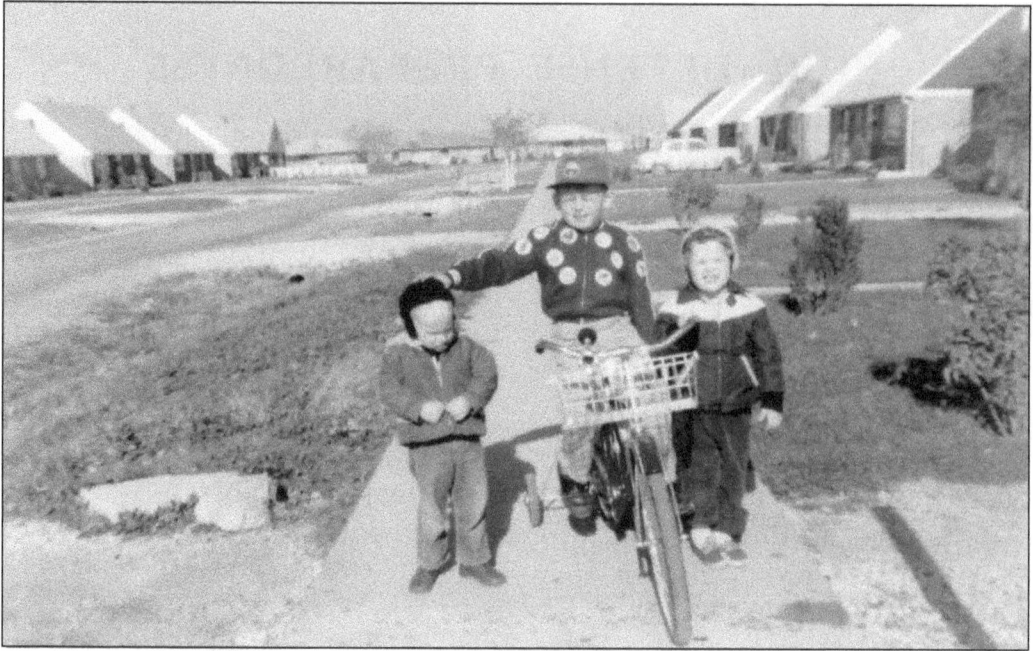

A few youngsters pause to take a picture with a wonderful shot of their Chicago Ridge neighborhood in the background. Note how barren the landscape is. This is a testament to how quickly neighborhoods sprung up. During the 1950s and 1960s, the population exploded in Chicago Ridge. (Courtesy of Charles E. Tokar.)

Pictured are the homes of the Rutz family and Polchow family as they were constructed. Herbert Polchow later became village president and was largely responsible for a great number of homes being built in the village. (Courtesy of Ken Rutz.)

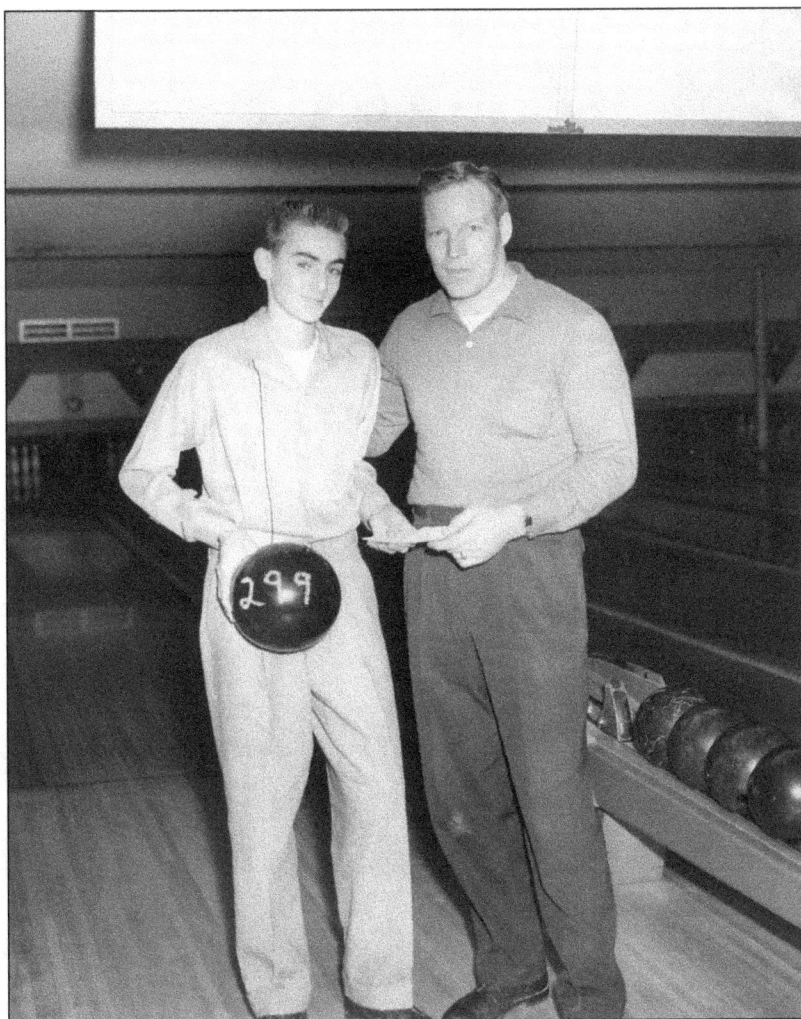

A popular place for recreation in Chicago Ridge was Ed Sprinkles bowling alley, also known at one time as Navajo Lanes, at 111th Street and Oxford Avenue. One can tell by looking at the picture below that Ed Sprinkles's lanes attracted a lot of attention.

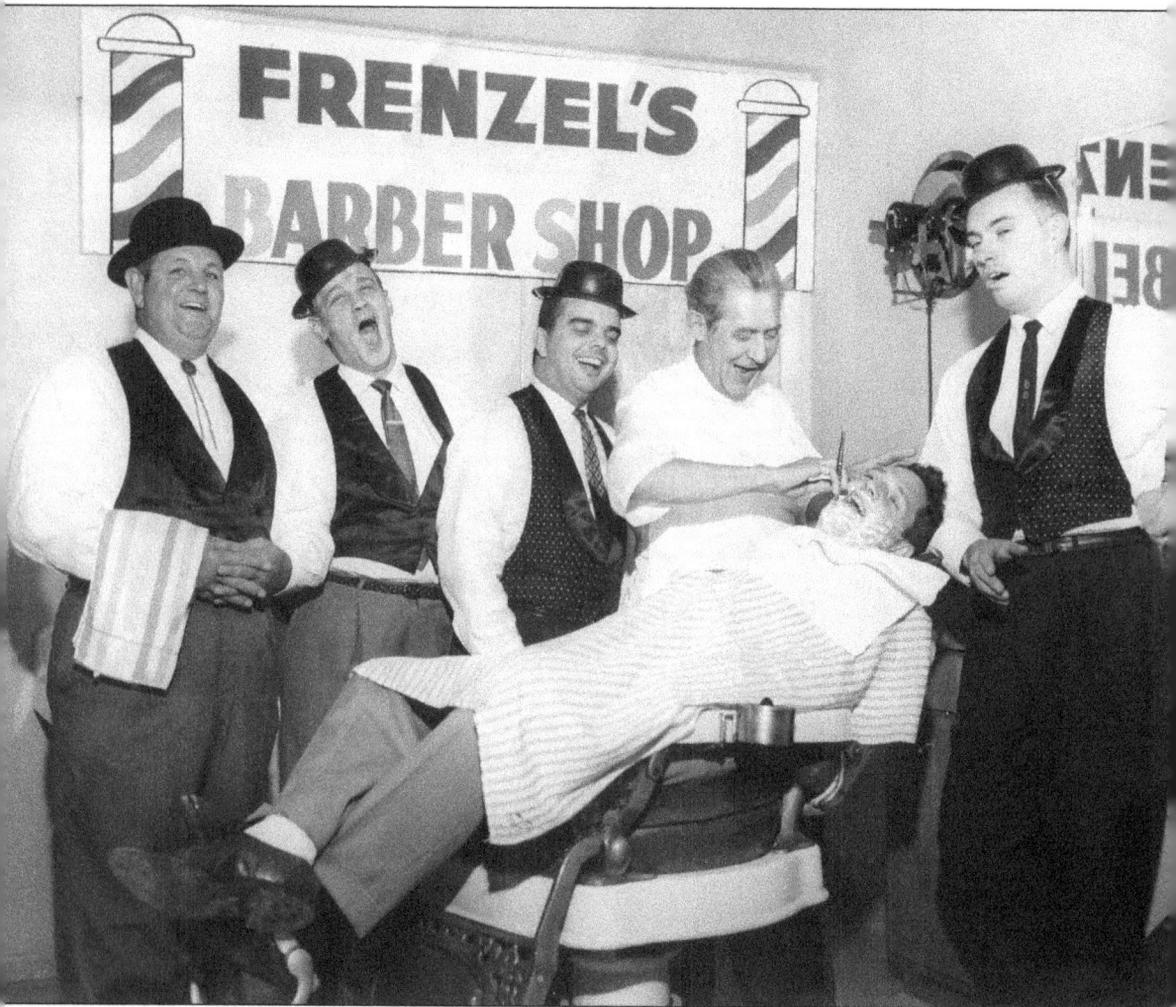

Village businessmen were extremely creative and constantly supplied the town with new and interesting ways of enjoyment. Here, housed in Frenzel's Tavern, is a barbershop, complete with its own quartet. This barber's name is John, but Marion Frenzel eventually got his barber's license and served as barber here for a number of years. Frenzel's still actively holds the first Chicago Ridge liquor license issued. (Courtesy of Susan Frenzel Kasper.)

Patrons stop in for a cold one at Frenzel's Tavern with grandpa Thomas Frenzel tending bar. The building located at 5936 111th Street was used during Prohibition as a liquor distributor under the guise of a diaper service. Liquor was delivered wrapped in diapers. One of the diaper pins used was recently found in the walls of the building by Susan Frenzel Kasper. Pictured below, patrons at Eddie's Jolly Inn square off in a contest. (Right, courtesy of Susan Frenzel Kasper; below, courtesy of Duane Exline.)

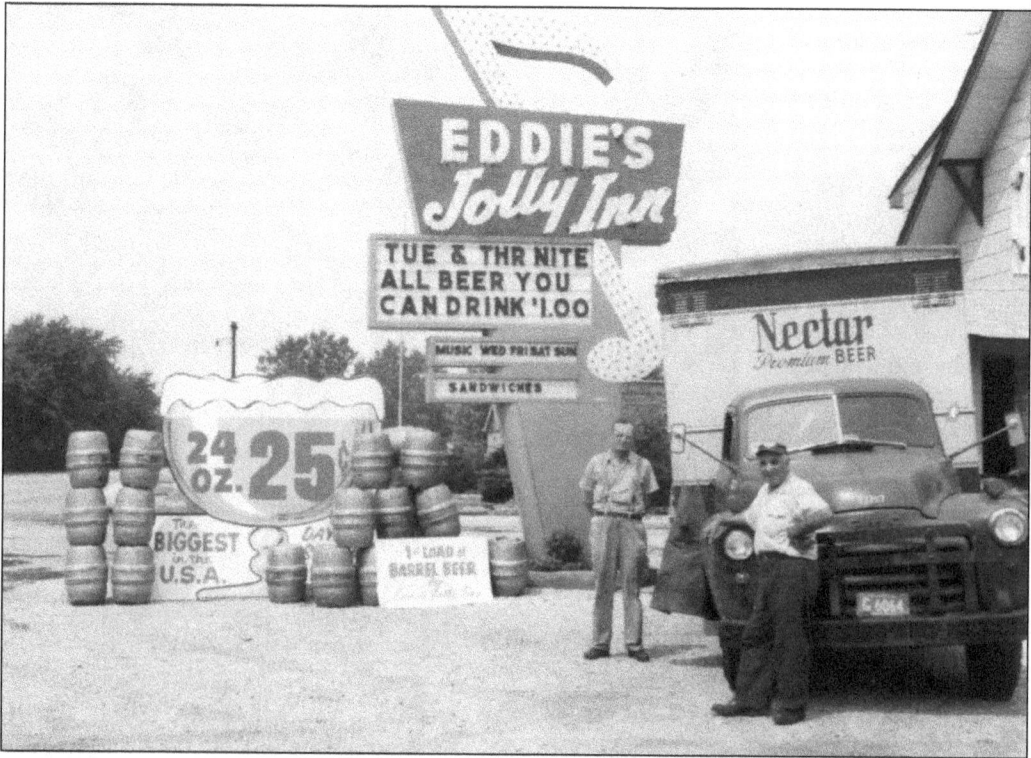

Here is Eddie's Jolly Inn and its huge sign shaped like a giant musical note. Lit up and flashing during the night in various colors, it was like a lighthouse for late-night entertainment seekers. Eddie's had it all, and sometimes too much for the village's liking, as legal battles between the two were not uncommon. (Courtesy of Duane Exline.)

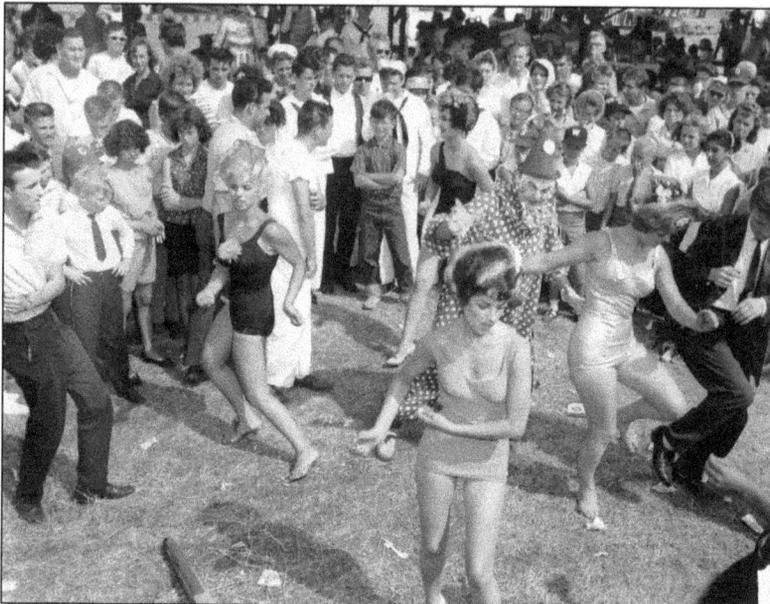

Eddie's Jolly Inn provided all kinds of entertainment and even participated in the Ridge Days festivities. Pictured are some of Eddie's dancers mingling with the Ridge Day Parade crowd. One never knew what to expect from a Ridge Days celebration. (Courtesy of Duane Exline.)

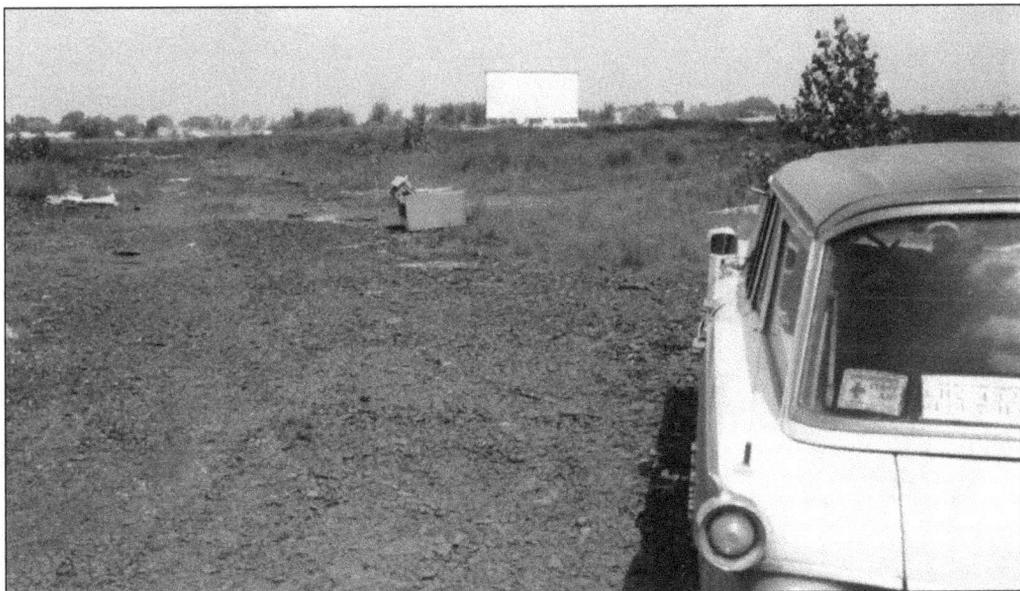

Drive-in movies were the rage in the 1950s and 1960s. This view shows the Starlite Drive-in movie theater screen from one of the back rows. The drive-in theater was located where the Chicago Ridge Mall currently stands. This photograph was taken looking toward Ninety-fifth Street from the direction of Ridgeland Avenue. On this site were the Studio Cinema, Community Discount store, and A&P grocery store, as well as a go-cart track, arcade, and a huge slide.

Vern's Supermarket was located at 6116 West 111th Street. Vern Roegner opened this store in 1957 and it never lost its small-town charm. In 1959, the parking lot was enlarged. Vern's hosted concerts, dances, and other celebrations for many years in its parking lot.

At that time, the place to go for a nice night out and a great meal with friends was Tokar's Supper Club. Located on 111th Street and Massasoit Avenue and opened in 1954 by George and Cecilia Tokar, it quickly became the place to be for fine dining in the area. Tokar's was one of the first establishments, if not the first, to employ female bartenders. (Courtesy of Charles E. Tokar.)

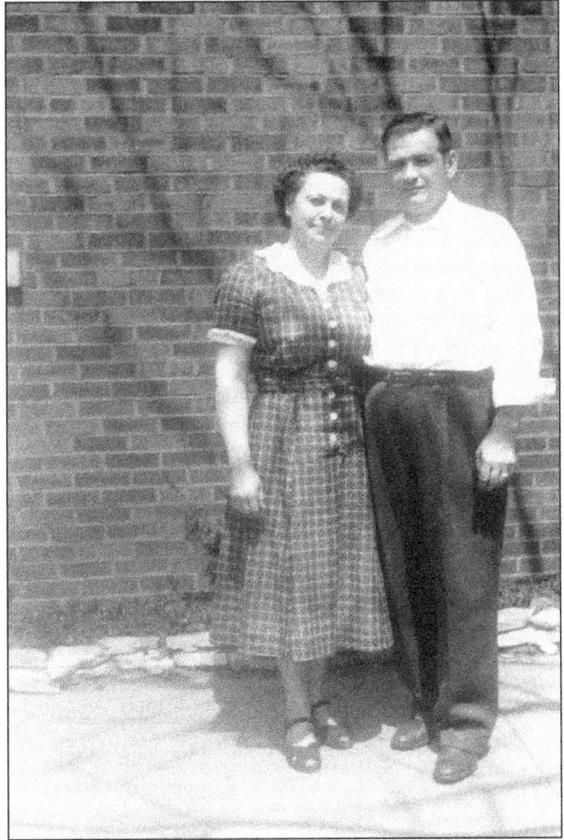

Pictured at right are George and Cecilia Tokar, owners of Tokar's Supper Club. Charles E. Tokar, current mayor of Chicago Ridge, George and Cecilia's son, was often seen playing the organ in the restaurant and enhancing the dining experience. Charles started playing in the supper club at the age of 12. His first job was playing the organ for the Wurlitzer store in Evergreen Plaza. (Both, courtesy of Charles E. Tokar.)

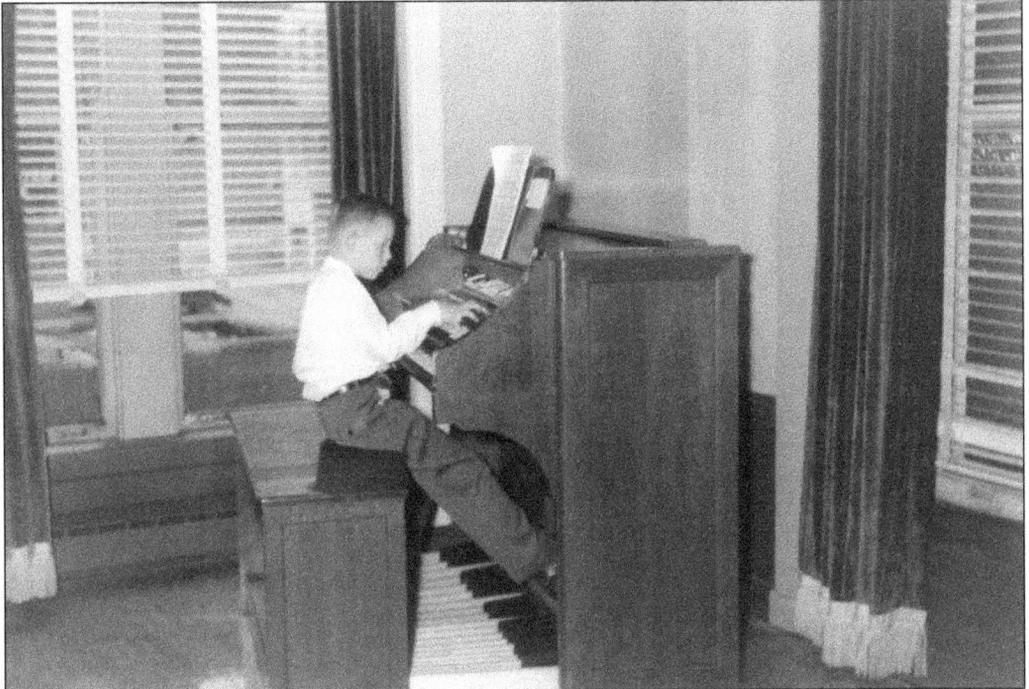

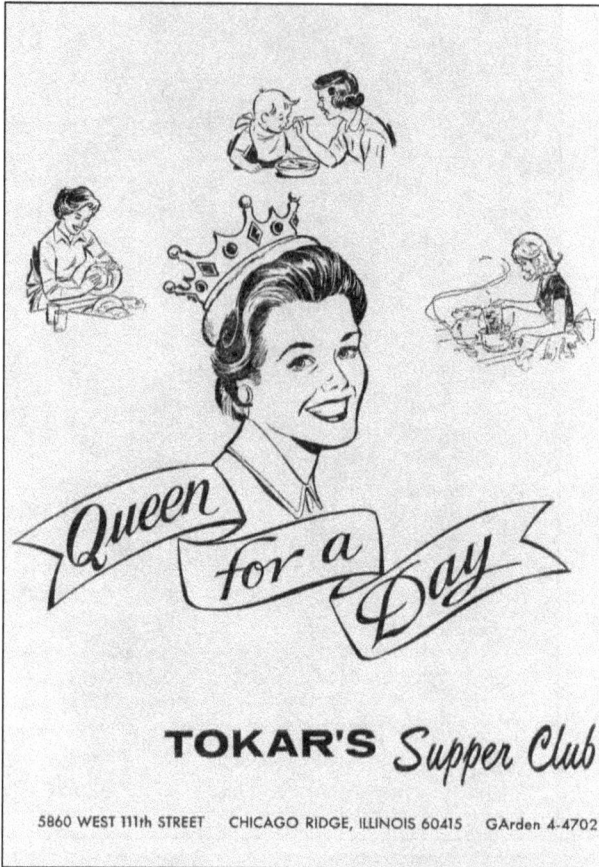

Queen for a Day

TOKAR'S *Supper Club*

5860 WEST 111th STREET CHICAGO RIDGE, ILLINOIS 60415 GArden 4-4702

This menu was made especially available at Tokar's Supper Club for Mother's Day patrons. It reflects the prices from the restaurant in 1970. Customers could purchase the filet mignon at $4 and African lobster tail at $6. (Courtesy of Charles E. Tokar.)

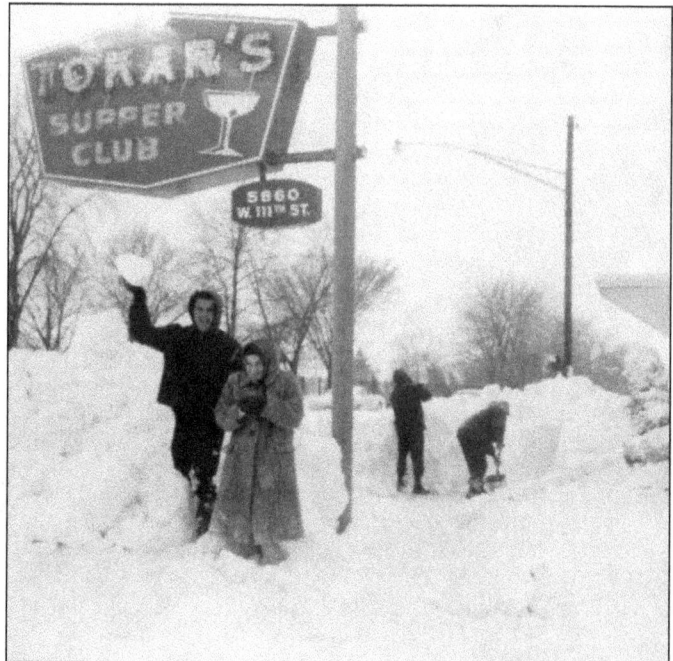

1967 was a year Chicago Ridge will never forget. That year, the Oak Lawn tornado miraculously skipped right over the town yet claimed one of the village's residents outside Shoot's Tavern, 15-year-old Catherine Zenner. There was also a blizzard that year too. In this photograph can be seen the results of the great blizzard of 1967. This was long before snow blowers, so people dug themselves out by hand. (Courtesy of Charles E. Tokar.)

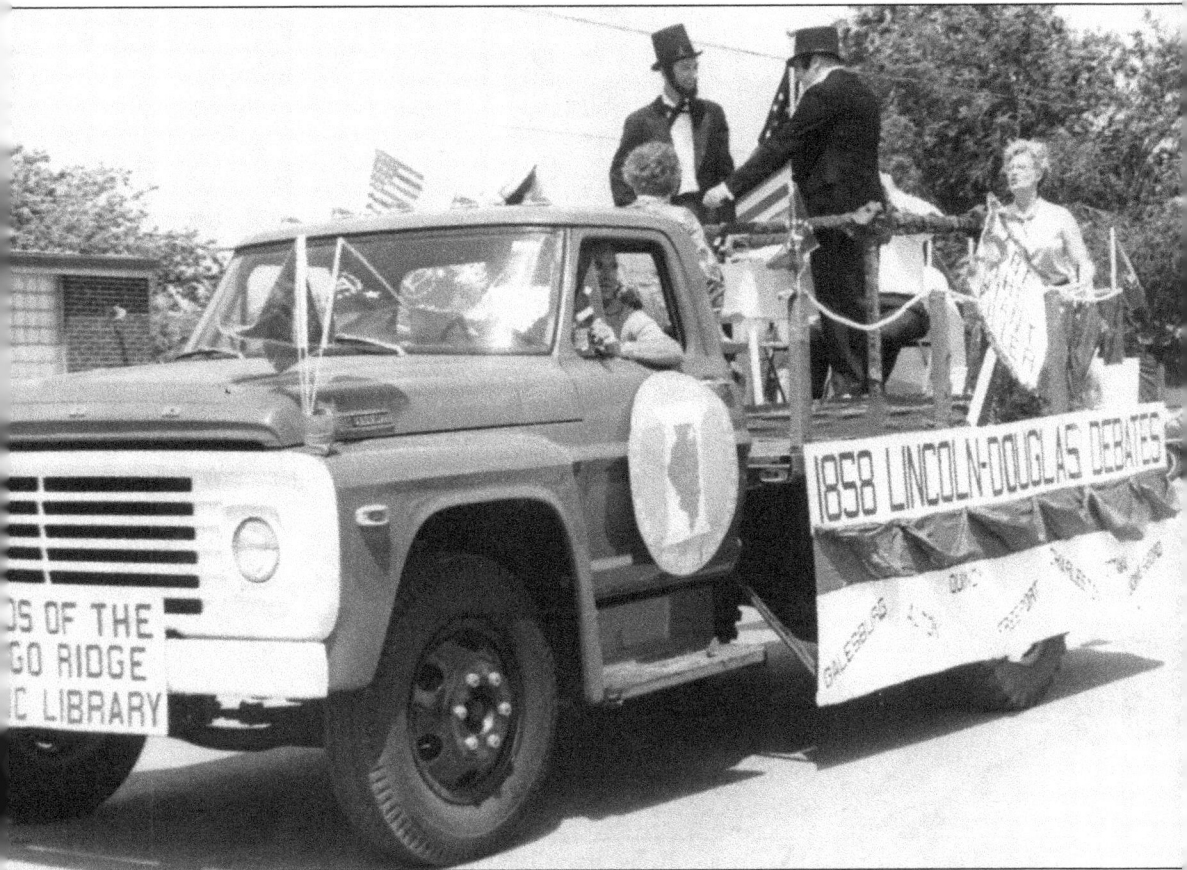

The Friends of the Chicago Ridge Library's float in the 1968 Ridge Days Parade is pictured here. Recreating the Lincoln–Douglas debates of 1858 are characters in full costume riding on a flatbed truck.

Landis Plastics resided in Chicago Ridge since 1956 and was the largest employer in the area for many years. Seen punching out after another hard day's work is Chicago Ridge resident Paul Reichard. (Courtesy of Leonard Reichard.)

Five

WHERE PEOPLE COUNT

Drive into Chicago Ridge these days on any of several main streets, and there will be a sign welcoming drivers that has the mayor's name, the town clerk's name, the population, and the slogan "Where people Count." Reading this book should give an idea just how much they do. The selfless devotion of families and individuals such as Polchow, Meyer, Klee, Duckwitz, Rutz, Demchuk, Pote, and Siegel, just to name a few, lived this slogan long before it was put on any sign. Their tireless devotion to people, Chicago Ridge people in particular, paved the way through the years for the underlying spirit that this town exhibits every day.

The employees and volunteers of this town who form organizations are second to none and have always gone that extra mile. The fire department was initially made up of volunteers and on 24-hour call. These volunteers often raced at ungodly hours to a resident in distress and put their own lives on the line. The police department also bravely protected and served the community without reservation. Public works sometimes had to fix water mains in the middle of the night during the dead of winter. Youth Service Commission (Transitions Community Outreach) gave people an alternative where there did not seem to be one. Chicago Ridge Public Library always seems to be at the center of good things for this town, as well.

Somewhere along the way, someone decided the community needed these things. They dedicated themselves to these ideas and put in the time and effort to make them a reality. Such accomplishments are never done selfishly because these things are timeless and individuals are not. They were established because someone cared enough for the future to pay the price in their present. These sacrifices have enhanced the quality of life in Chicago Ridge and saved many lives as well. In the space allotted in this book, it was not possible to recognized every group or person deserving of accolades, but this chapter is a reminder of some of them that undoubtedly made people count.

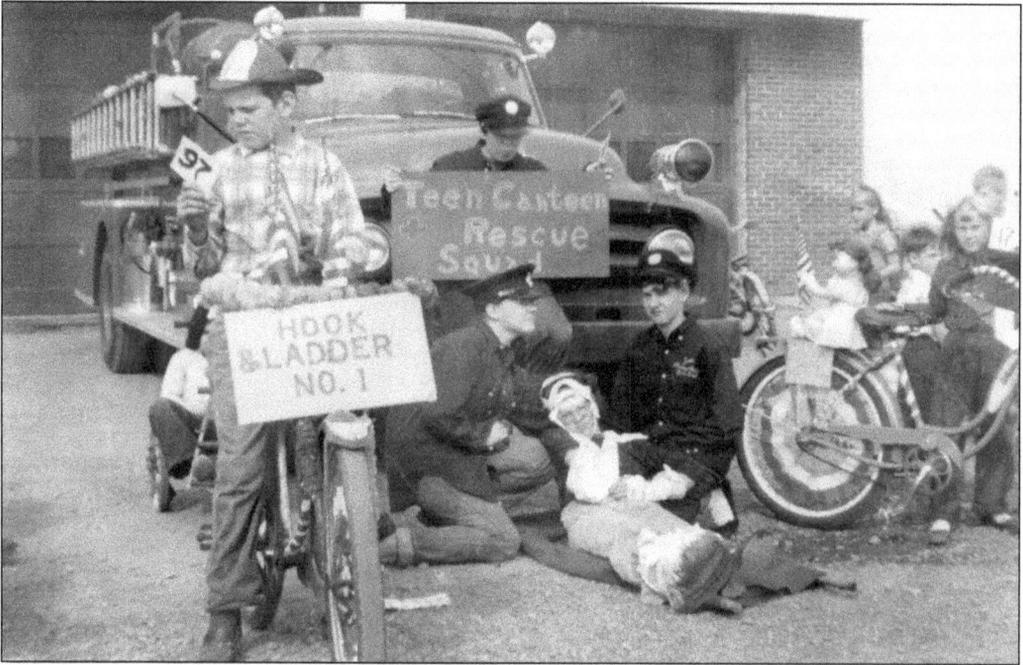

Public safety has always been a priority in Chicago Ridge, as evidenced by the drills practiced with the Teen Canteen Rescue Squad and the Chicago Ridge Fire Department at Firehouse No. 1 on 107th Street and Lombard Avenue. Children would label their bicycles as different rescue vehicles to simulate being fire department personnel. First-aid drills were also conducted, as can be seen by the heavily bandaged youth flanked by two young men dressed as firemen. Shown below is the civil defense building, which was utilized after World War II to alert the community in the event of an emergency.

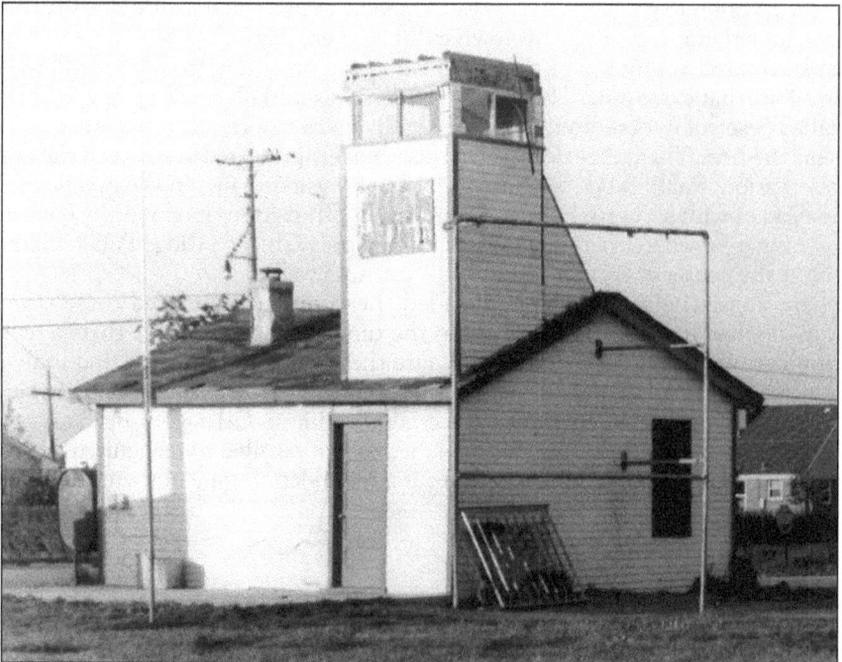

Prior to the establishment of a police department, village trustees served as constables, enforcing code and policing the streets of Chicago Ridge. At right is a photograph of the Village Trustee Badge given to Albert "Bud" M. Aldrich in the 1940s. (Courtesy of Bill Aldrich.)

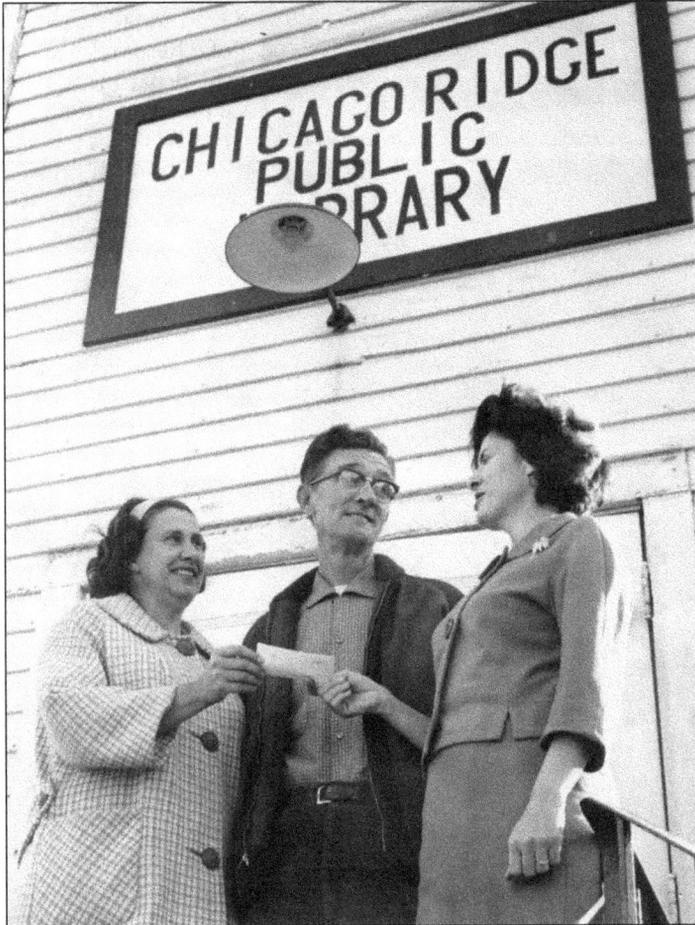

Here is the front of the Chicago Ridge Public Library at 105th Street and Oxford Avenue, formerly the site of the United Presbyterian Church. The church was built in 1927 and later sold to the village in the 1960s. Standing are, from left to right, library employee Elaine Zarnecki and library trustees Don Livesey Sr. and Audrey Clinton.

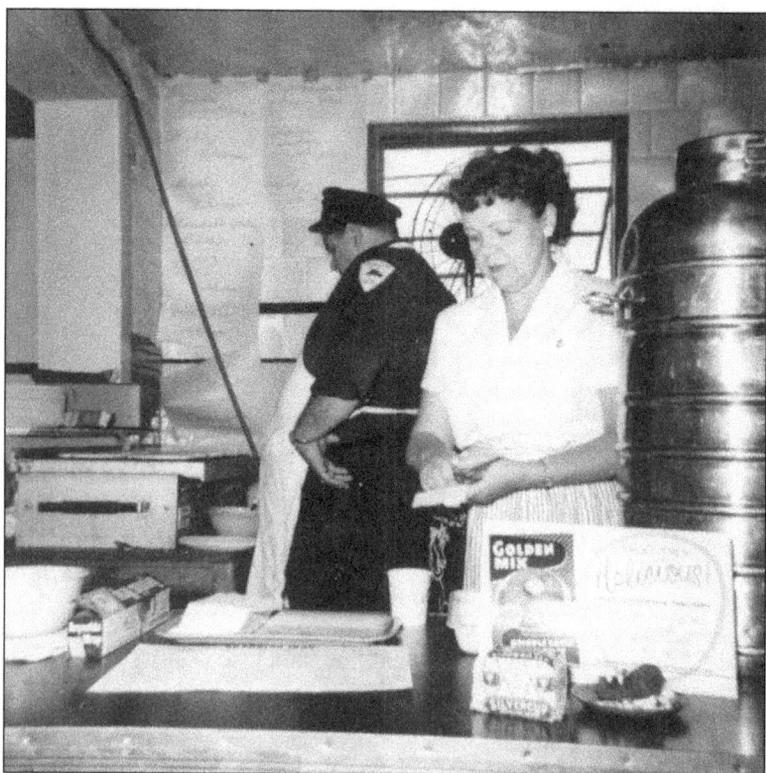

One can almost smell the pancakes and sausage cooking in this 1959 Chicago Ridge Fire Department Pancake Festival. Run by the ladies auxiliary, the men helped with the cooking as they raised money to purchase needed firefighting equipment. At this time, the department was made up of all volunteers who had to buy some of their own necessities. Below is an aerial view of Chicago Ridge's fire department equipment in the 1960s.

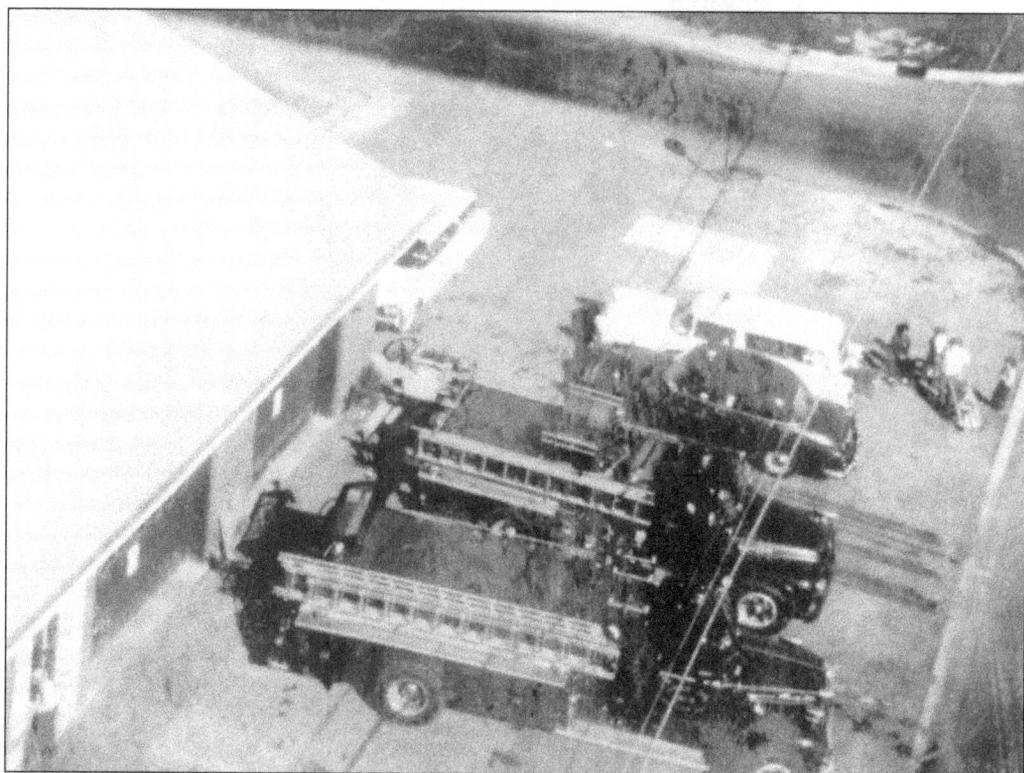

A rescue squad is on the tarmac of Firehouse No. 1. Mayor Herbert Polchow was instrumental in creating the first village fire department, and according to his son Gary Polchow, the first village fire truck was said to be created by welding together parts on an old Coca-Cola truck. Mayor Herbert Polchow also began the first organized police department. Prior to this, a police captain patrolled village streets.

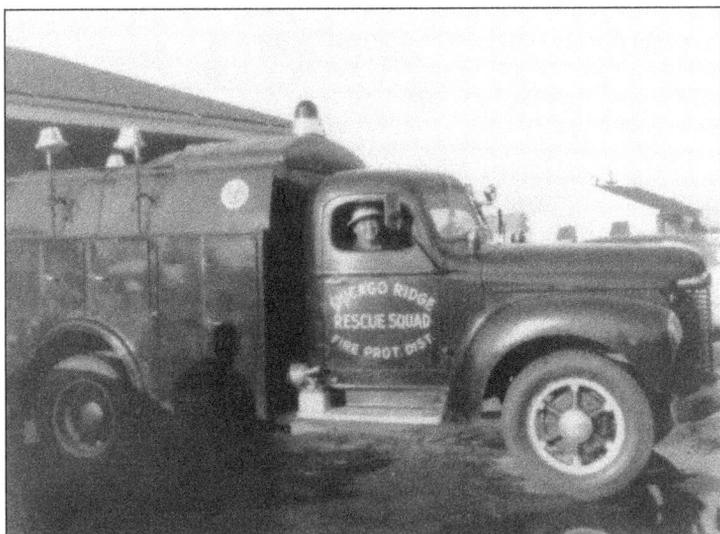

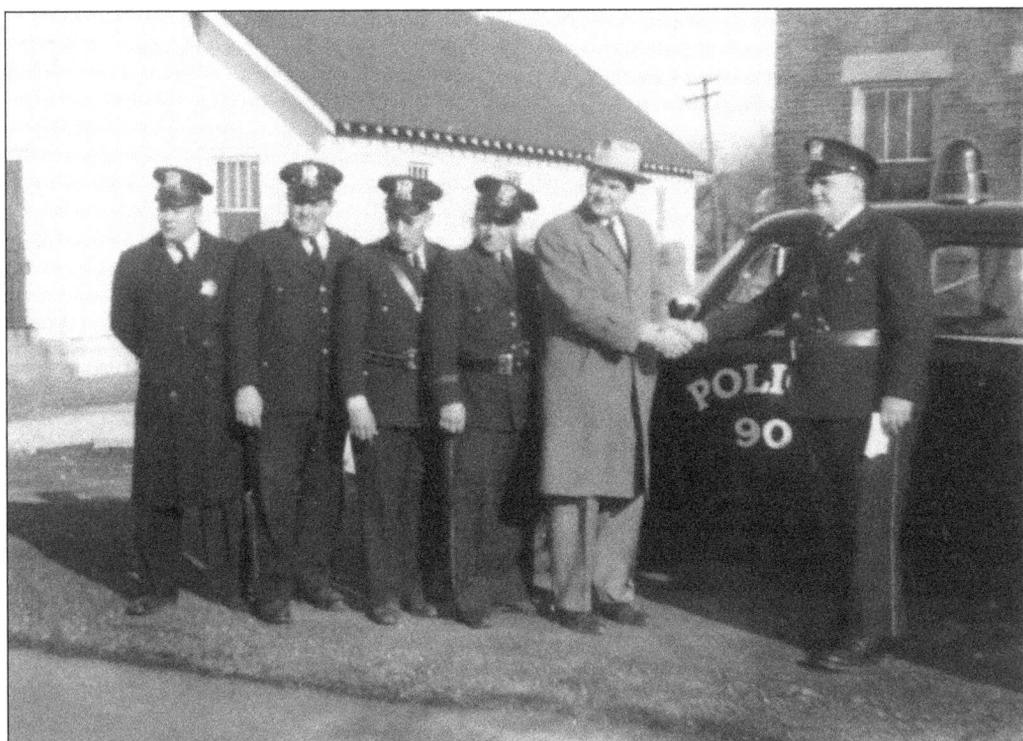

In an undated photograph, village president John Dokter congratulates the Chicago Ridge police force as they stand in front of a town police car. Behind them are, on the right, the police station and, on the left, United Presbyterian Church. (Courtesy of the Dokter family.)

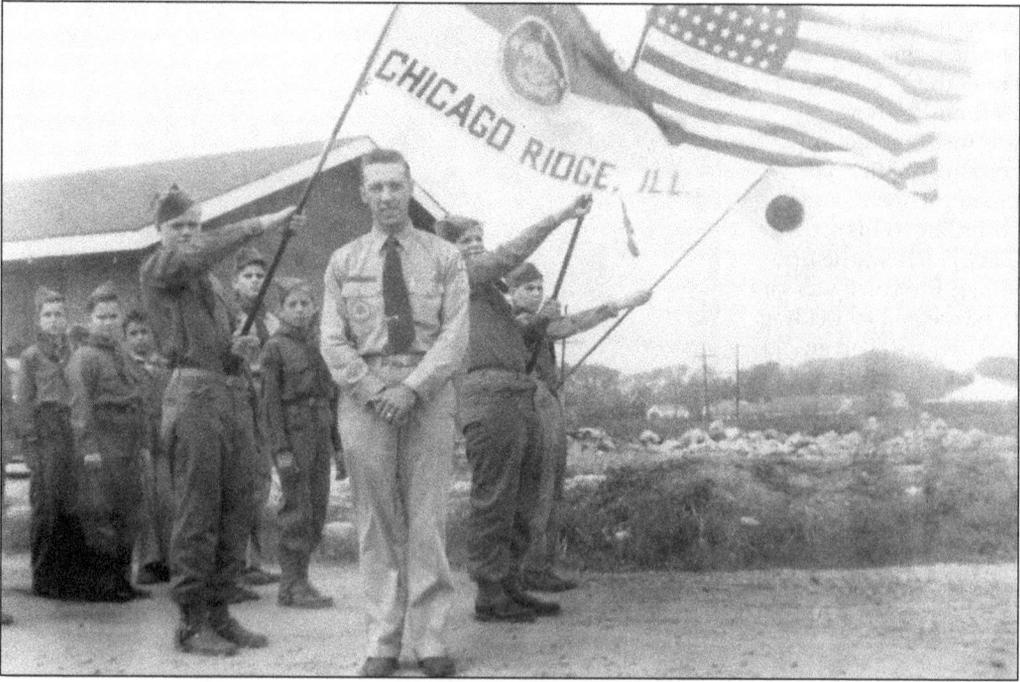

In 1954, the Boy Scouts march in the town's Fire Prevention Week Parade while proudly displaying the colors led by Don Livesey. Scouts would earn various merit badges after these events by training with Chicago Ridge firemen at the firehouse on site. Boy Scouts were active in the community in various functions, even school dedications, as seen above during the pledge of allegiance at the dedication of Henry Ford II School, later known as Ridge Central School.

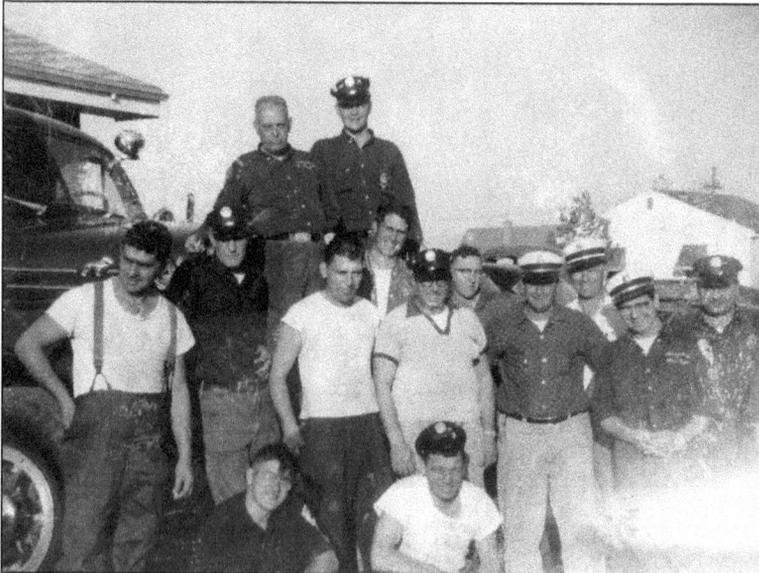

After a hard day's work, these volunteer firemen take five for a photograph outside Firehouse No. 1. These men along with the ladies auxiliary dedicated themselves to making Chicago Ridge a safe place to raise a family and often put their lives on the line doing so.

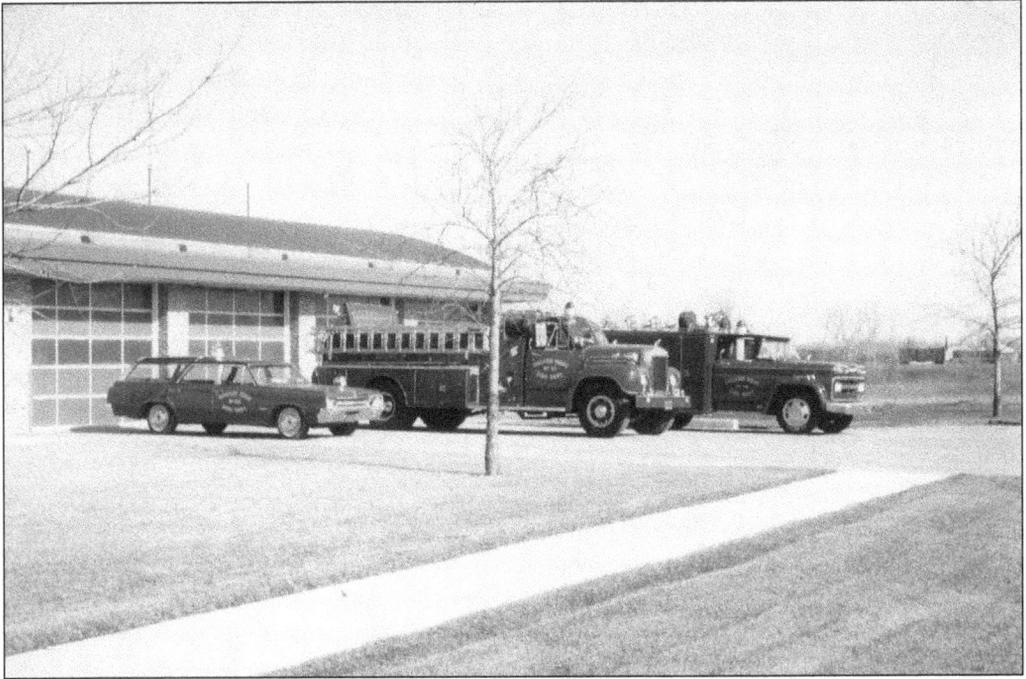

The fleet of the Chicago Ridge Volunteer Fire Department is on display outside Firehouse No. 1 on 107th Street and Lombard Avenue in the 1960s. Firemen would race to this firehouse with their blue MARS lights flashing when a call was received at home on their TEN-TEN radio. Some kept their boots at home and at the ready so they could jump into them quickly and grab their fire coat before hopping on the truck and rushing to the fire.

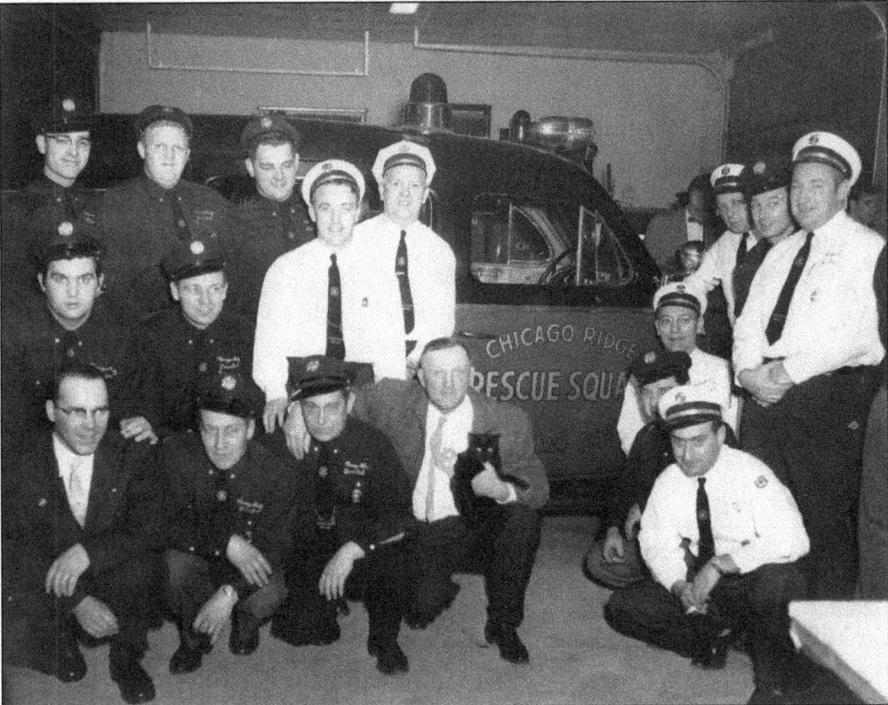

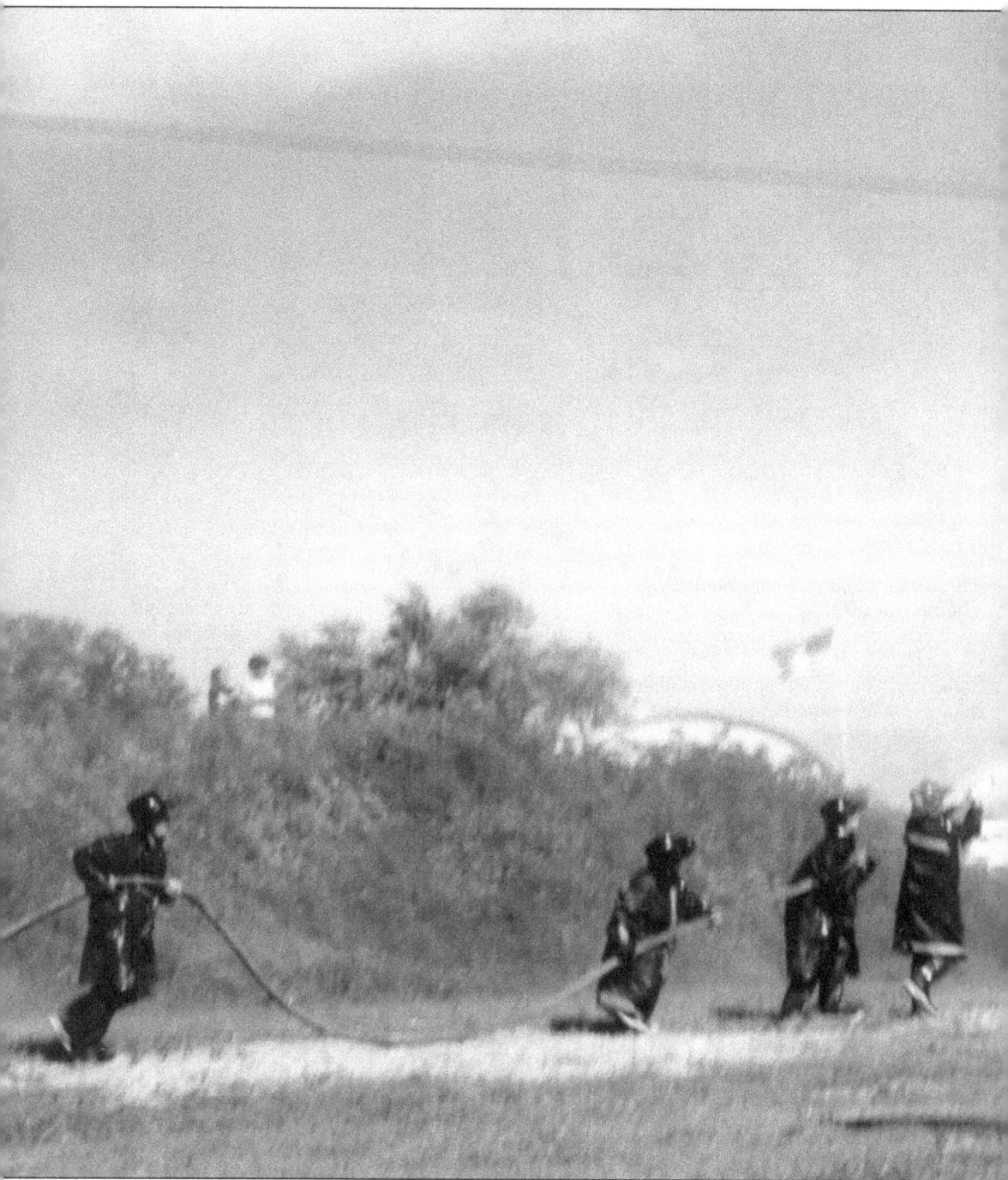

Held on area fairgrounds, this waterball competition between area fire departments required shooting a fully charged fire hose at a large red plastic ball (previously a beer barrel was used) suspended from a grommet threaded by a wire and run between the two teams on top of telephone poles. Striking the ball with the water stream slid it one way or another, and the object was to touch the ball to one's opponent's telephone pole. Chicago Ridge Fire Department, led by nozzle man Jake Cholke, was absolutely dominant. Ed Bergdahl, Ron Klingensmith, and Ed Maurer Sr.

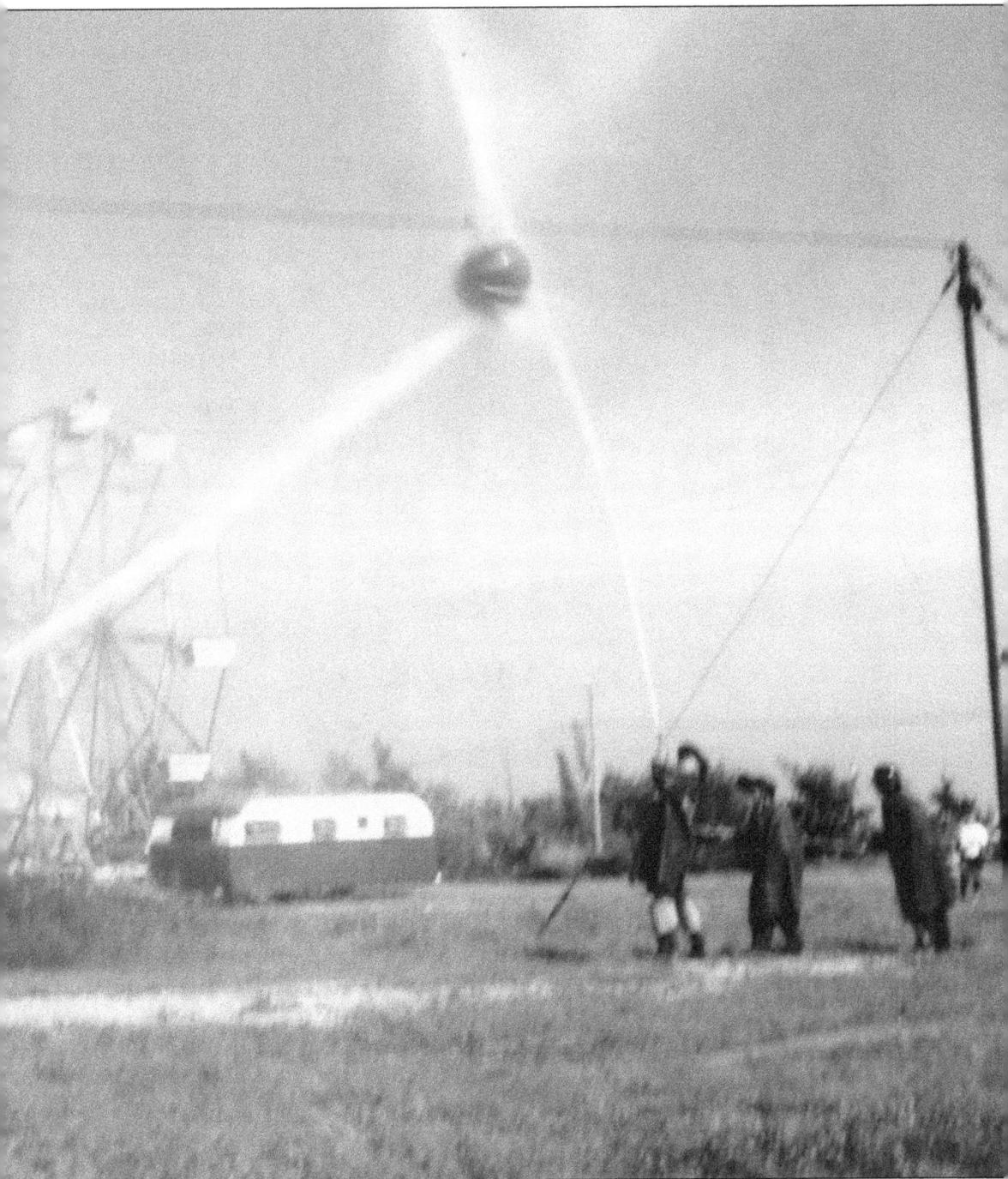

were some of the men on those winning teams. This department was victorious many times over, and the traveling waterball trophy called Chicago Ridge home for many years. In this picture, the firemen's wives go at it, donning the men's helmets backwards because they were too big. Third from the nozzle on the team on the left is the author's mother, Elaine Maurer. (Courtesy of the Maurer family.)

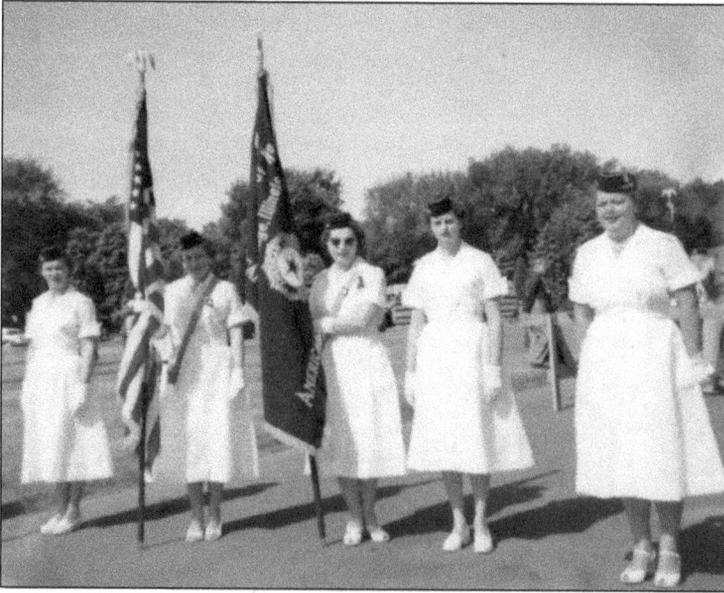

Glenn Maker American Legion Post No. 1160's Women's Auxiliary was started in 1953, and Virginia Bizzotto was its first president. Pictured on the far right is Bizzotto with her companions representing the auxiliary and the post's colors in the 1966 Ridge Days Parade. Also pictured are, from left to right, Alice Wollens, Dorothy Doyle, Anita Stecker, and Doris Rudolph. All had served as auxiliary president.

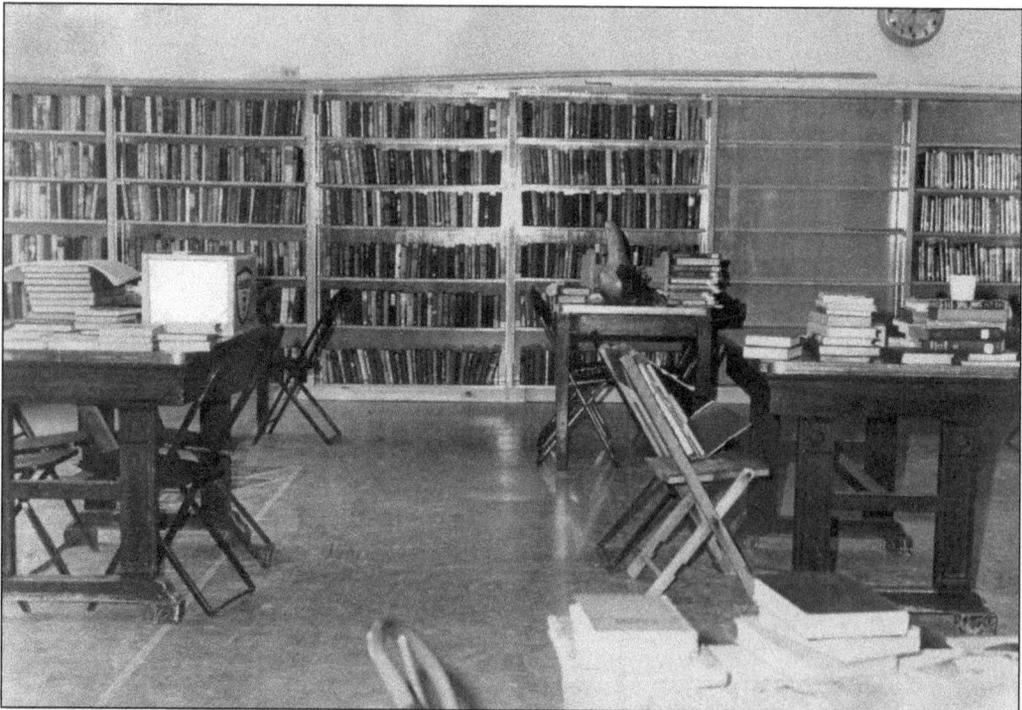

The library commission decided that the library would be placed in the old Presbyterian church at 105th Street and Oxford Avenue. Despite being ready to go, the old church building was never used by the public because of a structural weakness in the steeple. This picture shows the interior of the church lined with library books. The library opened in May 1966 at the Chicago Ridge Village Hall at 10655 Oak Avenue. Volunteers ran the library until December 1966, when a referendum was passed, and library trustees were elected.

Anne Pote, the first administrative librarian of the Chicago Ridge Public Library, from 1964 to 1981, is standing in front of the Chicago Ridge Village Hall and the library's book drop at 10655 South Oak Avenue. The library was located in the north part of the building from 1966 to 1979. Anne is responsible more than anyone else for compiling Chicago Ridge history and making it available to future generations.

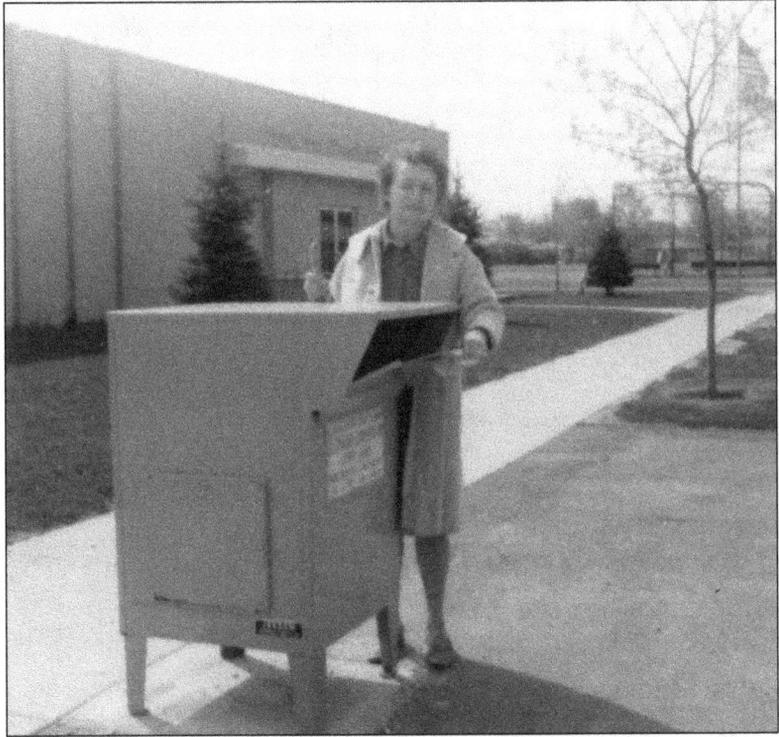

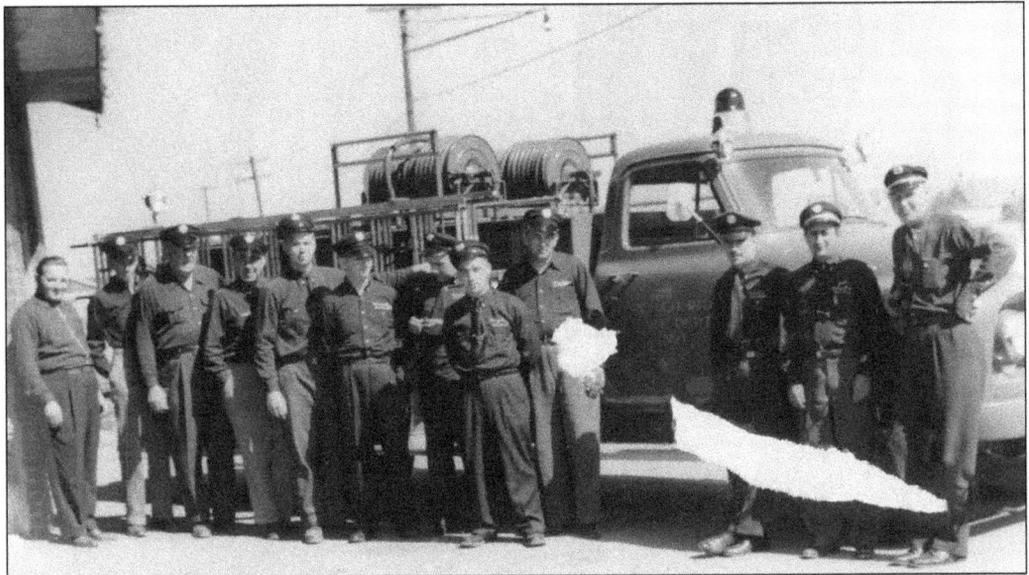

The Chicago Ridge Volunteer Fire Department poses proudly in front of its equipment in 1962. These men rushed from their homes when summoned by alarm to all kinds of emergencies. They endured difficult conditions in these duties and did so willingly for little or no pay. Because Chicago Ridge was such a small town with a limited budget, the men and ladies auxiliaries needed to have fundraisers to provide for some of their equipment.

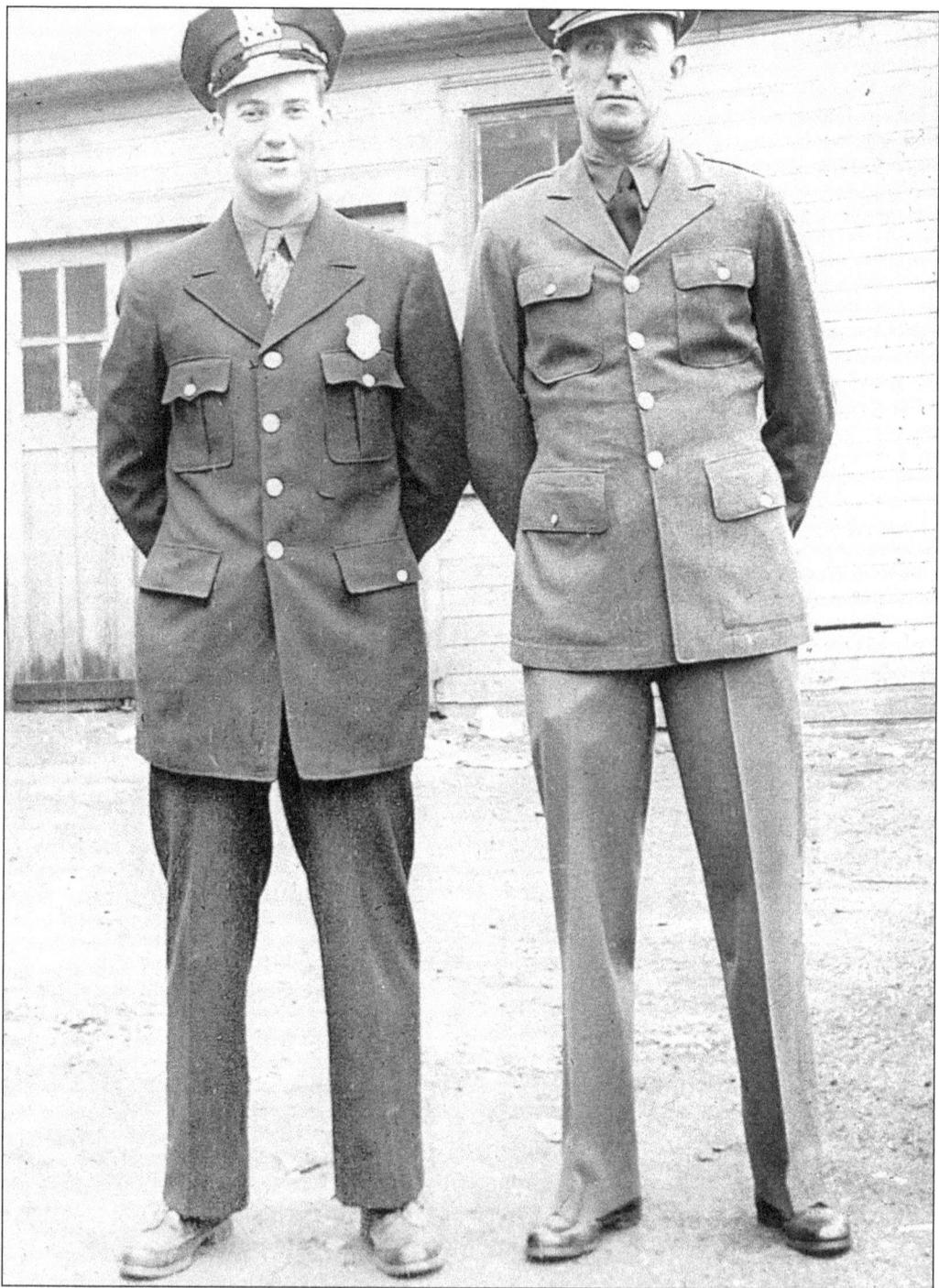

Pictured is past village president Herbert Polchow in the early 1950s wearing his Chicago Ridge Police uniform. Standing next to him is an unidentified railroad security employee. Polchow was instrumental in creating the town police force according to son Gary Polchow. (Courtesy of Gary Polchow and Herbert Polchow Jr.)

Girl Scouts march during a 1970s Ridge Days Parade on Ridgeland Avenue near 107th Street. In the background are Jack and Pat's Old Fashioned Butcher Shop, Coast-to-Coast Hardware, Carmen's Pharmacy, and Glenn Maker American Legion Post No. 1160. The first Chicago Ridge Brownie troop was started by Frieda Polchow Rutz in 1949. From there, the Girl Scouts blossomed into a popular activity for girls of all ages. (Courtesy of Carolyn Bates Horacek.)

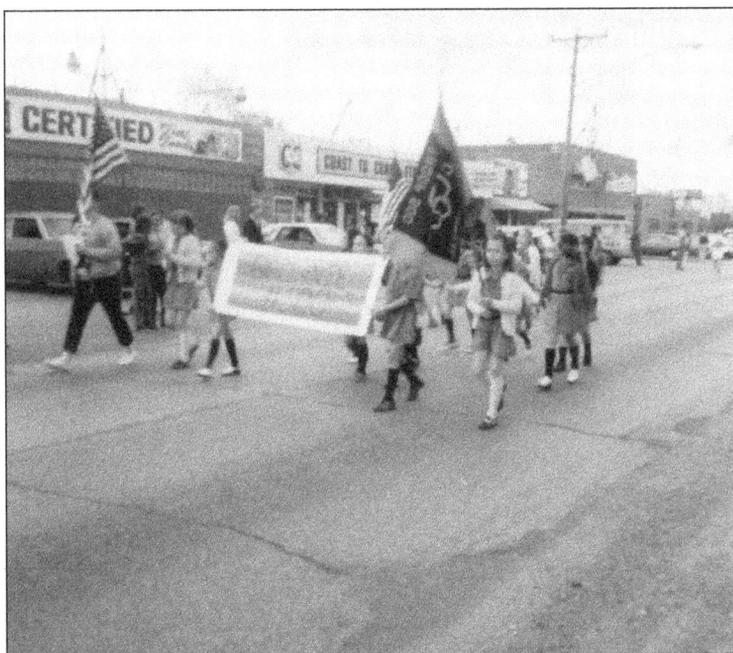

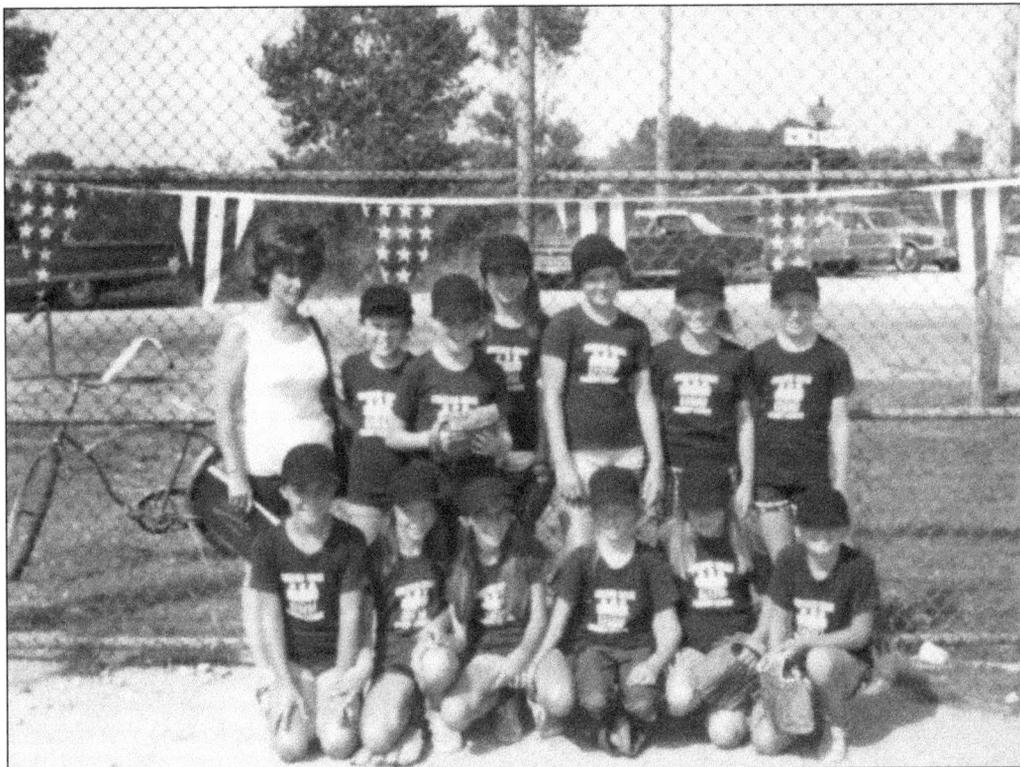

A girls' baseball team poses for a team picture at the ball fields of 107th Street and Menard Avenue in the 1970s. The Chicago Ridge Park District maintained the town's many parks and fields from its inception. The Chicago Ridge Parks and Recreation Board was created by referendum in 1963 and grew into the present-day Chicago Ridge Park District. (Courtesy of Carolyn Bates Horacek.)

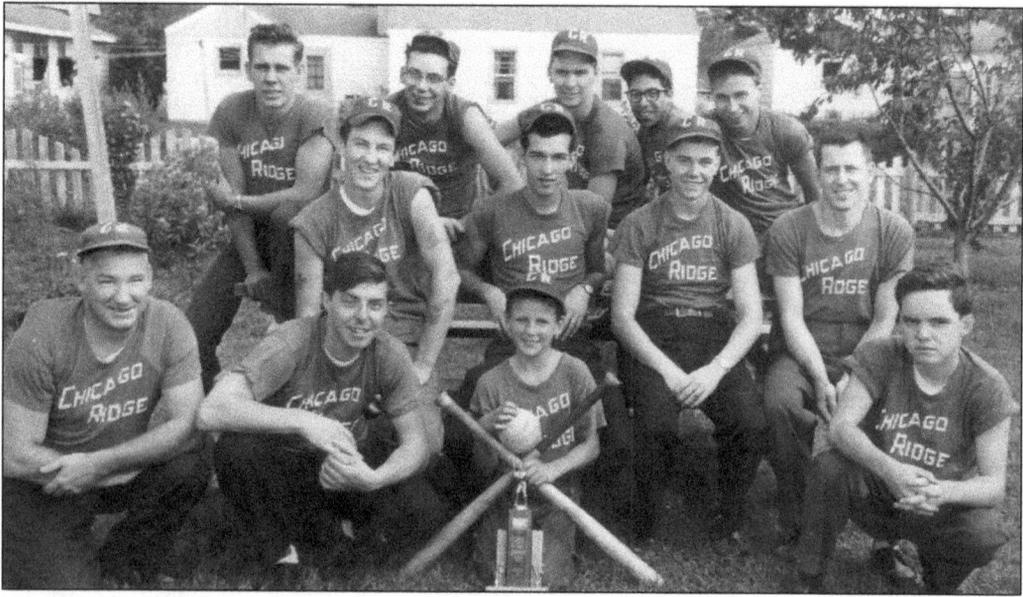

Baseball and softball have been woven into Chicago Ridge's fabric since fielding a fully uniformed team in the 1940s. Here is a 1950s town softball team that has won a tournament. Sixteen-inch softball has always been a passion here, and there have been many great players, like Tim McManigal, Darrell Hofer, the Lyons brothers, Eddie Daniels, Bob Kelly, and "Crazy" Dale Kwiatkowski just to name a few. (Courtesy of Larry Coglianese.)

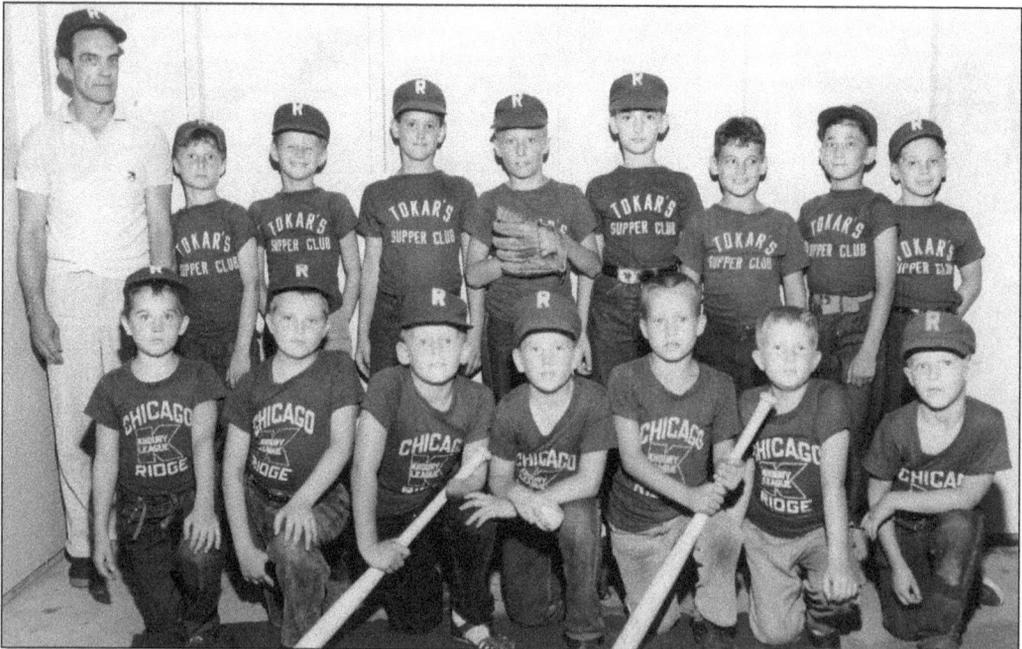

A typical sandlot baseball team pictured here could be found on every corner of the village on a summer weekend. Different sponsors were seen on every team's back. "Hey batter, batter" could be heard on every pitch and on every diamond. Concession stands selling pop and hot dogs were usually mobbed by the teams and their fans after every game. Pictured on this team is current Chicago Ridge village president Charles E. Tokar. (Courtesy of Charles E. Tokar.)

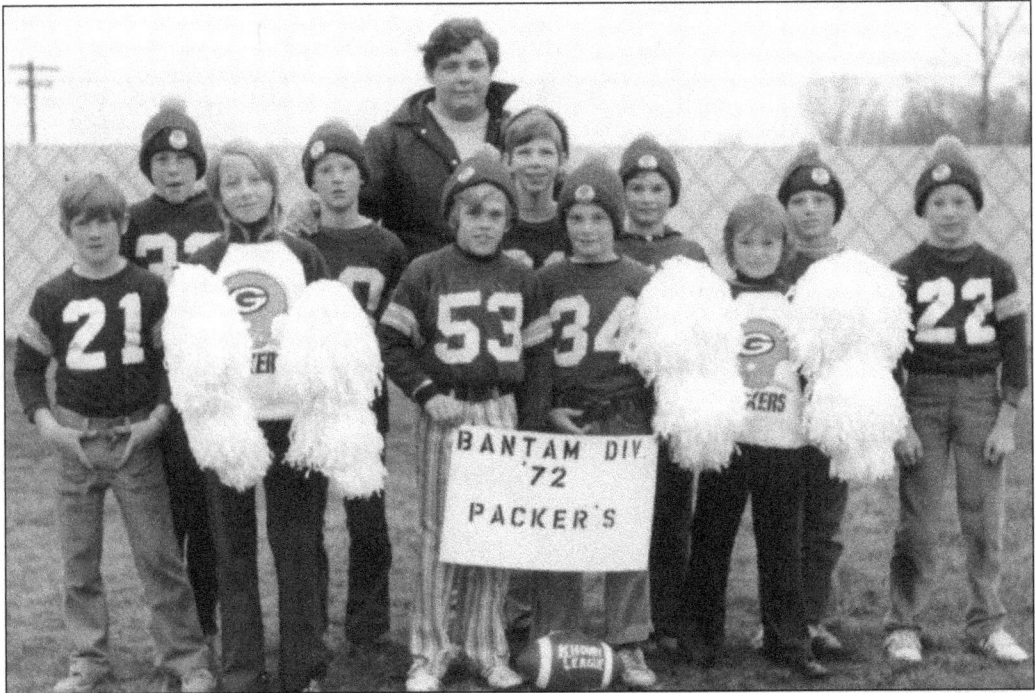

The Khoury League formed in Chicago Ridge in 1958 and chose Bob Scanlan as its first president. This league instituted sports programs for area youth, including baseball and, as seen here, flag football. Players wore a flag tucked under their belt and were considered tackled when an opponent pulled the flag from him. Players were given a team jersey and hat with their registration. Cheerleaders were optional but welcomed. (Courtesy of Carolyn Bates Horacek.)

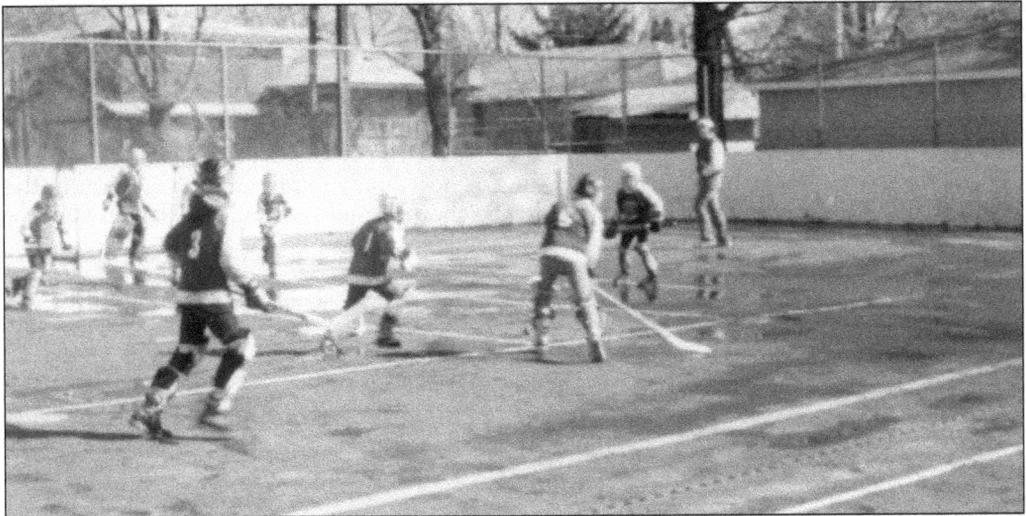

Boys' field hockey was a unique activity born out of the Glenn Maker American Legion Post No. 1160. Members Ray Pyznarski, Bill Stockdale, and others created a huge hockey following in the area. Played running on asphalt instead of ice and using plastic stick blades, this league became popular quickly. This picture shows the rink at 107th Street and Lombard Avenue, but initially, the rink was in the legion's parking lot. The Pyznarski family still runs the league today. (Courtesy of the Maurer family.)

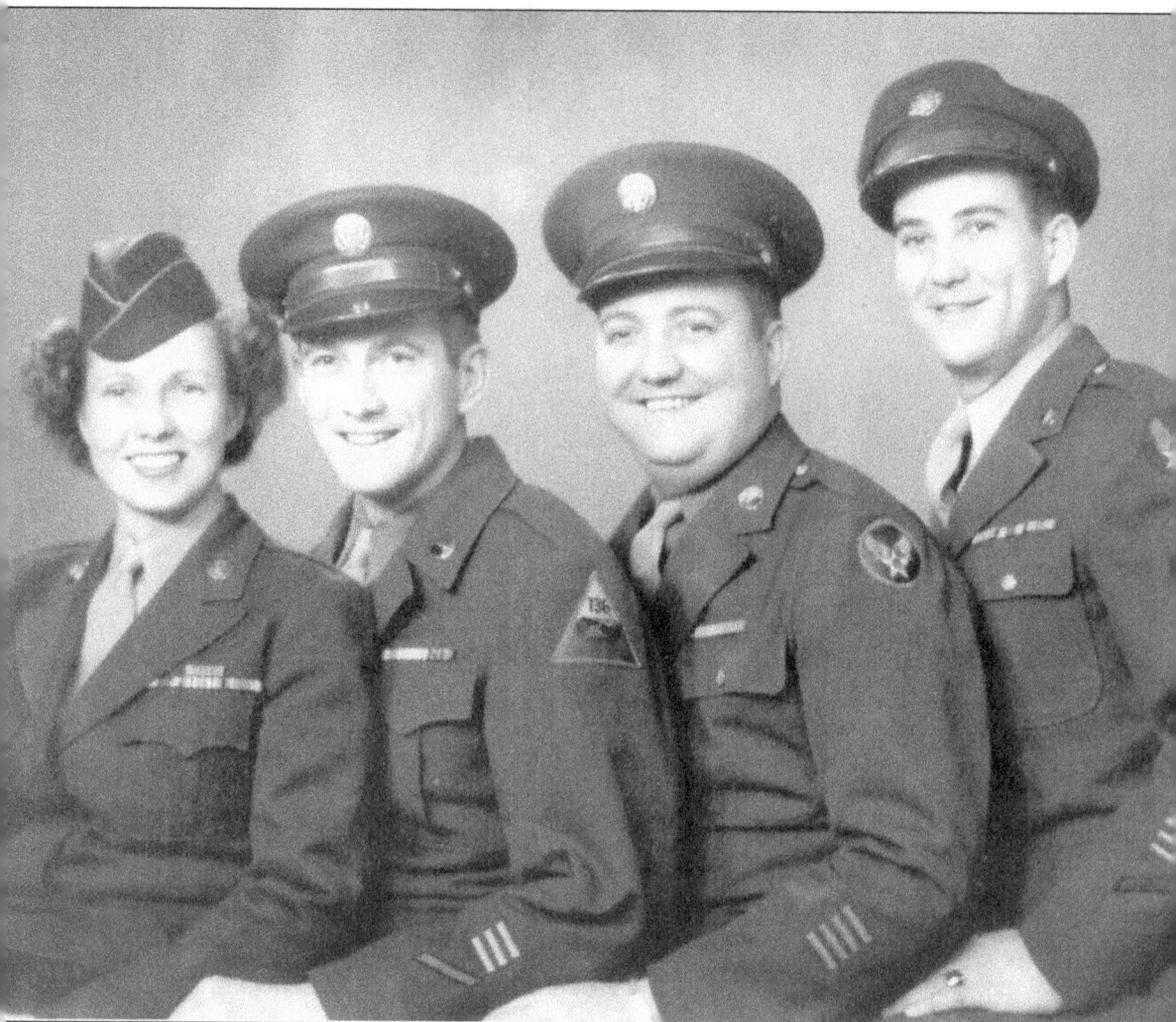

Pictured in this photograph are members of the Polchow family in full military uniform in the 1940s. From left to right are Ethyl Polchow, Walter Polchow, Arthur Polchow, and Herbert Polchow Sr. (Courtesy of Gary Polchow and Herbert Polchow Jr.)

In 1975, Mayor Eugene Siegel, pictured at right, helped begin the Youth Service Commission, which became the Chicago Ridge Youth Service Bureau. Hank Zwirkoski, pictured left, was its director. This organization served the community by meeting the needs of young people, parents, and families through counseling and was seen as a positive investment. Due to budget constraints, the Youth Service Bureau was discontinued in 2009. The organization has regrouped as a nonprofit and is called Transitions Community Outreach. Pictured below are area youths participating in Youth Service Bureau programs. From left to right are Sandy Davis, Becky Maurer, unidentified, and Bev Mikoff. (Courtesy of Transitions Community Outreach.)

Pictured are two area youths participating in Youth Service Bureau activities. From left to right are Cheryl Maurer, unidentified, and Susan Mikoff. Below, the Chicago Ridge Police Headquarters is pictured as it stood in 1992 on Oxford Avenue. The police department shared the building with the public works department, which was attached to the left of the building. Both organizations modernized and moved into new quarters in the 21st century. This 1992 site was the location of the United Presbyterian Church, Chicago Ridge's first church, and the Victory Garden in years past. (Above, courtesy of Transitions Community Outreach.)

Six

MOVING FORWARD

One thing Chicago Ridge can boast is that just like the railroad running through its heart, the village is constantly moving forward. It is forcefully pushing ahead with plenty of power behind it. Once this town got going, it has been very hard to stop. The village founders fed Chicago Ridge with coal, cranked it up, and sent it toward the future where people all along the way provided the energy needed to keep it driving and staying on track. Some people included are Mayor Emeritus Eugene Siegel and current mayor Charles E. Tokar.

Mayor Emeritus Siegel's administration was largely responsible for bringing this town into the modern era. Siegel is, at this writing, the longest-serving mayor of this town, serving nearly four decades. His administration's accomplishments have left an indelible mark that this town will never erase. It is indisputable that Chicago Ridge took a giant leap forward under his leadership. Sewers, curbs, streetlights, bridge safety, and a youth service commission were all created and services were significantly upgraded. Police, fire, and public works were modernized and brought into the 21st century. A major shopping mall was built, and much to their delight, it helped bring tax rebates to many homeowners. This chapter could almost be named after the Mayor Emeritus because his administration spanned such a long time, but Chicago Ridge has always been about the team game, and Siegel will be the first to support that idea.

Like Mayor Charles Polchow, the first mayor who deserves a lion's share of the credit for the village's incorporation, their success lies in the ability to lead people into the future and make things better. In an interview for this book, Mayor Tokar said, "Like many who grew up here, I spent much time at the Studio theater, the Community store, and the Starlite Drive-in, with its go-cart track. But, I am glad that in their place stands Chicago Ridge Mall, which has transformed our village from a small bedroom community into a dynamic and progressive municipality."

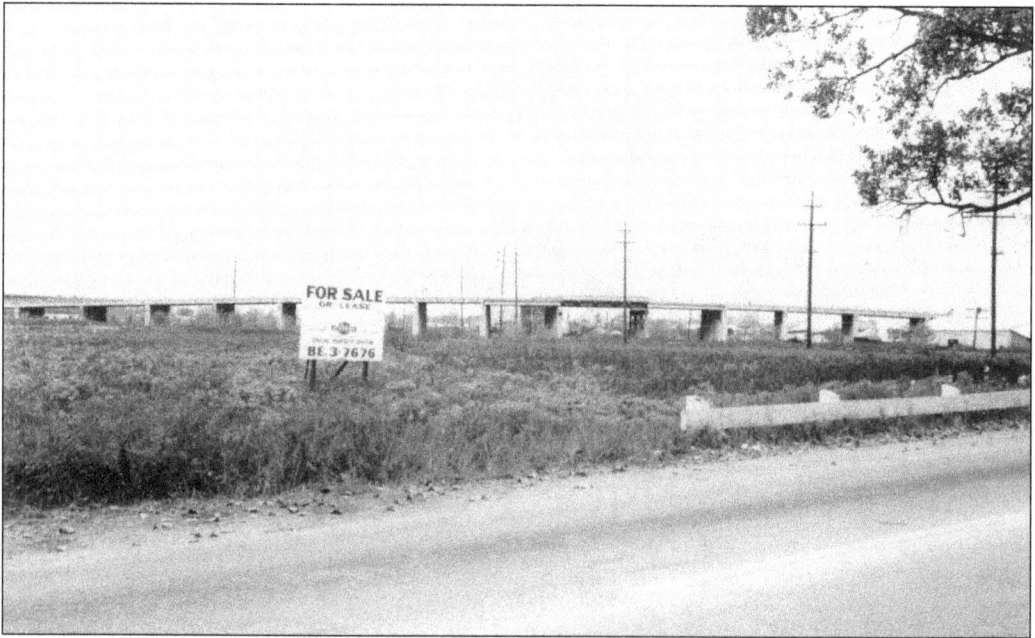

As the 1960s winded down, Chicago Ridge grew restless. The village contemplated staying in the past or moving forward toward the future. This 1964 photograph was taken from 102nd Street and Ridgeland Avenue, looking toward the Southwest Highway Bridge. The bridge was important for many reasons and provided a detour around heavy train traffic. Note the unobstructed view all the way to the bridge.

From on top of the Southwest Highway Bridge, one sees the site of North American Car Corporation, formerly Mather Stock Car Company, the major railcar manufacturer in the mid-1960s. In the forefront runs Stony Creek, the lifeline for the early settlers. North American Car Corporation would vacate this location in 1978.

Jack and Pat's Old Fashioned Butcher Shop has been a must stop in Chicago Ridge. Formerly Lil and Joe's, the store attracted people from great distances just to get Jack and Pat's. Brothers Jack and Pat Powers and family have operated at this location for decades. In addition to providing their delicacies to shoppers, they have also been heavily involved in the community. The present-day owners are Jack's oldest son, John Powers, and his wife, Karen. Below, one can see the Powers Drive-in situated on Jack and Pat's lot. It was named both Jack and Pat's 50's Drive-in and Snowflake Drive-in, but no matter what the name, the drive-in was known for its ice cream. (Courtesy of Kevin Zickterman.)

PUT YOUR HEART IN
CHICAGO RIDGE

POLITICS-ELECTIONS-1975

CHICAGO RIDGE
INDUSTRIAL PARK

ELECT THE
CONCERNED CITIZENS PARTY

VOTE APRIL 1 1975

In 1975, Eugene Siegel ran for an unexpired term as the town's mayor after Mayor Coglianese stepped down unexpectedly. In a crowded field, Siegel and his Concerned Citizens Party won by a huge margin. This started Siegel and his running mate Charles E. Tokar on an unprecedented run of political victories in Chicago Ridge.

Here, Mayor Eugene Siegel buries the town's bicentennial time capsule next to the flagpole at 107th Street and Oak Avenue. Interesting items in the capsule are menus from local restaurants, a vehicle license of Chicago Ridge, dog tags, a library reading club list, pictures of school students, history of Our Lady of the Ridge, a police department badge, a flag of Chicago Ridge, bicentennial postage stamps, coins, a bicentennial carpet, and the July 1, 1976, edition of the *Chicago Ridge Citizen* newspaper.

From the town's inception, flooding was a chronic problem for Chicago Ridge, as seen here in this picture of Moody Avenue after a rainstorm. Every administration from Mayor Polchow up to Mayor Siegel battled this affliction. Storm sewers were finally installed in the 1980s, which remedied the problem significantly, much to the delight of the residents. (Courtesy of Saunoris family.)

In addition to storm sewers, curbs were installed throughout the village in the late 1980s and early 1990s by the Siegel administration. This made the roadways much more durable and channeled water runoff to the sewers for removal. (Courtesy of Leonard Reichard.)

Senior citizens and the disabled rejoiced when Chicago Ridge purchased transportation for their use. This vehicle is available to help citizens conduct their errands, such as shopping, doctor's appointments, and even attending Sunday church. Pictured are Mayor Siegel and some grateful constituents in front of the town bus.

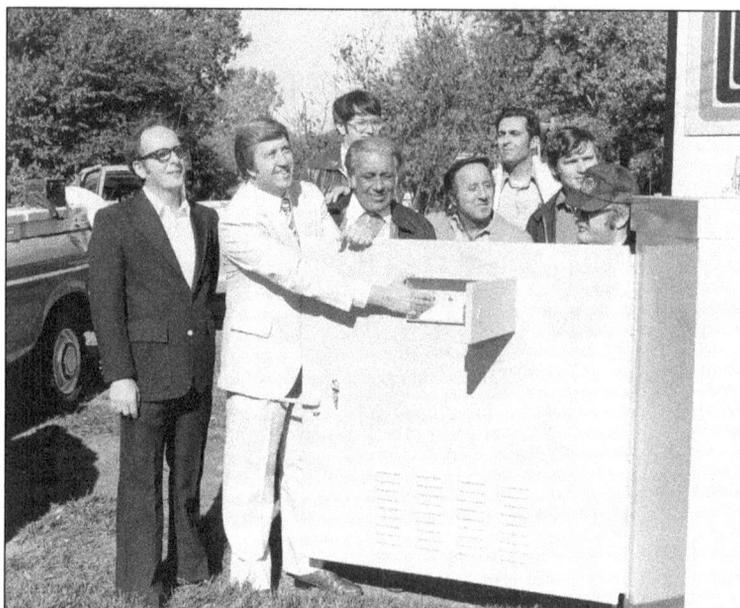

Mayor Siegel flips the switch after the town's street lighting was dramatically upgraded throughout the village. Constant outages were problematic, but from this day forward, the Chicago Ridge streets were brighter and safer.

Chicago Ridge needed a financial shot in the arm and got one when the Siegel administration landed the Chicago Ridge Mall for its Ninety-fifth Street and Ridgeland Avenue location. Along with a sales tax, this revenue allowed village homeowners to enjoy 13 consecutive years of property tax rebates. In this picture, Mayor Siegel is announcing the Chicago Ridge Mall agreement in Chicago with a mall prototype in front of him.

The Eugene L. Siegel Municipal Complex was built in 2000. Housing the village hall and the police department, this modern facility is state of the art. The Chicago Ridge history room is located in the lower level of this building and is open to the public by appointment through the Chicago Ridge Public Library. Pictured here, Mayor Siegel and various dignitaries break ground for the Siegel Complex.

Moving the public works department into the future, the village soon built a new home for it at 10046 Anderson Avenue. Seen here are various dignitaries, including Mayor Siegel, Mayor Charles E. Tokar, and public works superintendent Pete Chiappetti, breaking ground for the facility.

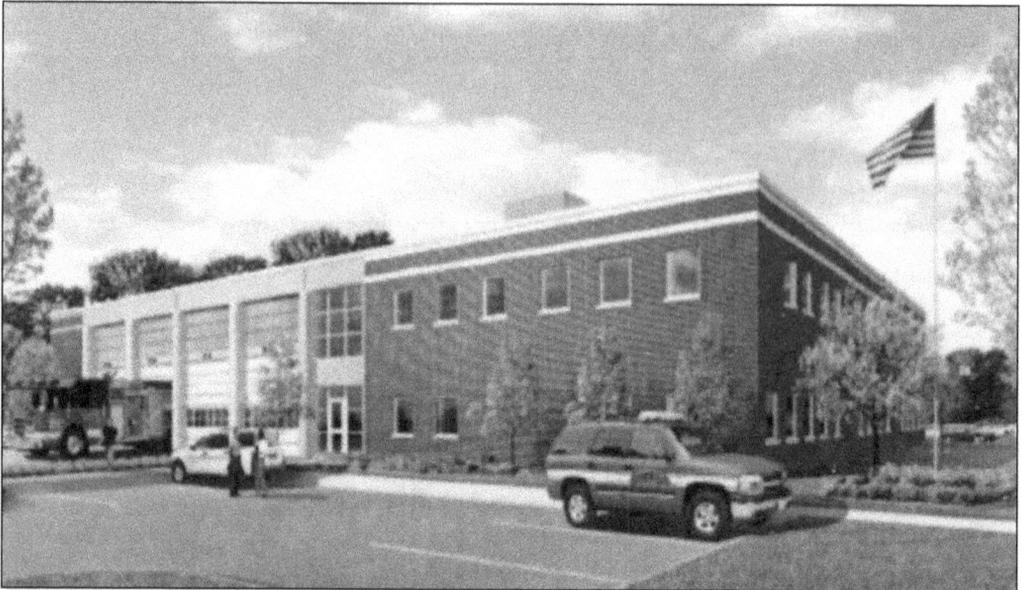

Chicago Ridge has always been at the forefront when it comes to its firefighters. It has always taken great pride in its force and has strived to provide frontline equipment over the years. In the early 2000s, the village had a modern fire station constructed to replace the crowded quarters at Firehouse No. 2 on Southwest Highway. Firehouse No. 2 was torn down and replaced with this new more efficient building.

Seven

SURPRISING FACTS

Many times in the course of constructing this book, the authors said, "Wow, I didn't know that!" This book has probably just scratched the surface of what's happened in this town, but if one stays in a place long enough, one would expect to at least get a whisper of most of the interesting things going on. That is the cool thing about Chicago Ridge, there seems to always be another fascinating fact right around the corner. If there had been no deadline for publishing this book, it's likely that more would have rolled in, and this book would have a few extra chapters.

This chapter is supposed to make jaws drop a bit, like the authors' did—"I didn't know that!" Even just a little "Wow!" will suffice. Like every town, Chicago Ridge has its quirks and idiosyncrasies, claims to fame, things that seem unbelievable, its wild, crazy, and sometimes just a little off-center qualities. The appetizer, soup, and main course have been served; now get ready for the dessert.

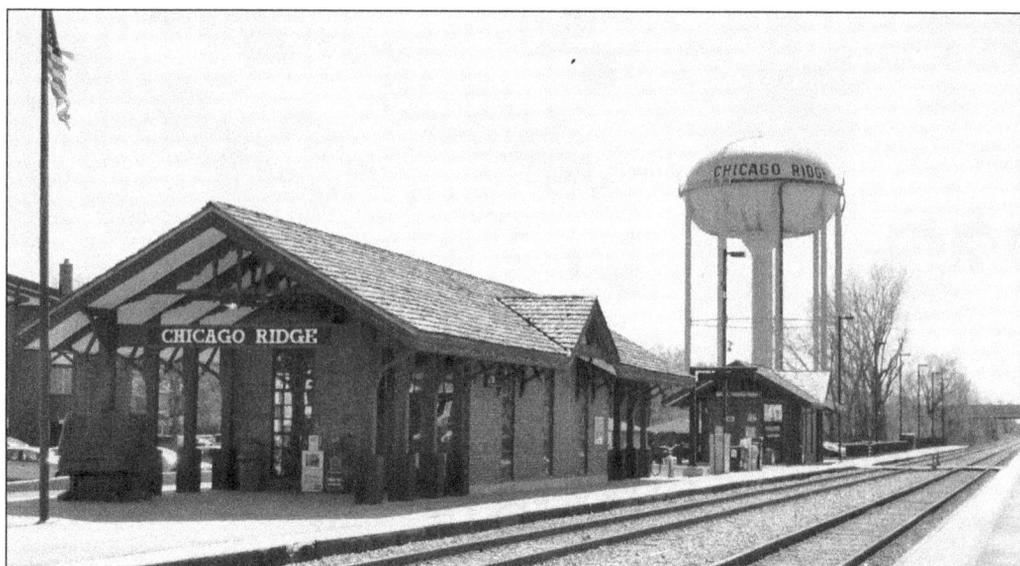

Chicago Ridge's namesake is still visible today; the "ridge," caused by removal of dirt for the World's Columbian Exposition, is widely thought to run from about 106th Street and Moody Avenue, diagonally across Lombard, Oak, Princess, Oxford, and Ridgeland Avenues, through Forest Lane, and then toward the water tower where it meets the railroad tracks. (Courtesy of Stacey Reichard.)

In order to incorporate in 1914, Chicago Ridge needed a minimum amount of residents and land, and both numbers were a bit short. According to a descendant of two village presidents, Gary Polchow, the land around Ridgeland Avenue and 107th Street was donated by the Polchow family and annexed to Chicago Ridge to meet incorporation requirements. This land was directly across from Polchow's Grove. The photograph above, taken in the late 1940s, is of members of the Polchow family. Seated are, from left to right, Gary's father, Herbert Polchow Sr.; his grandmother Luzina; and his grandfather Charles Polchow. Both Charles and Herbert Sr. held the office of village president, and Luzina was head of the chamber of commerce. (Courtesy of Gary and Herbert Polchow Jr.)

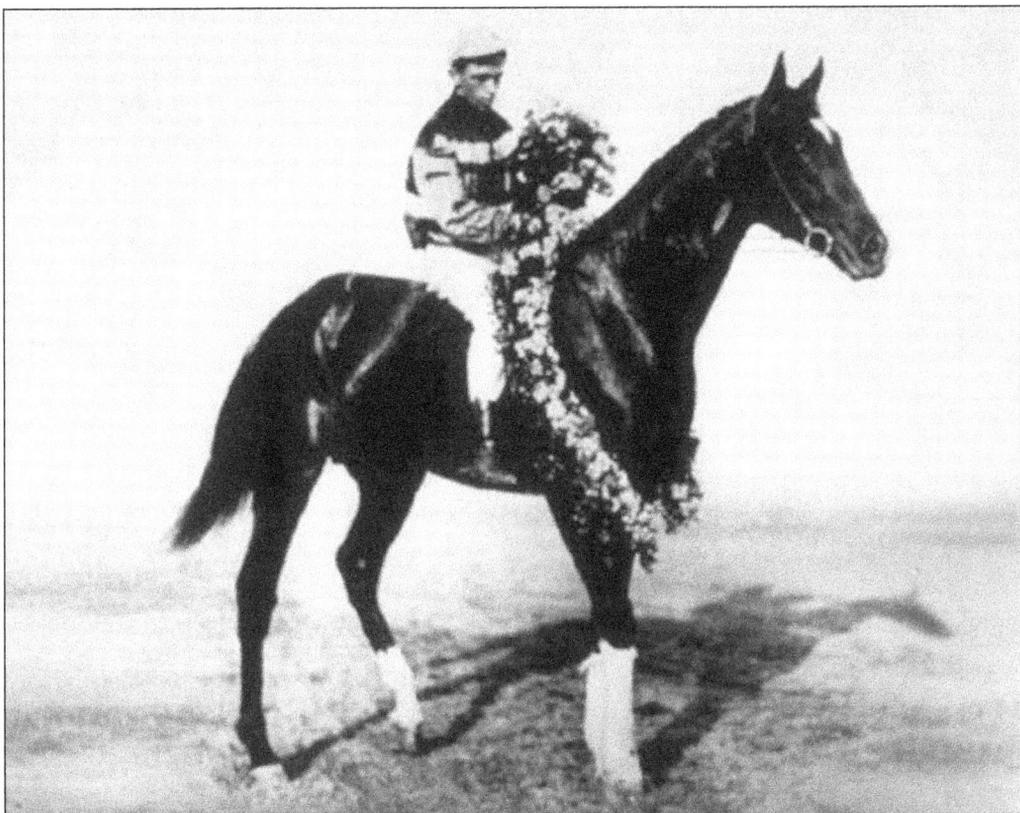

The 1910 Kentucky Derby was a thriller, and Chicago Ridge was there in a big way. Fred Herbert, a Chicago Ridge resident, rode Donau to victory. Herbert raced at the nearby horseracing track at 111th Street and Ridgeland Avenue, where Holy Sepulchre Cemetery is now. Herbert lived in town with his family but raced in major heats all over the world and rode for royalty as well.

Not only did Paul Berger open a slot-machine factory in Chicago Ridge around the turn of the 20th century, but he also named one of his first machines "Chicago Ridge." This machine was very popular and played all over the world. Its resale value is extraordinary, even today, fetching more than $15,000 at one auction. The old Berger factory may still be in use today as it was constantly scavenged for materials after its closing. (Courtesy of Arcade-History.com.)

One fabled Halloween night, young men disassembled a heavy farm wagon and reassembled it on the roof of the one-room village hall at 106th Street and Oxford Avenue for all to see. If that was not enough, some years later, someone did the same thing with an automobile. No one has ever claimed responsibility. Pictured is the second village hall, located at 107th Street and Oak Avenue.

One of the first Chicago Ridge municipal positions voted to be filled by the new village board was that of lamplighter. Fred Thomann was paid $12 annually to light the village's street lamps. Thomann would light the lamps at dusk and extinguish them at dawn. This illustration gives an idea of what was required.

Mickey "Grace" Cooper took her ambrosial cakes to almost everyone in town on their birthdays. There were less than 400 people in town at the time, but still, that is a lot of baking. Grace is pictured here on the left with her husband. (Courtesy of Tammy Cooper Mancini.)

GLENN MAKER POST 1160

AMERICAN LEGION

PRESENTS

★

VILLAGE OF CHICAGO RIDGE

PHONE DIRECTORY

1967

Before the yellow pages, the American Legion Post No. 1160 released the village phone book. Seen here is the cover for the 1967 edition, and every known resident's name, phone number, and address were listed inside. (Courtesy of Adehl Good.)

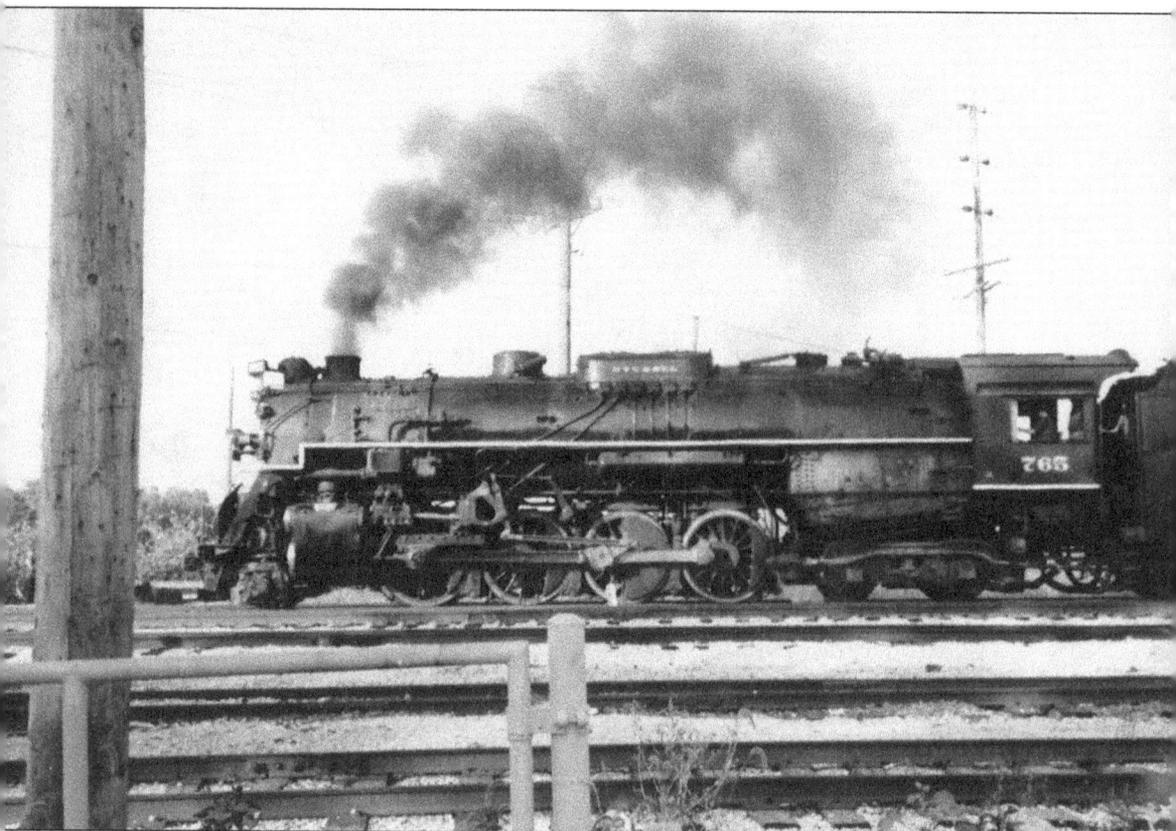

This old-fashioned locomotive ran right through the heart of Chicago Ridge up until 1993. Pictured is Nickel Plate Locomotive No. 765 on the railroad tracks near 103rd Street and Ridgeland Avenue. Between 1979 and 1993, No. 765 pulled 100,000 passengers for about 52,000 miles of special excursions in 16 US states east of the Mississippi River. The Fort Wayne Railroad Historical Society (FWRHS) in Indiana gained ownership of the engine in 1985. Around 1910, men known as "gandy dancers" lived in boxcars, located at 103rd Street and Marshall Avenue. Their roster included about 30 section men, 3 track foremen, 3 maintainers, 3 car inspectors, 3 tower men, 1 station agent, and 1 clerk. They all worked for the railroad and lived in what were called "camp cars" on the job site.

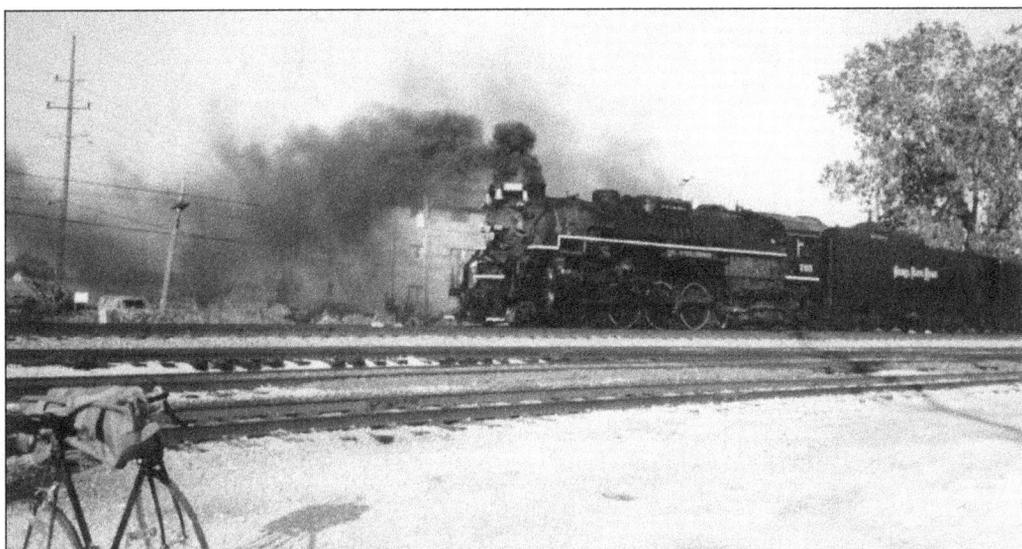

At one time, the tracks on the Baltimore & Ohio Chicago Terminal and the Indiana Harbor Belt Railroads through Chicago Ridge were the second busiest in the nation, running almost as many trains as the line between Philadelphia and New York City on the Pennsylvania Railroad.

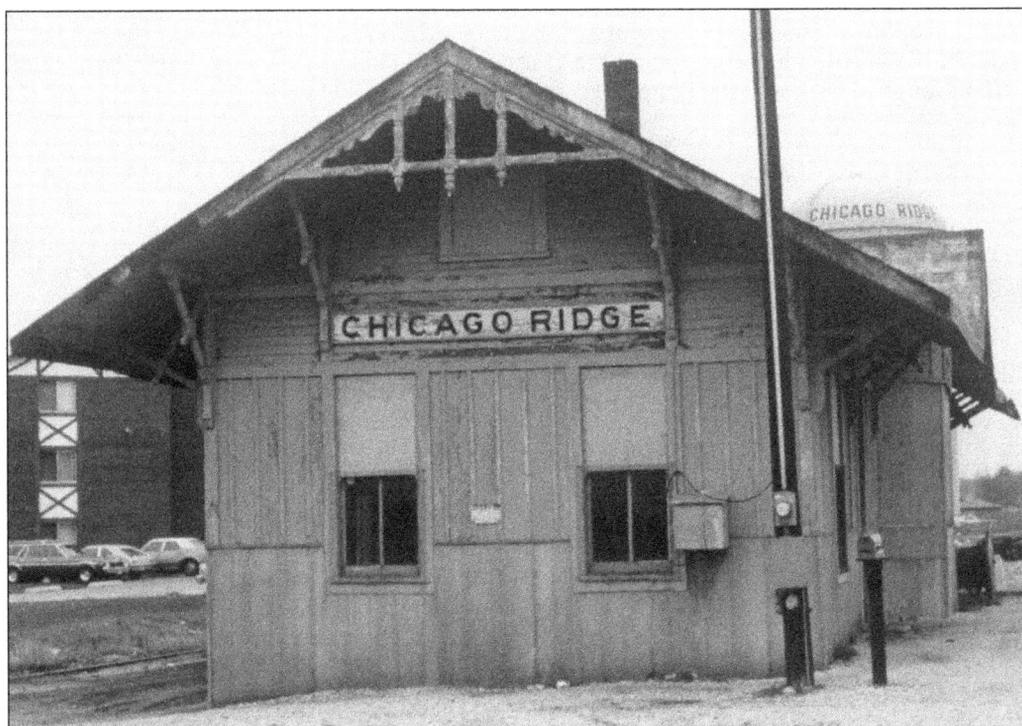

Chicago Ridge postmasters, into the 1950s, ran the post office out of their homes and were only paid commission from stamp sales. They brought the outgoing mail to the town train station, three times daily, and hung it on hooks so that the moving train could grab it. The train would throw the sacks of the town's mail onto the platform, and the postmaster would bring it home to sort for delivery into PO boxes.

If action by the village board of trustees meant anything, barbers in Chicago Ridge had it easy during the summer of Chicago Ridge's 50th anniversary. The officials, garbed in false beards, passed an ordinance making it unlawful to shave during the anniversary celebration from June 27 to July 5, 1964. A fundraiser to benefit the Chicago Ridge Public Library was held, and shaving permits for gentlemen who did not plan to grow beards were sold for $1.

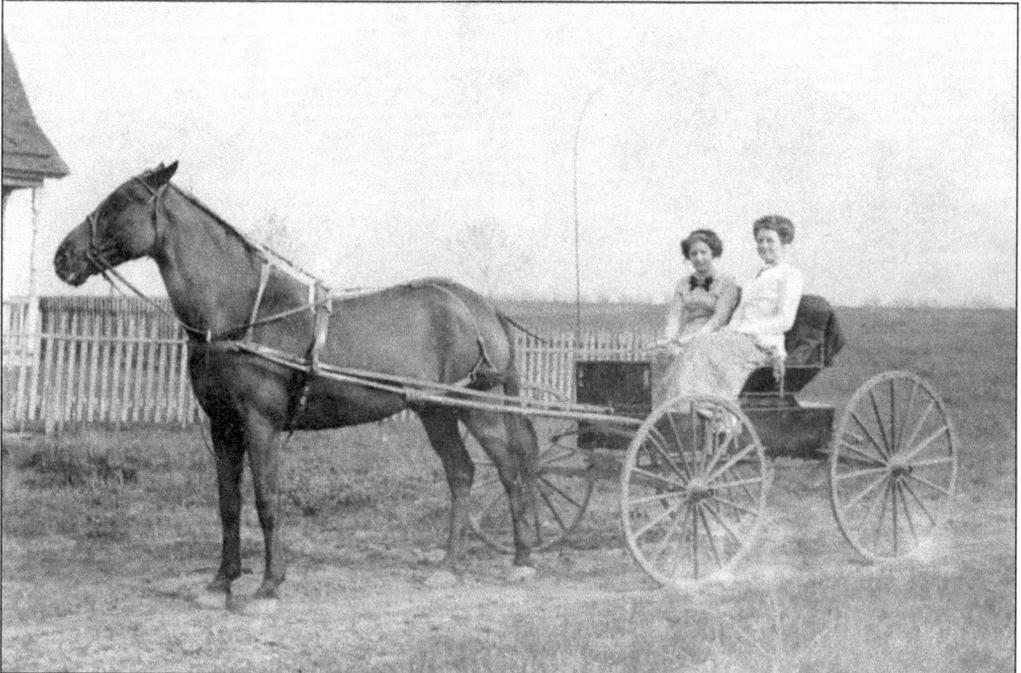

During the 50th anniversary celebration of Chicago Ridge, village trustees passed an ordinance prohibiting the use of motor vehicles between 1:00–7:00 p.m. on Sunday, June 28, 1964. According to jubilee chairman Robert Scanlan, horse-drawn taxis were provided to transport villagers.

As part of the village's 50th anniversary celebration, the town put on a lavish play depicting Chicago Ridge's history from its beginning. The play was emceed by famous Chicago disc jockey Wally Phillips, and the parts were played by townspeople.

INTRODUCTION

Narrator ...Wally Phillips

Presentation of Colors
Glenn Maker Post 1160 American Legion

Welcoming AddressArthur Cooper

Presentation of Awards

Introduction of GuestsVillage President

* * *

"THE GOLDEN YEARS"

A PAGEANT DEPICTING THE HISTORY

OF THE

VILLAGE OF CHICAGO RIDGE

Directed by

MRS. CHARLES REARDON

Written by

MRS. ANTHONY COLETTA

ACT I SCENE I
"The Beginning"

Hunters ...Mike Wolner
 Al Aiello
Charlie ..Bob Burns
Dan ..Joe Mikolajewski
Doc ...Chuck Lejeck

SCENE II

Tom ..Nevin Hahn
Hy ...Ken Marsh
Buck ShowdeyMike Wolner

SCENE III

First Man ..Al Aiello
Second ManChuck Lejeck
Doc ...Ray Geier
"You've Gotta Have Heart"Chorus
Dancer ..Jean Johnson

ACT II SCENE I

BartenderJoe Mikolajewski
Dancers ..Corrine Griffin
 Darlene Glassner
 Marie Burns
 Therese Konrath
 Maureen Sherry
 Joanne Dencek
 Irene Coglianese
 Donna Galas
 Barbara McDermott
 Joan Werges
Deputies ...James Dencek
 Charles Van Dyke

At one time, the area west of 107th Street and Ridgeland Avenue was a big sheep farm where the sheep were driven to the Chicago stockyards. Beyond that, near 107th Street and Harlem Avenue, lived Chi Chi, the goat man. Livestock was common in the area, and early laws regulated how many farm animals could be near the house. Once, a bull got loose and ran up and down Ridgeland Avenue, wreaking havoc on the population.

At one time, Chicago Ridge had 14 taverns and only 300 residents. These taverns were the social centers of their day, and children were often brought with and served hot dogs in an area designated for their play. Groves were often attached, which accommodated picnics and special occasions.

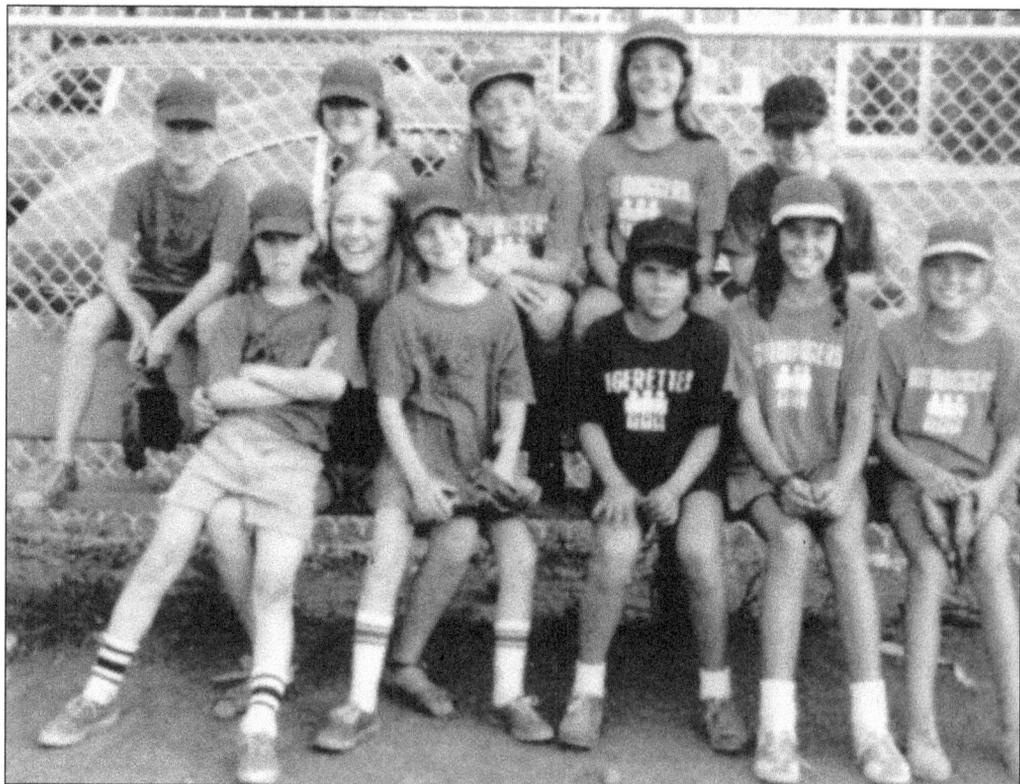

Baseball has always been a popular pastime in the village. Pictured in 1975 are the All-Stars Chic Division. Team members are, from left to right, (first row) Jean Tripana, Debbie Ryan, unidentified, Donna Mioni, Laura Wagner, and Tammy McManigal; (second row) two unidentified, Carolyn Bates, Cheryl Ryans, and unidentified. Three Chicago White Sox players—third basemen and current Sox analyst "Beltin" Bill Melton, outfielder Ken Berry, and catcher Ed Hermann—all lived in town during the 1970s. Their homes were in what was then known as Briargate apartments on Ridgeland Avenue and 105th Street. The players could often be seen around town. Tim Pyznarski, a major league first-round draft choice and Sporting News/Topps minor league player of the year in 1986, was raised in Chicago Ridge. Tim played for several major league teams over the course of his career and was active in the boys' field hockey program founded by his dad in town as well. (Courtesy of Carol Bates Horacek.)

Eight

VILLAGE PRESIDENTS

Included in this chapter are the men who stepped forward and led this town to its next point in history. They connected the dots and created the picture seen today. They were builders of industry and leaders, carving the village's path into the future. They tried to improve upon the accomplishments of their predecessors all while trying to maintain a decent family life for themselves. They gave countless hours and anonymous sacrifices in other facets of life, with some at great personal expense. They face many challenges, each one unique and some seemingly impossible.

Such is the life of a village president. Politicians are a favored target for criticism, but with this chapter, it is hoped that one gets to know them a little better and know they were essential to the growth of this town. Some did extraordinary things for Chicago Ridge, but all devoted their time to making this a better place to live in one way or another. It is hoped that, for a change, instead of trying to get some dirt on political leaders, one finds something to be grateful for instead. Local government consists of more than just a president, and throughout the village's history, the people in these positions are equally responsible for these accomplishments.

Unfortunately, this book does not have the necessary space to recognize all the clerks, trustees, police officers, fire chiefs, and other officials who have contributed greatly to the village's progress.

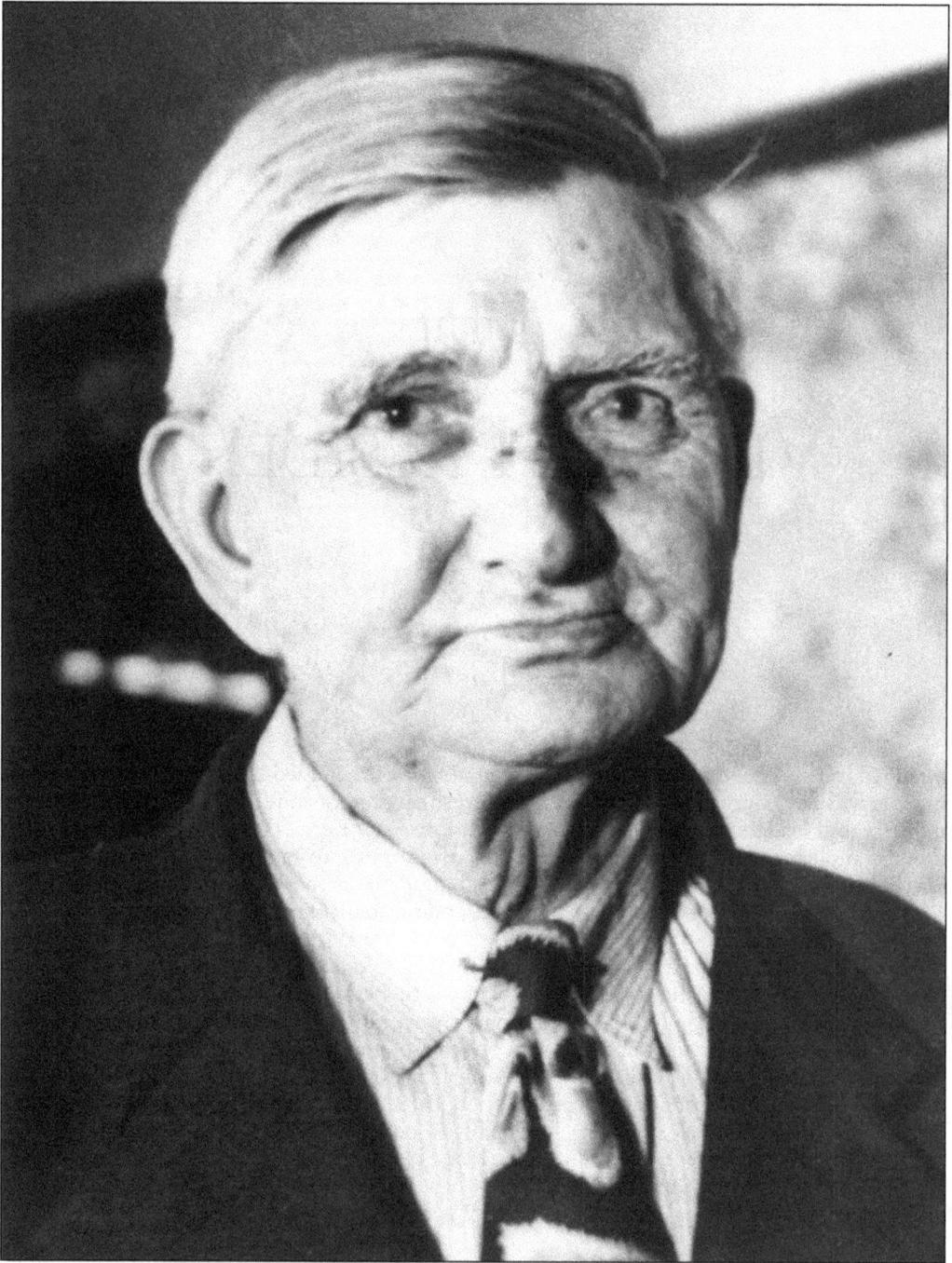

Charles Polchow served as the first president of Chicago Ridge in 1914. Charles and his wife, Luzina Zippel, arrived at Chicago Ridge on March 10, 1897. Their first home was a farmhouse at 107th Street near Oak Park Avenue. Later, they moved to 105th Street and Central Avenue where he created an underground icehouse from which he sold ice all summer. At this location, Polchow also ran a popular hunting club. One of his sons, Herbert Polchow, became village president of Chicago Ridge in 1953. Charles Polchow Sr. died in 1951 at 78.

Henry Schmalen was village president of Chicago Ridge from 1921 to 1924. He moved from Chicago to Chicago Ridge after he retired from the wholesale meat business. His niece was Mary Maker, the first woman trustee of Chicago Ridge.

Arthur W. Meyer was village president of Chicago Ridge from 1925 to 1926. His father was John Henry Meyer, who operated the Chicago Ridge Inn and Hotel, which included a tavern, next to the railroad tracks at 103rd Street and Ridgeland Avenue.

Peter Rucies was village president of Chicago Ridge from 1927 to 1934. The Rucies family owned Rucies' Tavern and Grove at 106th Street and Ridgeland Avenue. Rucies' was a popular spot for special celebrations.

William Paulus was village president of Chicago Ridge from 1935 to 1936. Mayor Paulus was married to Marie Paulus, the town's postmaster from 1927 to 1954, and the post office was operated from their home.

Bruno Duckwitz was village president of Chicago Ridge from 1937 to 1942. He resigned his position as mayor to enlist in the armed forces in 1942 and serve active duty during World War II. After the war, Duckwitz operated a popular Laundromat in Chicago Ridge at 106th Street and Ridgeland Avenue.

John Dokter was village president pro tem for Chicago Ridge from 1943 to 1944. Dokter spent 20 years of his life in public service. Dokter was on the local school board and was a longtime member of the town board of auditors. Upon his death in 1968, Worth Township issued resolution No. 68-1 honoring his service.

William Walsh held the offices of village president from 1945 to 1952, president of the board of education, justice of the peace, and Worth Township Democratic Committeeman. His parents, William Sr. and Mary Walsh, settled in the Wales-Tobey subdivision in 1914 after selling their store in Chicago.

Hebert Polchow Sr. was village president of Chicago Ridge from 1953 to 1956. He was one of 11 children born to Charles (first village president 1914–1920) and Luzina Polchow. Mayor Polchow is said to have started the first organized youth baseball on their field across from Polchow's Grove. Polchow instituted garbage removal for the town at a cost of 25¢ a can. The Polchow family has been instrumental in Chicago Ridge's birth and longevity.

Arthur Cooper was elected village president in 1957 and served until 1964. He was born to Minnie Ehmckie Cooper and Anthony Cooper in 1912 and was raised at 10636 Oxford Avenue. His maternal grandmother was Frederika Polchow Schroeder, sister of the village's first president, Charles Polchow. Cooper was the first Chicago Ridge mayor born here. He married Ida Bizzotto in 1939 and lived at 10640 Oxford Avenue.

Joseph Coglianese was village president of Chicago Ridge from 1965 to 1974. The Chicago Ridge library, public works, and park district were formed under Coglianese's administration. Firehouse 2, a park district building, a police car garage, and Eldon D. Finley Junior High School were built during this time as well. Mayor Coglianese's term was cut short by legal proceedings.

124

Eugene Siegel was elected as part-time village president of Chicago Ridge in 1975 to fill an unexpired term. Elected as a full-time mayor in 1993 and retiring in 2013 undefeated, he was Chicago Ridge's longest serving president. The Chicago Ridge Village Board named the Eugene L. Siegel Municipal Complex at 10455 Ridgeland Avenue after him for his years of service. Chicago Ridge Mall, the modern village hall, firehouse, and public works facility, to name only a few, were under his administration.

AFTERWORD

As I write this in mid-June 2013, I am very positive about the future of Chicago Ridge. While the economic downturn of the last five years has had a negative impact on our village, as it has on all municipalities, I do see signs of a slow recovery. I am much encouraged by some of the new businesses that have opened recently, or will soon, including Chick-fil-A, Flaming Grill, Doughs Guys Bakery, and Five Guys Burgers. Along with that, it seems home foreclosures have bottomed, and new homes are once again being built.

Probably most significant for our future is the opportunity to redevelop some areas of our community, as we have in the past with the Chicago Ridge Mall, the Commons Annex, our industrial park, and the Lennar Townhome project. In the near future, I hope to see properties bordering Harlem Avenue and Southwest Highway established as a tax increment financing (TIF) district. Chicago Ridge has made effective use of the TIF concept in three successful areas over the last 25 years, and using TIF again to bring in mixed-use development would be a boon not only to our village but also to the southwest suburban area.

In the years ahead, I expect to see our community remain progressive, to see positive changes that will enlarge the business tax base, and to see redevelopment bring much-needed jobs to many seeking employment. I also expect to see these measures aid our efforts to keep a lid on the village's portion of residents' property tax bills.

Maintaining the quality of services provided to our residents is a top priority, whether it is police, fire, ambulance, or public work services. As a village celebrating its 100th birthday, the repair and replacement of older infrastructure, such as water mains and streets, must be continued.

Most importantly, I want to see our residents remain "small-town friendly," good neighbors who still enjoy block parties, meeting up at church, and Little League games, sharing their garden vegetables, and conversing over backyard fences. I want those looking to make Chicago Ridge their home to see that it is our people—caring, honest, and hardworking—who make our village stand out. Happy 100th birthday, Chicago Ridge!

—Charles E. Tokar, village president

BIBLIOGRAPHY

Babcock, Robert. "Railroads in Chgo. Ridge." Personal memoir, 1976.

"Chicago Ridge: 60 Years as a Village." *Worth-Palos Reporter*, June 25, 1964.

McClellan, Larry A. "Chicago Ridge, IL." *The Encyclopedia of Chicago*. Chicago: University of Chicago Press, 2004. 146.

Pote, Anne. "In the Olden Days: An Outline History of Chicago Ridge, Illinois." Village of Chicago Ridge Bicentennial Memoir. 1976. 1–7.

"Saluting Chicago Ridge on its 70th Anniversary." *The Reporter*, October 25, 1984.

"Village of Patriotism, Chicago Ridge, 1914–1974." *Worth-Palos Reporter*, July 4, 1974.

Visit us at
arcadiapublishing.com

www.ingramcontent.com/pod-product-compliance
Lightning Source LLC
Chambersburg PA
CBHW080610110426
42813CB00006B/1466